T0373919

ART DECO
BRITAIN

First published in the United Kingdom in 2019 by
Batsford
43 Great Ormond Street
London WC1N 3HZ
An imprint of B.T. Batsford Holdings Ltd

ISBN: 9781849945271

A CIP catalogue record for this book is available from the British Library.

10 9 8 7 6 5

Reproduction by Rival Colour Ltd, UK
Printed by Leo Paper Products, China

This book can be ordered direct from the publisher at the website:
www.batsfordbooks.com or try your local bookshop.

ART DECO
BRITAIN

BUILDINGS OF THE INTERWAR YEARS

ELAIN HARWOOD

BATSFORD

INTRODUCTION

In the 1930s, a sixpenny (2½p) ticket to the cinema brought an opulent interior in the latest taste within reach of everyone in Britain. The coquettish twists of metals, marquetry and mosaics are symbolic of an age of glamour that the movies conveyed, even if real life was not like that. The difference between rich and poor was vast at this time – yet each was more aware of the other's world than ever before thanks to advances in transport, publishing and the movies. Architecture sought to bridge something of the gap. What we now call Art Deco embraced many sources. Architects were more aware of 'a style for the job' than of one overriding idiom and no period embraced such diversity of building as the two decades between the world wars. The architecture of luxury is hardest to find today, for most of the restaurants and hotels and virtually all the ocean liners synonymous with the era are gone, and many survivors in London's West End are a pastiche of their former selves. But among Britain's more prosaic buildings built in the 1920s and 1930s are many that tell a broader story, while including fashionably modernistic elements, a sense of either massiveness or movement – contrasts that define an era of individuality and extremes. It is this variety, and the accessibility of modernity to all, that may explain why the architecture has wide appeal today.

This introduction begins with the influence of American classicism and the sources of decorative modern styles from around the world. Many of these came together in the Exposition Internationale des Arts Décoratifs et Industriels Modernes held in Paris in 1925, which four decades later gave Art Deco its name. Contemporary accounts, when not wholly dismissive of the middle ground between modernism and classicism, wrote about jazz-modern, a descriptive term that succinctly referenced both the music of the age and the jagged diagonals with their sense of movement found in much architectural decoration. If the term Art Deco existed at all it was as a diminutive, referring to the exhibition. In 1966 the Musée des Arts Décoratifs in Paris held an exhibition, Les Années 25: Art Déco, Bauhaus, Stijl, Esprit nouveau, shorthand for the multiplicity of movements across Europe at that time. Hillary Gelson lifted the phrase 'Art Déco' for a review in *The Times* and two years later Bevis Hillier made it stick with his book, *Art Deco of the 20s and 30s*. In practice, however, much of what we call Art Deco today is a simplified but attractive 'moderne' style indebted to Dutch and German models that became pervasive in the 1930s. This was the style of many of the new building types of the decade, of airports, public buildings and the seaside, made possible by increased familiarity with concrete and steel construction.

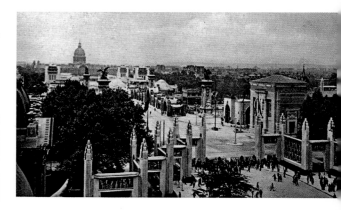

Exposition Internationale des Arts Décoratifs, Paris, 1925. The entrance at the Alexander III Bridge, with, to the right, Robert Mallet-Stevens's information point and clock tower

AMERICAN CLASSICISM

In early 1919, Robert Atkinson, principal of London's fastest-growing school of architecture, the Architectural Association, secured a sabbatical to study education and cinema design in the United States. There he witnessed New York's latest sensation, the luxurious super cinemas being erected under the supervision of Sam 'Roxy' Rothapfel. They included the world's first 5,000-seat cinema, the Capitol Theatre, opened that year to the designs of Thomas W. Lamb. It took the established classical style of public buildings – the very name Capitol set the tone – and subverted it by simplification and gilding for a popular audience. Atkinson brought the super cinema to Britain with his Regent, Brighton, opened in 1923, and with it a striking form of American classicism. He went on to design many of Britain's most thoroughgoing Art Deco buildings.

The wider story of Art Deco in Britain begins with this updated American classicism. It could be explored on the office stool thanks to the growing availability of American magazines and advances in architectural education, although easier travel increased its impact. While Atkinson's successors at the Architectural Association made links with northern Europe, in the 1920s Britain's largest and most potent school of architecture remained that in Liverpool, umbilically linked by ocean liner with New York. Its powerful head, (Sir) Charles Reilly, drew the school's alumni into a close-knit group who recognised their 'Prof' as the profession's elder statesman, and following his retirement in 1933 they continued to teach a distinctive style of architecture through successive appointments from among their number. Reilly's methodology followed that of the École des Beaux-Arts in Paris, based around grand but logical planning exercises and the latest construction techniques, which students clothed in an Imperial Roman style as reconsidered in the Italian Renaissance or

The Regent Palace, Brighton, by Robert Atkinson, 1920–21, demolished 1974

17th-century France. Americans had thronged to Parisian ateliers since the 1880s, and the Beaux-Arts provided a consistent formula for North America's public buildings and commercial architecture until the Depression. Throughout the 1920s, Reilly sent his most promising students to work in the leading New York offices, where they saw how classicism could be distorted and decorated into a heavyweight form of Art Deco more prevalent even than it was in Paris.

Other British architects also developed close connections with the United States. (Sir) John Burnet was the first Scot to train under the Beaux-Arts programme, in 1872–76, and disseminated its values to his young staff, along with American contacts. He built extensively across Scotland before, in 1904, he won a competition for the extension of the British Museum that led him to open a London office. He brought south a brilliant young assistant, Thomas Smith Tait, who became a partner only after a bitter quarrel had led him to spend over a year in New York. Francis Lorne joined them after working in the United States for over 15 years; he brought to the firm not only American architectural predilections but also its stylish suits and silk shirts (which stood out against conservative British dress) and an assiduous

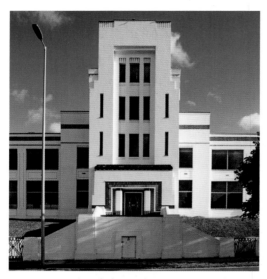

Pyrene Factory (Westlink House), Great West Road, 1928–30 by Wallis, Gilbert & Partners

cultivation of new clients and publicity. Through several mutations the practice (known in the 1930s as Burnet, Tait & Lorne) charted the evolution of architecture in Britain from classicism to the moderne, always with a decorative twist that places its buildings in the Art Deco canon yet without losing the dignity that won it a series of major public buildings.

Only a little less exciting were the American influences on new factories, when its companies established European markets for their consumer goods. Many had ties to the vehicle industry, such as Firestone and India tyres, but Wrigley's gum, Hoover vacuum cleaners and Pyrene fire extinguishers also secured large sites on the new roads that radiated from Britain's major cities in the 1920s. Their factories were organised on rational production lines behind bold facades that could convey a simple message of modernity and sound construction to passing motorists in a few seconds. American techniques lay at their heart, for from the United States came an efficient method of reinforced concrete construction when in 1907 the Kahn brothers,

Moritz and Julius, began to market their patent reinforcement bars in Britain as 'Truscon', a subsidiary of their Trussed Concrete Steel Company based in Detroit. The firm provided a valuable training at the interface of architecture and engineering for the young Owen Williams, the engineer responsible for some of Britain's finest early Modern Movement buildings.

NEW CONSTRUCTION TECHNIQUES

The 1920s saw the maturity of the two forms of framed construction that distinguish 20th-century architecture from that of earlier eras: reinforced concrete and steel. Concrete – an artificial stone made from lime or cement mixed with an aggregate of sand and pebbles – goes back to Roman times, but from the late 19th-century reinforcement bars or wire mesh were embedded in the mix to add tensile strength. Companies from France and then the United States patented their bars in Britain. Steel, which offered greater tensile qualities than cast iron, was smelted in a sufficient quantity to be used in buildings from the 1880s. The first framed buildings of concrete and steel appeared in Britain a decade later, but their numbers grew when the London Building Act of 1909 permitted their use in the capital behind a thin cladding rather than a self-supporting wall. Kodak House, erected in 1910–11 by Burnet and Tait as the European headquarters of the famous photographic company, had a stripped down facade and large windows in which the presence of the supporting steel frame could be clearly read – a suitably scientific and progressive image for a modern business and a model for office building after the First World War. Concrete and steel frames made possible the towers and contorted shapes of Art Deco, giant overhangs and greater spans. Again cinemas were good examples, from the advertising towers on the outside to the huge auditoria where massive steel girders permitted perfect sightlines without columns. Additionally, steel was used

for windows, a practical necessity thanks to a shortage of timber after the First World War, becoming fashionable with good marketing.

A skin of chromium oxide to prevent steel from rusting appeared in the 1920s; sometimes known as 'Staybrite' steel, it was used on the canopy of the Savoy Theatre in 1929. Glazed terracotta bricks or tiles, known as faience, had long been used in courtyards and functional interiors for their shiny, easily washed-down finishes, but now came to the fore for their ornamental qualities. New techniques made glass cheaper and available in larger sheets: Pilkington's secured British licences in 1910 to manufacture machine-drawn cylinder glass and in the 1920s to make Vitrolite, an opaque compound available in a variety of colours whose name was applied across the genre of structural glass, just like that of Crittall was used to refer to all makes of the steel windows that gave the new architecture its machine-finished appearance.

Although local authorities, led by the London County Council, were wary of new structural techniques, government buildings lay outside their control. Architects in the Office of Works became specialists in the use of reinforced concrete and in 1914 Truscon head-hunted one of their number, Thomas Wallis, to open an office as Wallis, Gilbert & Partners, nominally with an American sleeping partner. Gilbert's identity remains a mystery or (as Wallis's biographer Joan Skinner suggested) he may have been entirely fictitious. Wallis provided simple Beaux-Arts facades for the Kahn brothers' concrete factories, until in the 1920s his practice blossomed with the introduction of exotic decoration based on giant orders of columns that were distinctive for their brilliant colours and Egyptian motifs. Wallis's most intricate example was a factory for Firestone tyres built on London's Great West Road in 1928, a colossal temple to the gods Amun and Ra with details of green, vermillion and midnight blue. Marcus

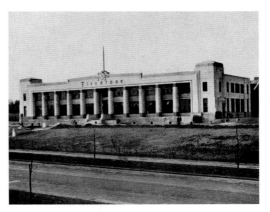

Firestone Factory, Great West Road, 1924–28 by Wallis, Gibert & Partners

Collins of architects Collins & Porri was a still more passionate advocate of Egyptian motifs.

SOURCES FOR ART DECO

Greek, Egyptian and other exotic motifs formed a major strand of what we today call Art Deco, the decoration of large, framed buildings with modern interpretations of historicist styles from all ages and cultures. They were created using the latest claddings, plus linoleum products and early plastics such as Bakelite. Greek and Egyptian architecture share some common origins, both being based on decorative orders of columns and beams. Sloping or battered facades balanced by very large splayed cornices, capitals incorporating palm, papyrus buds or lotus leaf motifs, and simply moulded entablatures enhanced with Egyptian figures and runes had appeared sporadically in western architecture before Napoleon's invasion in 1798 prompted more detailed study. Another revival followed the First World War in an enthusiasm for those cultures untainted by Europe's soured history, encouraged by advances in photographic publishing. Variety theatres had long celebrated exotic architecture, as Victorian venues with names like Alhambra and Hippodrome testify, and the Louxor (Luxor) Cinema in Paris, built in 1920–21 was just one example of a newly

completed building with Egyptian motifs when in November 1922 Howard Carter discovered the undisturbed tomb of the boy-king Tutankhamun. A craze for Egyptian motifs swept across the decorative arts, from furniture to book design and fashion; even Lady Elizabeth Bowes-Lyon wore an outfit embroidered with Egyptian motifs when she married the future George VI in 1923. Other exotic sources of inspiration included the Orient, Mayan and Aztec temples and African carvings.

MODERNISM

Other sources were closer in time. The evolution of Art Deco out of Art Nouveau is less easily seen in architecture than in the fine and decorative arts, part of the Romantic Movement that blossomed around 1900. A trail of simple and sinuous motifs can be seen across Europe – especially in smaller and emerging countries such as Belgium, Finland and Latvia – and in America at around the same time. Art Nouveau made little impact on Britain's prosaic culture, and when the rugged realism of the Arts and Crafts Movement gave way to neo-classicism inspired by Christopher Wren, it seemed that the architecture of St Paul's Cathedral and Hampton Court had been assimilated as a national style. A severe classicism dominated British architecture in the 1920s. In 1925 Peter Behrens built New Ways in Northampton, generally considered to be the first Modern Movement house in Britain, although it featured a version of classical dentils in the detailing of its porch.

Modernist architecture and Art Deco have more common sources than their respective fans might admit. A decisive shift in architectural taste towards modernism only occurred in Britain around 1933–34, seen in magazines such as the *Architectural Review* and in the schools of architecture. British taste, like that of northern Europe and its American diaspora, was always circumspect about decoration, and in the most

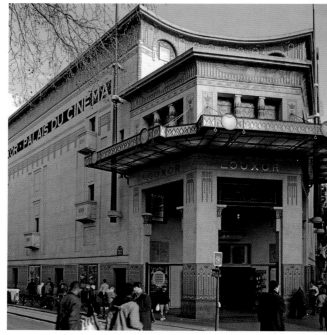

Louxor (Luxor) Cinema, Barbès, Paris, 1920–21 by Henri Zipcy

luxurious buildings the distinctions between Art Deco and modernism can be blurred, since both laid emphasis on the quality of the finest veneers and finishes over superficial ornament.

In a book published to accompany their exhibition on the International Style at the Museum of Modern Art in New York, Henry-Russell Hitchcock and Philip Johnson extolled modernism's principles as an 'emphasis upon volume, space enclosed by thin planes or surfaces as opposed to the suggestion of mass and solidity; regularity as opposed to symmetry or other kinds of obvious balance; and lastly, dependence upon the intrinsic elegance of materials, technical perfection, and fine proportions, as opposed to applied ornament'.[1] The exhibition, held in 1932, included only one British building, Joseph Emberton's Royal Corinthian Yacht Club, built in 1930–31 at Burnham-on-Crouch, Essex, a complex, steel-framed structure disguised as a

rectangular rendered box with large windows, overlooking the river. Even here, in his letters to Emberton, Johnson criticised the circular external staircase and a slanted row of windows as overly decorative. In a similar spirit, Berthold Lubetkin proclaimed that the slender, unfaceted shape of the door handles designed for his Highpoint flats in north London was 'modern, not moderne'.[2]

The key source for both modernism and Art Deco was Vienna, entrenched as the creative capital of Eastern Europe even as its political power declined. The architect Adolf Loos provided a link between the city and the United States, his architectural sensibilities stimulated by a stay in 1893–96. Regularised patterns in brilliant colours appeared in the highly decorative work of the Wiener Werkstätte in Vienna and the Deutsche Werkbund around 1900. Otto Wagner's Wienzeile houses in Vienna of 1898, one clad in majolica-glazed tiles patterned with flowers, were followed the next year by offices and flats for Portois & Fix from his pupil Max Fabiani, where similarly brilliant tiles glow in the evening sunshine.

Viennese organisations also exhibited and published works by British architects, in particular Charles Rennie Mackintosh and M.H. Baillie Scott, who secured a dozen commissions in Europe. Both entered an international competition run by a Darmstadt publisher for a 'house for an art-lover', with Scott's entry effectively the winner although Mackintosh's incomplete entry was more admired and widely published. The square panelling and jagged spearhead decoration of Mackintosh's last major interior, at No.78 Derngate, Northampton, from 1916 exemplifies much of the symmetrical, cubist and most vibrant patterning of early Art Deco. The same client, W.J. Bassett-Lowke, later commissioned New Ways. Glowing, too, were Leon Bakst's rich set designs for the Ballets Russes, seen across Europe as Serge Diaghilev endlessly toured his company following a triumphant launch in Paris in 1909; they attracted younger artists and choreographers into the 1920s, when long seasons in London provided some financial stability.

Perhaps only the critic and cartoonist Osbert Lancaster could ridicule both genres. In his book *Homes Sweet Homes* of 1939, he lampooned both the skinny aesthete perched nervously on his Alvar Aalto stool and the buxom *bon viveur* reclining on her over-stuffed sofa, cocktail in hand, swooning over her beloved lapdogs amid a clutter of fan-shaped mirrors and *objets d'art*. In addition to his pages on 'functional' and 'modernistic' styles, Lancaster offered such confections as 'Curzon St Baroque', 'Stockbrokers Tudor' and 'Vogue Regency' to describe the homes of his middle- and upper-class neighbours. Today, 'Art Deco' is an umbrella term for many of these idioms, for which there is no clear definition such as Johnson used for modernism.[3]

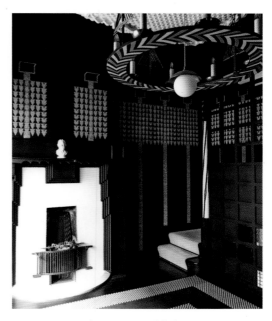

78 Derngate, Northampton, remodelled in 1916–17 by Charles Rennie Mackintosh

THE 1925 EXHIBITION

In the era before television, themed trade fairs were the principal means of bringing new products and ideas to a large audience. The Exposition Internationale des Arts Décoratifs et Industriels Modernes held in Paris in 1925 was the greatest of the decade, attracting over 16 million visitors. It spilled across the greensward either side of the River Seine. All Paris's leading department stores erected pavilions, as did the state-sponsored manufacturers of luxury goods that the exhibition set out to promote and which in the master plan by Charles Plumet were given the most prestigious locations. The foreign pavilions and those of the French regions and colonies squeezed on to the Right Bank. Critics praised the luxurious materials and monumental classicism of Emile-Jacques Ruhlmann; Süe et Mare and the pavilions of the Société des Artistes Décorateurs and L'Ambassade Française. The style survives in two original interiors at the Palais de la Porte Dorée, now the Cité Nationale de l'histoire de l'immigration, built in 1931 by Albert Laprade, Léon Jaussely and Léon Bazin. René Lalique's exhibition of structural glassware was also admired, together with his illuminated fountain, *Les Sources de France*. Yet the overall assessment was one of disappointment.[4] Many of the exhibits seemed over-encrusted with luxury or were downright cumbersome, not least those of the British Pavilion designed by Easton & Robertson. It resembled an escapee from its Palestine protectorate, a stripped-down and institutionalised colonialism.

Nevertheless, with unprecedented speed, many motifs from the more fantastic pavilions quickly found themselves transcribed to buildings and objects around the world. Fluted pylons, stripped classical orders implied by two or three horizontal lines, and variations on the giant sunburst over the entrance to the pavilion of the Galeries Lafayette or Lalique's glass fountain are immediately recognised as 'Art Deco' today. In Britain, H.C. Bradshaw of the Department of Overseas Trade also noted how the ubiquitous plaster surfaces were finished in new ways, and how 'silver and gold painted in lines or dusted over rough plaster surfaces gave brilliancy to many buildings'.[5] Searchlights and waterworks contributed to a dream city that revealed itself at night when concealed coves of artificial lighting framed the buildings or picked out low-relief sculptural panels.

The United States did not participate in the Paris Exhibition, its government declaring that 'American manufacturers and craftsmen had almost nothing to exhibit in the modern spirit'.[6] This comment indicates the divergence between the architectural mainstream and the many small designers of the time with close links to Europe. These included émigrés such as Joseph Urban and Paul Frankl from Vienna, while Frank Lloyd Wright was pulling together European, Mayan and oriental sources in his work – albeit in relative obscurity at the lowest ebb of his long career. Links with the latest European thinking were reinforced by a competition for a skyscraper organised by the *Chicago Tribune* newspaper, which attracted 260 entries from both American and European designers in every variant of every traditional and modern style. The most influential was an unplaced modern design by Walter Gropius and Adolf Mayer, which featured three half bands at the top of the tower like an abstracted wing. This became a recurring motif, from its adoption by Robert Mallet-Stevens for the clock tower to the Paris Exhibition to that by Thomas Tait for a still larger tower at Glasgow's Empire Exhibition as late as 1938.

Despite their government's reticence, American designers and reviewers flocked to Paris in 1925, and the next year Charles Richards, director of the American Association of Museums, organised a tour of over 400 objects from the show. Other exhibits were displayed in major department stores across

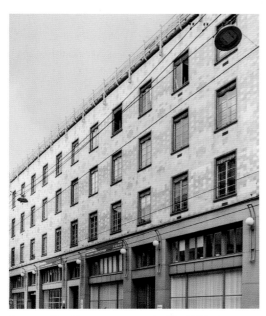

Portois et Fix, Vienna, 1899–1900 by Max Fabiani

the United States as the economy soared. The building boom of 1925–30 saw the building of great cinemas, department stores and railroad stations, but most impressive of all were the new skyscraper office towers made possible by advances in steel construction, high-speed elevators, artificial lighting and air conditioning. Thirty major new offices were built in New York in 1926 alone, and the next years saw the building and decoration of the Chanin and Chrysler buildings, the most exotic skyscrapers of them all, set at kitty-corners in the mid-town grid transformed following the rebuilding of Grand Central Station for commuter traffic. Architects and their decorators plucked motifs from the objects sent over from Paris and out of photographs of the original pavilions; they further simplified or over-scaled classical motifs and enriched the colours of cubist patterns, semi-abstract forms and fountain motifs. As well as creating vibrant entrance halls and lift lobbies, there were unheralded opportunities for decoration at the tops of towers, subject in New York to a zoning ordinance that in 1924 began

to enforce the stepping back of upper floors and led the architect Raymond Hood to christen Art Deco the 'vertical style'. Hood's Ideal House is one authentic piece of New York architecture in London, erected for the American Radiator Company as its European showroom.

THE LONDON SCENE

The extensive rebuilding of Mayfair undertaken by the Grosvenor Estate between 1870 and 1914 had created an enclave of upmarket housing, shops and services in the heart of the West End, home to the London Season. The rebuilding of Claridge's set the tone, as did its remodelling and extension amid changes to the area in the interwar years. The 1920s saw Britain's aristocracy surrender their town houses for a pied-à-terre in a flat or one of the mews houses that replaced the old stable yards. Death duties forced the abandonment of Devonshire House in Piccadilly in 1919 and its demolition for a hotel, flats and an office block – the latter by the American firm of Carrère & Hastings. After five years of prevarication, Grosvenor House was torn down in 1927, and Aldford House followed in 1930, prompting the transformation of Park Lane with giant blocks of flats and hotels, a trend repeated around Grosvenor Square. Firms of decorators were engaged to deck out the new flats, some headed by society women such as Lady Sibyl Colefax and Syrie Maugham, who was celebrated for her white interiors and stripped furniture.

In place of the private mansions, hotels became centres for display. They accommodated not only the distinguished visitors arriving in increasing numbers off the great ocean liners, but also their ballrooms hosted the most prestigious events of the London Season. The Park Lane Hotel, its ballroom and foyer the finest example of Parisian Art Deco surviving in London, is on the site of a former Rothschild mansion and the Savile Club, both owned by the Rosebery family by the 1920s. When Joe

Lyons remodelled the middle-class Strand Palace Hotel, his architect Oliver Bernard (who had worked at the Paris Exhibition and was a specialist in lighting effects) transformed the foyer with illuminated glass columns and a glass staircase balustrade, which he combined with pale marble, chrome and mirror. Recognition of Art Deco came too late to prevent their removal in 1969, but they became the first pieces in the style to be salvaged by the Victoria and Albert Museum. Other decorative schemes of the late 1920s included the refitting of Claridge's restaurant and the Savoy Hotel and Theatre, all by Basil Ionides (1884–1950). Ionides wrote of the importance of the 'elimination of unnecessary details and a practical use of new media and conditions', using simple proportions and the finest materials accented by contrasts of texture and colour, and heightened by focused artificial lighting.[7]

Theatres also enjoyed a revival in the 1920s. Critics lamented the lack of new serious drama, or of Shakespeare productions save at the Old Vic and Stratford, but commercial theatre thrived, mainly on a diet of musicals and operettas. At Drury Lane, spectaculars by Ivor Novello and Noël Coward used large casts, extravagant costumes, huge sets and corresponding budgets. Epics like *Cavalcade* contrasted with Coward's drawing-room dramas and bitter-sweet comedies such as *Hay Fever* (1925) or *Private Lives* (1930) that defined the elegant wit and manners of the times. A flurry of building activity around 1930 created a series of tasteful foyers and delicately restrained auditoria for these entertainments, giving us the West End theatre world we know today. The most ambitious example of this good taste was the rebuilding of the Shakespeare Memorial Theatre at Stratford-upon-Avon in 1929–32 to the designs of Elisabeth Scott, from which the handsome foyers survive. Smaller theatres adopted a still lighter touch, as when the Anglo-Russian architect Serge Chermayeff produced

an interior for the Cambridge Theatre in 1930 that eschews all decoration in favour of a series of arches framed by concealed lighting. The Liverpool Philharmonic Hall, rebuilt in 1937–39 following a fire, similarly rejected the lavish decoration of earlier decades for a sophisticated simplicity that emphasised technical advances in lighting, sound and acoustics.

BUILDINGS FOR LEISURE
Though not strictly new building types, super cinemas, theatres, libraries, department stores, funfairs and stadia for sports made the greatest impact on people's lives. High streets like Westover Road in Bournemouth or Lister Gate in Nottingham were transformed with new entertainment buildings and multiple chain stores by in-house architects. Department stores generally remained classical, interrupted at Barkers in Kensington by two siren-like staircase-cum-advertising towers straight out of the most radical German movie. Chains like Burton's, British Home Stores and Woolworth's, along with the stores and service buildings erected for the co-operative movement, adopted more stripped back, expressionist styles as they assembled in-house architecture departments of considerable size, organised to build nationwide.

Going to the pictures provided the easiest form of escapism and their interiors reflected this; the Russian interior designer Theodore Komisarjevsky was patronising but realistic:

> 'The picture theatre supplies folk with the flavour of romance for which they crave. The richly decorated theatre, the comfort with which they are surrounded, the efficiency of the service contribute to an atmosphere and a sense of wellbeing of which the majority have hitherto only imagined. While there, they can with reason consider themselves as good as anyone and are able to enjoy their cigarettes or their little love affairs in comfortable seats and amidst attractive and appealing surroundings.'[8]

Two advances in the 1920s ensured cinema's popularity and longevity. The first was the advent of the 'talkies'. The first major release with a synchronised sound track was *The Jazz Singer*, starring Al Jolson, a box-office sensation when released by Warners in the United States in October 1927. Jolson's follow-up, *The Singing Fool*, the next year was the first talkie to be widely shown in Britain. The second change in 1927 was the Cinematograph Act, which required cinemas to show a quota of British films as a means of encouraging filmmaking in Britain and the empire. The larger exhibitors rushed into partnerships with the leading British studios and distributors to secure the best product, and assembled national circuits of large cinemas with expensive sound equipment and good acoustics. Comfortable new cinemas run by ABC, Gaumont, Granada and Odeon made the Edwardian 'Electrics' and fleapit 'Palaces' obsolete. Warmth and stimulation were available for less than the price of light and a fire at home, and with their refined auditoria, powder rooms and cafés attracted an increasingly middle-class and also female clientele. So much decoration did not please everyone, as when the *Architect and Building News* snobbishly declared a preference for Sadler's Wells's austere interior, left uncompleted in 1931 for lack of funds, to 'the Babylonish fungoid cinemas which seem to breed in our cities and suburbs'.⁹

The 'reformed public house' was a turn of the century concept that came to prominence in the First World War when the government introduced its own state-managed pubs in Carlisle. They offered a range of alternatives to standing and drinking that included a restaurant service, an assembly hall for dances and even a bowling green. Breweries were made to surrender several licences in city centres in return for one large public house on a new estate. Birmingham, with a tradition of sober non-conformity, followed the policy wholeheartedly and smaller cities followed suit.

The value of the sun for strengthening bones and as an aid to respiratory diseases such as tuberculosis began to be recognised in the 1890s, and sunbathing followed as a fashion among the leisured classes in the 1920s. Coco Chanel caught too much sun on a Mediterranean cruise in 1923 and her tanned skin spawned a new look; the first suntan lotion was marketed in 1928. Fresh air, better health and lighter clothes encouraged a greater involvement in sports, and many authorities built open-air swimming pools to relieve unemployment. More indoor pools followed, and though they still included individual bathtubs and laundries for those without facilities at home, the large pool with a balcony for audiences to watch galas and water polo became the predominant feature. Seaside facilities – funfairs and concert halls set out on the pier or along new esplanades laid out with banks of seating and flower borders – escalated as demand rose, partly thanks to the 1938 Holidays with Pay Act, which entitled those workers whose wages were regulated by trades boards to a week's paid holiday.

BUILDINGS FOR TRAVEL
More innovative still were buildings connected with travel, as the combustion engine and aeroplane began to seriously challenge the might of the railways. It was the golden age of the ocean liner, though little survives save photographs and the RMS *Queen Mary*, partly preserved in Long Beach, California. A few buildings in Britain reused elements from liners, most commonly the RMS *Mauretania*, whose fittings were auctioned in May 1935 before she was broken up for scrap and parts reappeared at Pinewood Studios, the Mauretania bar in Bristol, and a private house near Poole. Skilled joiners from the shipyards of the Clyde, Tyne and Wear also worked on nearby houses, hostelries and restaurants. Britain's railways struggled in the interwar years, having been run into the ground during the war and denied

capital investment thereafter; instead of being fully compensated by government, the railway companies were pushed into four groups ill-prepared to withstand growing competition from road hauliers. In compensation they looked to expand their passenger traffic, introducing new locomotives and hotels, while electrification led to a few new station buildings – although not even Surbiton Station could match the sophistication of Charles Holden's stations for London Underground. Garages and petrol stations proliferated, along with road houses to service the thirsty traveller that exemplified the 'reformed' plan.

An entirely new building type in the 1920s was the airport terminal. A terminal was designed for the Air Ministry at Croydon in 1928, prompting Air Marshall Sir Sefton Brancker and Sir Alan Cobham, then Britain's most famous pilot, to invite local authorities to build a network of airports across Britain. Some 50 had opened by 1940, many designed by the engineer/pilot Sir Nigel Norman and his architect partner Graham Dawbarn. Their first scheme, for a private club at Heston Air Park (now Heathrow), took the form of a tall central concourse bounded on either side by offices, with a 'cockpit' control room perched on top and wings either side for restaurants and baggage facilities. Observation decks and cafés provided facilities for the many visitors who came for the simple excitement of watching the planes taking off and landing. Dawbarn and S. Hessell Tiltman repeated this expressive plan across Britain, and it was only at the end of the decade that Robert Hening and Kit Nicholson produced more thoroughly modern designs.

STREAMLINED MODERNE

A lighter style still often known as Art Deco defines the 1930s – sophisticated and scientific-looking for the hotel or airport, yet it was born out of adversity and the need for economy, making it equally suited to the funfair and soup kitchen. It is sometimes termed 'Depression moderne', or 'art moderne', but most usually 'streamlined moderne'. The decorative arts and examples of poster and book design show how moderne conveyed impressions of luxury and the latest in technology by artfully simple lines that evoked sleekness and speed.

Britain's economy struggled throughout the interwar period, output falling by 25 per cent in 1919–21 and not fully recovering until 1939. While it was spared the extremes experienced in other countries, there was no building boom until the very end of the 1930s, when it had to compete with the rearmament programme to secure materials. The Wall Street Crash and consequent world depression of 1929–34 only aggravated longer-term problems, although there was no extreme economic collapse in Britain: gross domestic product fell by 5.3 per cent in these years compared with 26.6 per cent in the USA. There, Franklin D. Roosevelt promised a 'new deal' as part of his successful election campaign of 1932, including a programme of public works. Simple brick libraries and post offices, many with decorative murals, are an easily recognisable legacy. In pockets of new development, notably in the expanding seaside resort of Miami Beach, a streamlined moderne took shape with aerodynamic forms and strong horizontals that suggested a go-faster sense of movement and clean living. Projecting staircases and vertical fins offered a punctuating counter-point as well as vehicles for signage, while so much render, combined with nautical references such as funnel-like turrets and porthole windows, made the style particularly suited to the seaside. Moderne featured prominently in Britain's growing seaside resorts. It is equally evident in the slick blocks of labour-saving flats for young professionals who were marrying and starting families later than previous generations. Most cities managed one such development, but it was on the main roads out of London and in the

new suburbs developed as London Underground spread its network that these model flats were most evident, with minimal galley kitchens, a balcony and sometimes an outdoor swimming pool set in the well-maintained grounds.

For most British architects, the sources of the moderne style lay in northern Europe rather than in America. One was the brick tradition of The Netherlands, especially as revived during and immediately after the First World War by the Amsterdam School of Michel de Klerk and Piet Kramer, responsible for swathes of social housing with prominent zig-zag corner motifs and rounded stair towers before the style was pushed into stores and office buildings. These exaggerated mouldings and vertical punctuations were taken further in German expressionism, especially in the commercial work of Erich Mendelsohn, designer of a chain of department stores for the Schocken brothers in Germany. Cinema architects also began to look to German models for innovation, particularly to Berlin, where Mendelsohn's Universum Cinema and the Titania-Palast by Schoffler, Schloenbach and Jacobi both opened in 1928. All owed something to the long, low prairie style of Frank Lloyd Wright who, having fled to Europe with a client's wife, Mamah Cheney, produced a hundred lithographs of his work in two volumes for the Berlin publisher Ernst Wasmuth, issued in 1911. The volumes made little impact in Britain but were a potent force across northern Europe.

Wright's influence is particularly well seen in The Netherlands. It is evident in the work of Hendrik Berlage and Robert van't Hoff (who both visited the USA), but most importantly in that of Willem Dudok, director of public works from 1915 and municipal architect from 1928 to the new town of Hilversum, between Amsterdam and Utrecht. In his masterpiece, the town hall of 1928–31 for Hilversum, there is again a tower where the clock was placed asymmetrically next to 'go faster' stripes and openings, but now the tower itself was on the corner of a low building, interrupting a series of disjointed blocks where long bands of fenestration and staircases comprised the principal decoration. In the surrounding schools and housing he evolved an asymmetrical idiom based on neat brickwork banded with exposed concrete floor plates and large areas of glass, which created horizontal planes interrupted by the expressive treatment of staircase towers. The result was economical yet formal and distinctive, and was widely adopted in Britain. Dudok's importance in Britain was such that he was awarded the RIBA's Gold Medal (Britain's highest award for an architect) in 1935, while Frank Lloyd Wright had to wait until 1941.

CIVIC PRIDE

Building town halls was a means of providing employment and showcasing a borough's status, as seen in programmes as far apart as Sheffield, Swansea and Bristol. Commanding council chambers and panelled committee rooms were tucked behind more convivial assembly rooms intended primarily for dancing. Such buildings were symbols of public pride, and the principal rooms were lined in the best materials available; the interwar years produced many of Britain's finest town halls. Elsewhere, the main swimming pool in a baths complex was commonly boarded over for dances in the winter. Concerted programmes of building libraries, schools and fire stations followed in the late 1930s, while digging roads and open-air swimming pools supported less skilled labourers. After a decade of austere government policies that frustrated economic growth, the National Government belatedly made modest capital investments, supporting the construction of RMS *Queen Mary* and creating 'Special Areas' with incentives for industries to invest in Scotland, Wales and parts of northern England. British politicians from the centre left and moderate right proposed a middle way where public and private interests

could combine to the greater good, exemplified in little books by Harold Macmillan and Herbert Morrison.

A more dynamic form of consensual socialism appeared in Sweden, where the Social Democratic Party came to power in 1932 with a welfare policy of *folkhemmet* ('people's home'), the belief that a nurturing government should provide a safe place where its people can develop their skills. The influence can be seen not only in the movement towards the British Welfare State, with more schools, libraries and health centres built in the late 1930s, but also in the style of architecture. The country moved from a gentle neo-classicism termed 'Swedish Grace', well seen at Ragnar Östberg's much admired city hall of 1911–23, towards an equally tempered modernism – often of brick and with pitched copper roofs because of the harsh climate. This new style was heralded in 1930 by an exhibition in Stockholm devoted largely to home-making and crafts, which brought together elements of German expressionism and Russian constructivism in a series of vivid displays masterminded by Gunnar Asplund and Sigurd Lewerentz, masters of the stylistic transformation. Stockholm City Hall was the model for the most advanced civic centres of the interwar years, notably at Norwich, while copper roofs and large weathervanes were widely adopted. Robert Atkinson assumed these elements and the filigree decoration of Swedish Grace at his Wallington Town Hall and Barber Institute in Birmingham, a progression from his Art Deco interiors of the early 1930s.

Britain's building boom of the late 1930s adopted the simpler styles of Dudok and streamlined moderne. Those buildings looking to impart an escapist or exotic image, such as cinemas, hotels and the entrances to blocks of flats, were rendered; in more serious public buildings the bands of brickwork were left exposed. Houses by F.R.S. Yorke and Mary Crowley adopted Scandinavian monopitch roofs and a vogue for lightly constructed, better-lit schools offered pointers towards post-war design.

The Second World War brought building to an end, with materials directed to the war effort and controlled by licensing from 1940. Uncompleted buildings were covered over, to be resumed once peace was restored – though some were not finished for a decade or more. Shortages of materials limited Art Deco motifs to Vitrolite and hardwood panelling from the British Empire, the latter more readily available than Scandinavian softwoods because of the weakness of the pound against the dollar. It was the slender Scandinavian style that won out, with functional planes and decorative patterns that disguised the fact that buildings or estates were often being built in phases over long periods as money and materials allowed.

SAVING ART DECO

In 1951 Nikolaus Pevsner described the Hoover Factory of Wallis, Gilbert & Partners as 'perhaps the most offensive of the modernistic atrocities' along Western Avenue.[10] Pevsner had a powerful influence on taste, not least since he was a member of the government's panel of outside experts who advised on listing matters in the 1960s and 1970s. After contributing to a survey of Victorian buildings in 1969–70 he proposed a list of nearly 50 buildings from the interwar years, all of which were strictly Modern Movement in style.[11] Although the New Victoria and Tooting Granada cinemas were listed as part of a study of London theatres in 1973, opposition to other Art Deco buildings remained staunch. The Hoover Factory was first suggested for listing in 1974 but this was not achieved until 1981, and it was upgraded to II* in 1983. By then, however, circumstances had changed.

In the summer of 1980 the Firestone Factory on the Great West Road was threatened with demolition. The embryonic Thirties Society proposed listing, and the inspectors at the

Department of the Environment at last agreed. The recommendation was about to go through, but the day before the August Bank Holiday the owners, Trafalgar House, learned that there was no senior civil servant available to sign off the paperwork. That weekend they sent a bulldozer through the middle of the facade. The loss ensured that Firestone became far better known in death than it had ever been before its destruction, while establishing the credentials of the Thirties Society, now the Twentieth Century Society. It prompted the government's listing team (now part of Historic England) to make a survey of Art Deco and traditional buildings from the interwar years, leading to some 150 further additions to the list. Those recommendations formed the basis of this book and many more listings have followed.

England has a grading system for its listings, whereby grade II is awarded to buildings of special architectural and/or historic interest. Outstanding buildings are grade I, usually where they are of international regard, or grade II*; less than 10 per cent of all buildings fall into these categories. Scotland, Wales and Jersey have their own listing programmes. That operated by Cadw in Wales separated from the English system in the early 1980s and follows the same grading classifications. Scotland uses a system of A, B and C, whereby grade A relates to all outstanding buildings, B most other listings and C is reserved for ancillary structures and those included for group value. Jersey has recently undertaken a comprehensive survey of its 20th-century stock, but its listing system is surprisingly complicated, with a 'local' list in addition to statutory grades of 1 and 2.

As the Twentieth Century Society reaches its 40th anniversary, what is the situation of Art Deco? Young enthusiasts are more likely to be campaigning for brutalism and even post-modernism, but support for Art Deco is as widespread as that for buildings of earlier periods; it has come of age. Many houses have been beautifully conserved, but others are still demolished where they occupy large and valuable suburban plots. They have included the grade II listed Greenside, a house more modern than Art Deco, overlooking Wentworth Golf Course, which was torn down by its owners in 2003 without consent. Cafés have been restored, but industrial buildings have generally been rebuilt as offices and flats retaining only their facades, which works for very large blocks but destroys the character of smaller units such as garages and hospital wards. Many public buildings are in peril because of threats to their funding, and readers may be surprised by the number of derelict buildings featured in this book.

This book is not exhaustive: there are many more buildings which could have – perhaps should have – been featured. Many more are regularly visited by the Twentieth Century Society, the national charity that has campaigned for the preservation of architecture and design since 1914.

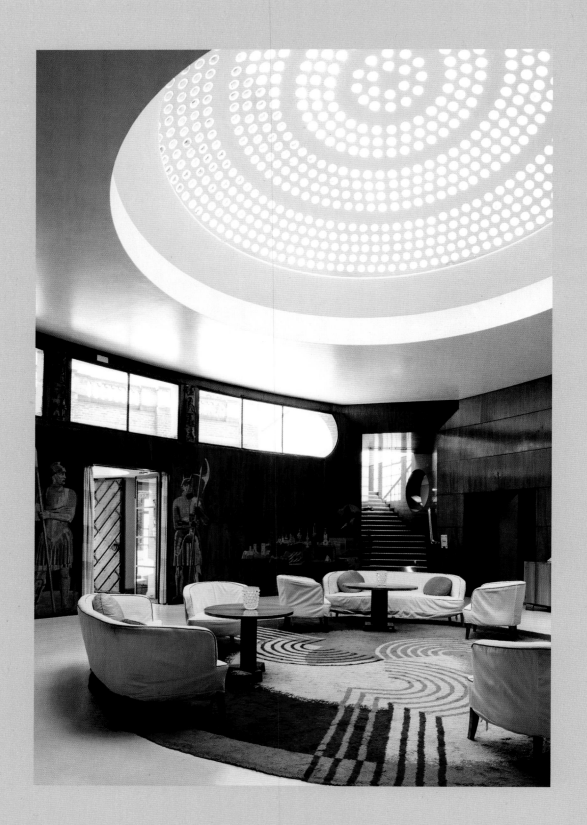

HOUSES
AND FLATS

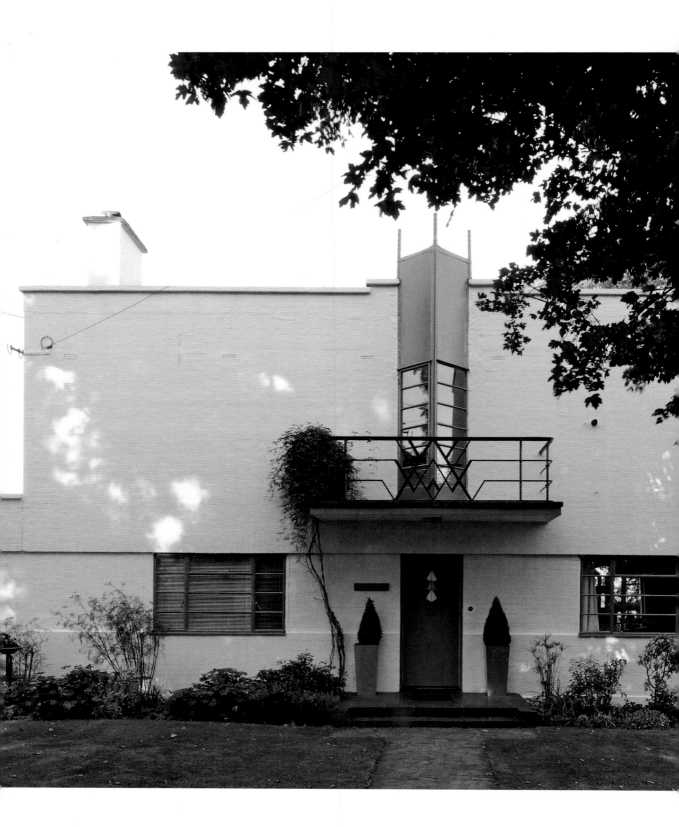

WOLVERTON

BOARS TYE ROAD, SILVER END, ESSEX
1927; THOMAS S. TAIT AND FREDERICK MACMANUS
LISTED GRADE II

Francis Crittall manufactured metal windows, initially for factories, but after expansion in the First World War business boomed during the 1920s due to a shortage of timber. His slim, elegant designs were a perfect component as modern architecture advanced. When he needed a new factory, Crittall also built a model village that represented what he called 'a new order', offering modern housing and facilities for his workforce that extended to its own allotments and piggery. Begun in 1926, the model village was also a perfect showcase for his product. Crittall and his son Walter 'Pink' Crittall chose Garden City specialists to make designs, but also the one representative of the architectural establishment with a taste for the modern, Thomas S. Tait. His assistant Frederick MacManus, who did much of the work, went on to specialise in housing.

Wolverton is one of three houses built for managers on the edge of the village, beautifully restored by the current owners. Built of rendered brick, its central staircase window in an otherwise blind upper floor is reminiscent of Peter Behrens's New Ways, Northampton (1925), acknowledged as Britain's first Modern Movement house, but its door and the balcony feature a 'flying V' motif that is quintessential Art Deco. Tait and MacManus designed semis and terraces of smaller houses in the adjoining Silver Street with similarly prominent staircase windows, although other housing was more traditional.

The Depression ended development in 1931, but the core of the village is now a Conservation Area of growing popularity with homeowners.

FINELLA

QUEEN'S ROAD, CAMBRIDGE
C.1840; REMODELLED AND DECORATED 1927–29; RAYMOND MCGRATH
LISTED GRADE II*

Mansfield Forbes, a reformist don of English literature, leased a dingy Victorian villa, The Yews, from Gonville and Caius College and made it a cradle of modernist design, intended for receiving guests and enjoying stimulating conversation. He renamed it Finella after a Scottish queen, a fabled discoverer of glass who was thrown down a waterfall to her death; fountains accordingly featured in the garden and dining room. Forbes thus acknowledged his Scottish ancestry, while sculptures from Ceylon (now Sri Lanka) referenced his birthplace.

'He was the inspiration and I played up to his tastes', wrote McGrath of his patron. He was a young Australian architect for whom Forbes secured a research post in theatre design at Cambridge after meeting him near the British Museum. He gave Finella's exterior a fashionable Regency dress with French windows and trellises. A glazed door lit the long hallway, otherwise illuminated theatrically and lined in glass and reflective silver leaf, contrasted with black induroleum on the floor. Glass pilasters supported a silver vault over the staircase hall. Black lacquer doors opened into the two drawing rooms christened 'The Pinks', their 'rosy-room skies' still linked by folding doors of copper-faced plywood (Plymax).

McGrath became an expert on glass, which dominated Finella. Britain's first modernist society, the Twentieth Century Group, was founded here, and for all its excesses it had higher ambitions of taste and scholarship than is generally associated with Art Deco. Yet it is narrative rather than abstract and, above all, still has a 'wow' factor.

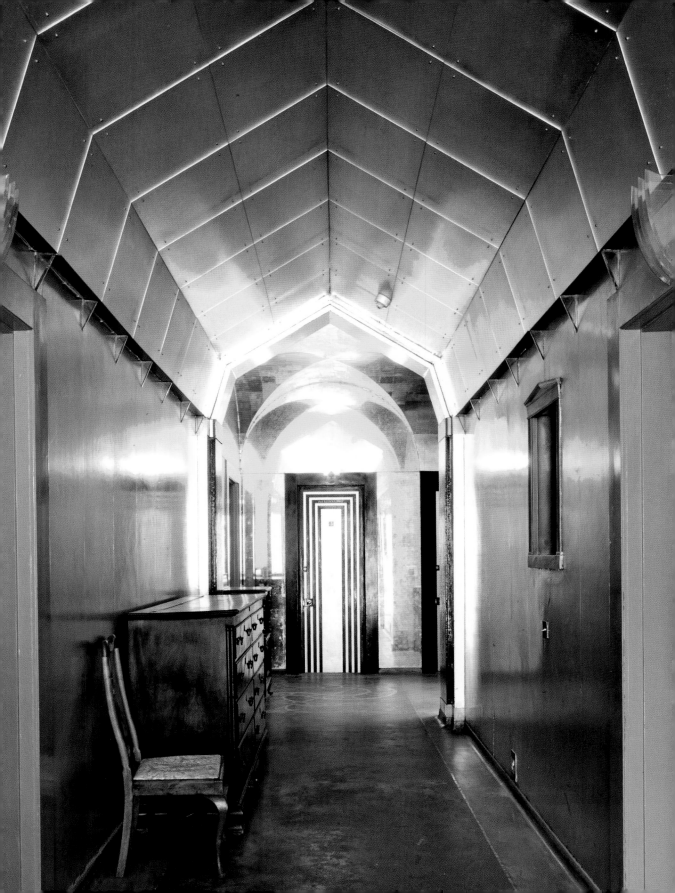

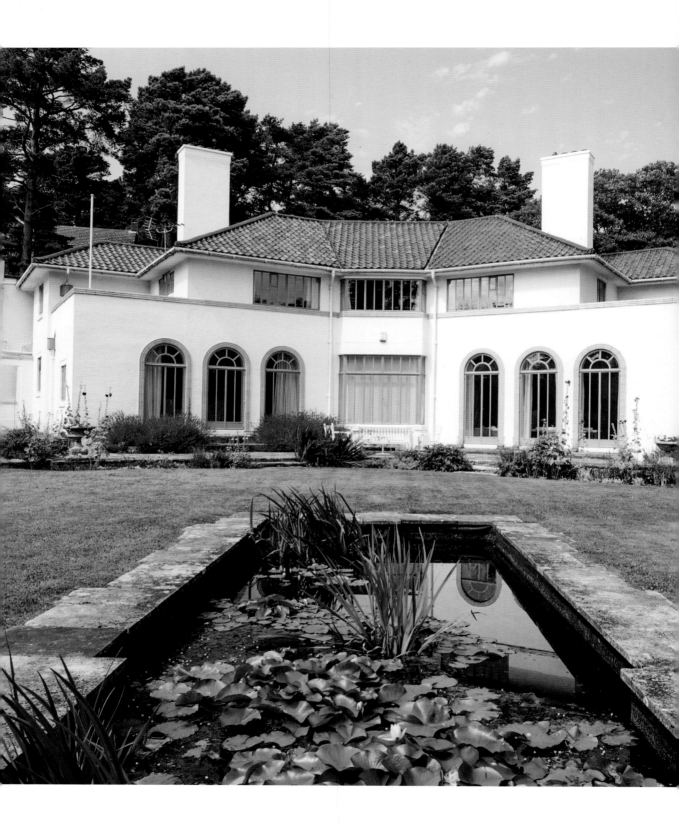

YAFFLE HILL

WATER TOWER ROAD, BROADSTONE, POOLE
1929–30; EDWARD MAUFE
LISTED GRADE II

Cyril Carter was head of Poole Pottery, founded by his grandfather in 1873, and in 1930 he married one of his most talented designers, Truda Adams. Before Maufe came to specialise in churches, he enjoyed a reputation for domestic design, enhanced by his marriage to Prudence Stutchbury, an interior designer and director of Heal's, and he contributed to the British Pavilion at the 1925 Paris Exhibition.

Yaffle Hill has the open-armed butterfly plan beloved by Maufe since designing Kelling Hall, Norfolk, in the Arts and Crafts style in 1912–13. It is supremely logical and surprisingly modern – a single big living room and a library are separated by a small dining recess off the entrance hall, while flat-roofed sections serve as balconies to the main bedrooms. Details are in Poole Pottery's distinctive matt faience, adopted for window surrounds and parapets alongside a shiny black for the door surround; Carter had the roof pantiles specially glazed in Chinese blue. A ceramic woodpecker (locally called a yaffle) sits over the entrance, while a mosaic featuring the house, a view of the factory by the harbour and the Carters' and Maufe's initials grace the hall floor.

A narrow rill remains the principal garden feature. But, having bought the site for its superlative views across Poole Harbour, Carter then created a lavish garden filled with English shrubs that concealed much of it. After many years in other hands, when it was slightly extended, the house was purchased in 2007 by his grandson Paul and restored.

ST ANDREW'S GARDENS

Copperas Hill, Liverpool
1932–35; Lancelot Keay and John Hughes,
City Architect's Department
Listed grade II

Outside London, only the housing departments of Liverpool and Leeds built large numbers of flats to relieve their housing problems in the 1930s. Leeds's showcase Quarry Hill was demolished in 1978–79, but Liverpool's masterpiece survives as student housing. It was the brainchild of Lancelot Keay, director of housing and a rare supporter of building municipal flats as a statement of civic ambition.

Arthur Greenwood's Housing Act in 1930, designed to encourage slum clearance, gave Keay his chance. He secured a valuable assistant in a young graduate, John Hughes, whose first unrealised design, for a site in Regent Road, was inspired by the Hufeisensiedlung or 'Horseshoe Estate' at Britz, Berlin. Keay had visited in 1931. They then included a horseshoe block on the site of the city abattoir, part of a larger scheme that has now otherwise been demolished. Hughes argued that horizontal windows permitted a larger amount of window space per room, and the inclusion for the first time of small 'sun balconies' also made the block look modernistic. Long known as 'The Bullring', its half-circle is pierced by corresponding archways through an axis along St Andrew's Street, the thoroughfare through the spine of the development. They have the look of Karl Ehn's monumental Karl Marx-Hof in Vienna, built in 1927–30 and the best known of a crop of prestigious blocks by the city's left-wing council. Hughes's later schemes (also all demolished) were lighter in touch, suggesting the influence of Erich Mendelsohn, who lectured in the city in 1933.

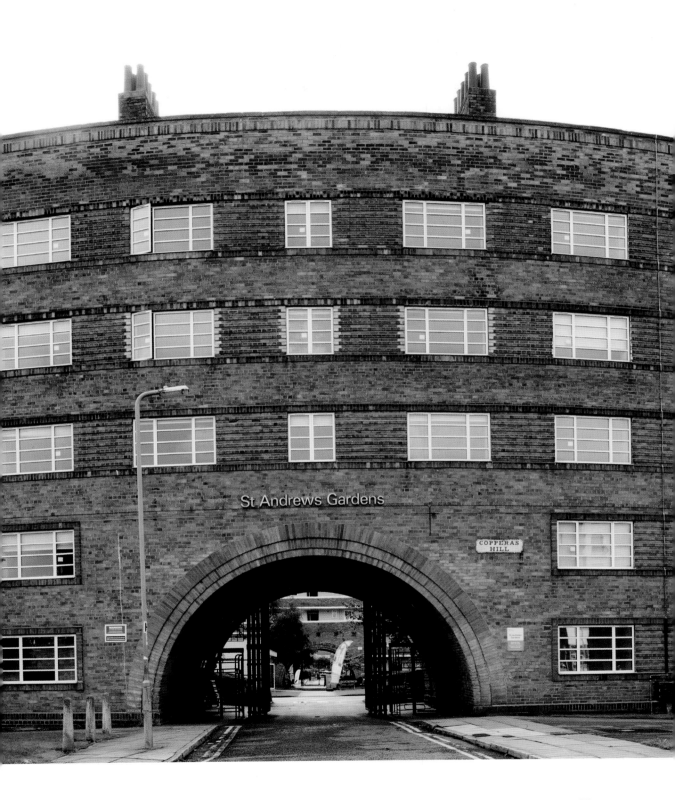

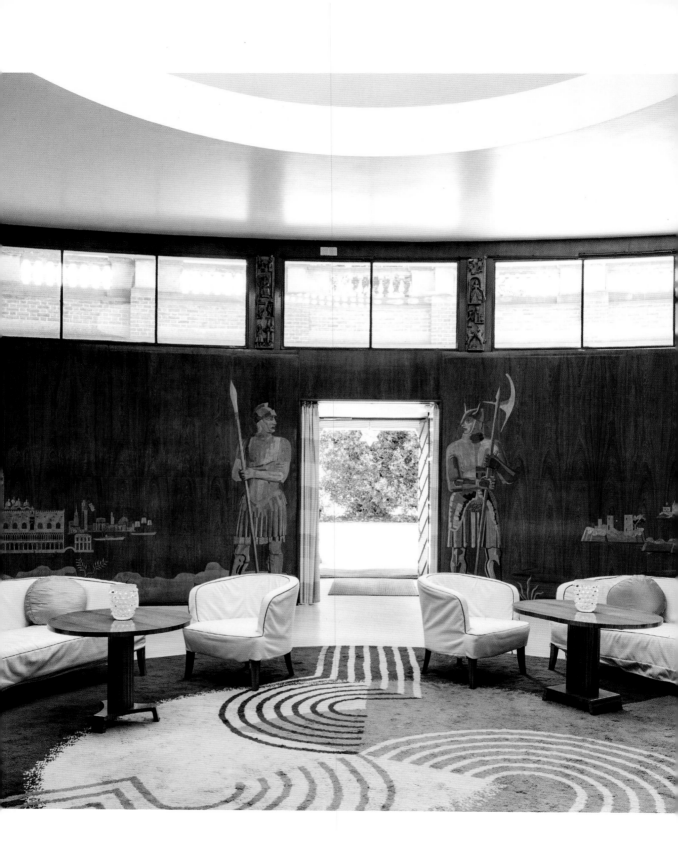

28

ELTHAM PALACE

COURT YARD, ELTHAM, GREATER LONDON
1933–36; SEELY & PAGET
LISTED GRADE II*

Eltham Palace is a romantic hideaway, yards from Eltham High Street yet accessible only across a medieval bridge and moat. Edward IV's 15th-century great hall survived as a barn until 1818 when it was incorporated into a villa. The Office of Works undertook repairs in 1911–14. Stephen and Virginia Courtauld combined these remains with a new house, its exterior inspired by Hampton Court but with an Art Deco interior featuring the latest technology.

The Courtaulds built their house for entertaining, advised by the painters Winifred Knights and Tom Monnington, the Swedish interior designer Rolf Engströmer and an Italian decorator, Peter Malacrida. Two wings are linked by a near-circular entrance hall, its Australian blackbean panelling incorporating marquetry by the Swedish artist Jerk Werkmäster, his romantic interpretations of Italian and Swedish buildings a response to fashionable architectural tastes. The painted ceiling beams in the drawing room reflect traditional Swedish designs. More sophisticated is Malacrida's dining room, with aluminium and black marble decoration featured in a Greek key and fluted surround to the electric fire, and black and silver lacquer doors. Most luxurious are the private bathrooms, Virginia's with marble panels and gold-plated taps set in a gold mosaic niche below a bust of the goddess Psyche. All this luxury was little used; the Courtaulds travelled extensively before the Second World War, and emigrated in 1944.

English Heritage's re-creation in 1999 of Marion Dorn's geometric rug and white leather furniture by Engströmer were controversial but now look 'right'.

DORSET HOUSE

GLOUCESTER PLACE,
between MARYLEBONE ROAD AND DORSET SQUARE, LONDON
1934–35; T.P. BENNETT & SON
LISTED GRADE II

Dorset House wears its sophistication on its sleeve, so that while the interiors have been modernised the exterior still exudes 1930s ostentation, an update of the mansion flats that had transformed St Marylebone Road into a middle-class neighbourhood in the 1890s. The edifice of 185 (originally 180) flats occupying an entire street block enjoyed its own basement car park as well as a petrol filling station and shops.

The upper floors are predominantly of brick, fluted at their many corners. All the flats have a dual aspect and the largest project into bays, so have three facades. All have balconies with green ships' railings, reached through Crittall's French windows, while the penthouses on the top two floors are set back. Only the largest flats had coal fires in addition to central heating.

The developer was Claude Moss Leigh, notorious in the 1930s for buying up working-class tenements and redeveloping them for higher rents. Here he brought in Joseph Emberton to provide a moderne fillip to the shared foyer areas (now altered), while Eric Gill carved stone panels to either side of the entrance on Gloucester Place. Bennett's task was to produce a compact plan that minimised public corridors and separated tenants' lifts and stairs from those used by staff and tradespeople. Banks of maids' rooms are a reminder that the 1930s was still an age when most middle-class families had a servant. The original rents ranged from £150 to £385 per annum, the latter for a three-bedroomed flat with two bathrooms.

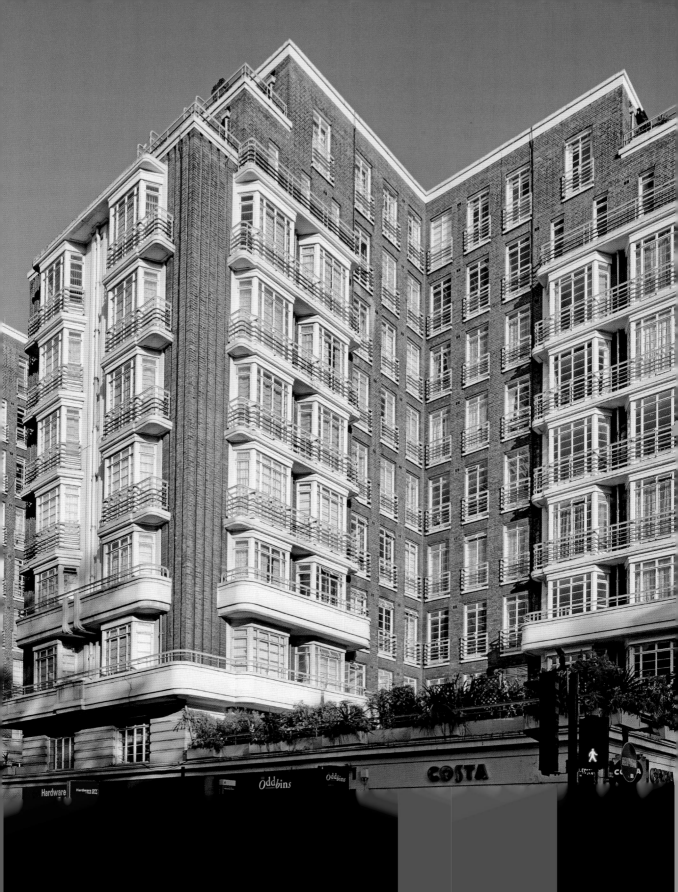

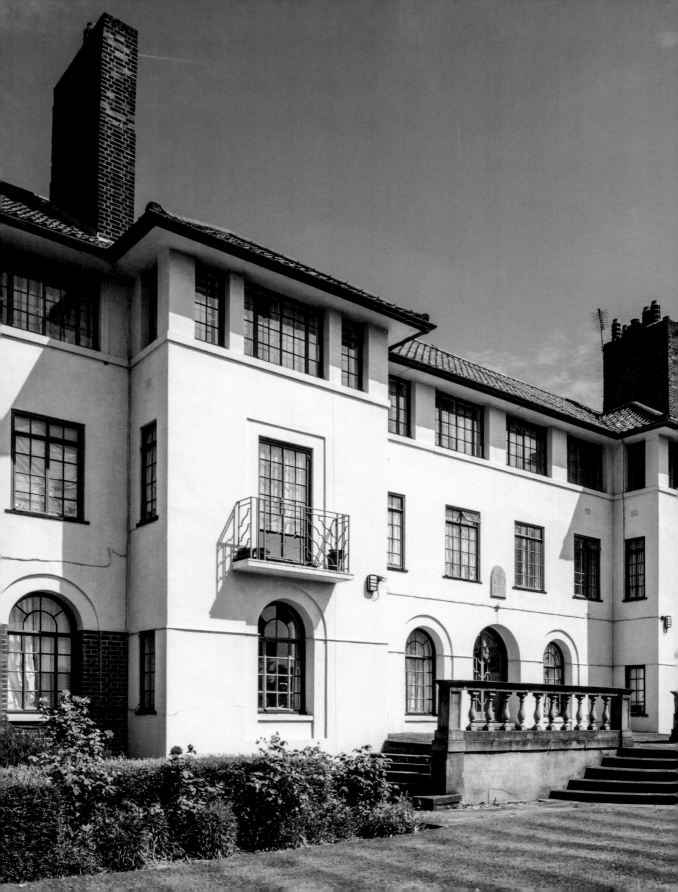

THE PANTILES

FINCHLEY ROAD, TEMPLE FORTUNE, BARNET
1934–35; J.B.F. COWPER
LISTED GRADE II

The hacienda style had a short-lived popularity in the 1930s, inspired by the movies of Hollywood and Miami. The Pantiles does the idiom particularly well, with a touch of the Italianate in its round-arched ground floor, emphasised by a raised position up flights of steps that set it high above Finchley Road and behind immaculately smooth lawns. The block is most remarkable for sitting in a conventional high street rather than in a quiet suburb, offering a little touch of unexpected glamour. The architect, James B.F. Cowper, came to prominence as a specialist designer of flats after winning a competition for labour-saving flats in nearby Hampstead Garden Suburb, eventually built as the block Heathcroft. The Pantiles was a conventional commercial development, typical of the 1930s in looking grand while in fact the flats were extremely compact.

Part brick, part rendered, with unusually large Crittall windows giving an exceptional quality of light, the hipped roof is covered in green-glazed pantiles that give the block its name. There are 40 flats, those in the centre of a conventional size with two bedrooms, while those in the wings are bedsits, originally with a built-in fold-down bed. The scheme incorporated 13 garages, and – so its manufacturer noted – the latest in Ascot gas water heaters. There were also gas fires, though traditional chimneys remain an important part of the composition. The brick staircase towers, with their full-height glazing, and functionalist rear elevation with a banded treatment suggest a more moderne styling.

LICHFIELD COURT

**Sheen Road, Richmond upon Thames, Greater London
1934–35; Bertram Carter and L.L. Sloot
Listed grade II**

'Every flat has its own enclosed balcony', was the selling feature of this imposing development set conveniently close to Richmond Station. The builders/developers, Bovis, erected it on the site of Lichfield House, thought to have been designed by Sir Christopher Wren, a sensitive location that demanded a careful design, tucked away down its own entrance drive behind shops. The huge main block is built around an entirely enclosed courtyard, its inner face lined with a second set of balconies, a continuous sequence of horizontal bands across the facades that give access to all the flats. Kitchens and bathrooms are on this elevation, allowing the reception rooms greater privacy and the best views. On the other side of the entrance drive is a smaller block and to the rear a large garage with tennis courts on the roof. The development offered both gas and electricity as well as central heating, thus embracing all the modern conveniences of suburban London living. Rentals in 1935 began at £70 a year for a bedsit, rising to £160 for the largest three-bed flat.

George Bertram Carter (1896–1986) was a former assistant of Edwin Lutyens who came to specialise in modernist flats around London, an unusual stylistic leap that reflects the diversity of the age. After Lichfield Court the best known is Taymount Grange, a similarly large block in Forest Hill (1935–36). He turned to shop work in the 1950s, designing Dunn's of Bromley (demolished), the most influential supplier of modern furniture in suburban London.

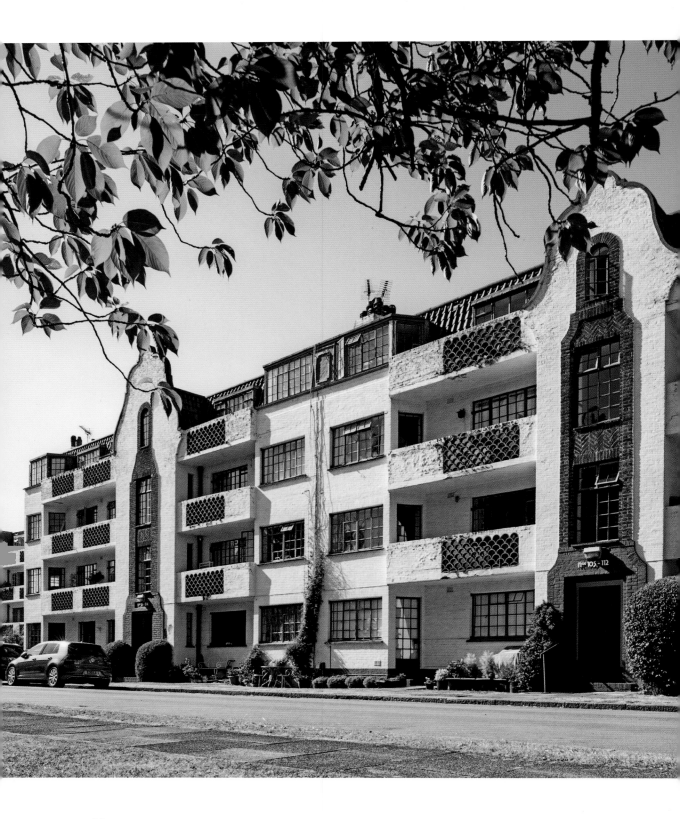

EALING VILLAGE

EALING, LONDON
1934–36; R. TOMS & PARTNERS
LISTED GRADE II

Ealing was the 'Queen of Suburbs', a term coined in 1902. Its claim to have the best air quality and sunshine records around London led in 1908 to the founding of the Ealing Film Studios. Advertisements for nearby Ealing Village by the developers, the Bell Property Company, promised 'health and happiness ... both indoors and out', thanks to the tennis court, bowling green, outdoor swimming pool and a social pavilion with a billiard room and restaurant. The popular notion that the 132 flats were designed for the studios' starlets is optimistic, however, for Post Office directories of the time list only conventional middle-class professionals living there. A lodge and renewed gates give seclusion, ensuring the estate's reputation today.

Ealing Village is architectural fantasy, a piece of Dutch colonial whimsy that embraced the simplest materials with panache. The white-painted brickwork, red ceramic balustrading, green pantiled roofs and green metal windows in attenuated stepped gables were cheap, even crude, yet playful, qualities enhanced by a central club house and pool that offered a more outgoing vision of the new, relaxed outdoor lifestyle than most 1930s developments. The architects R. Toms & Partners remain a mystery: London developers who designed large numbers of suburban flats for Bell Properties that dominate Streatham, including Manor, Wavertree and Streatham Courts, Leigham Hall Mansions, The High and Corner Fielde – all more sophisticated yet somehow less charming versions of the Cape Dutch model. As Stone, Toms & Partners, the company went on to specialise in speculative office building in the 1960s.

FRINTON PARK ESTATE

FRINTON-ON-SEA, ESSEX
1934–36; OLIVER HILL
THE ROUND HOUSE, 55 QUENDON WAY AND 4 AUDLEY WAY
LISTED GRADE II

The resort of Frinton originated in the 1890s. Richard Powell Cooper took over existing proposals but, instead of a pier, stipulated only the highest quality housing and prohibited boarding houses and pubs. High-class hotels and a golf course confirmed its superior status.

In 1934 the South Coast Property Investment Co. Ltd bought a 200-acre (81ha) site on the border with Walton-on-the-Naze and planned a second development. Frederick Tibenham of the board introduced Oliver Hill, whom he had met at the exhibition of British industrial art at Dorland Hall in 1933. Modernist designs were to dominate the 40 acres (16ha) nearest the sea. But building societies refused mortgages for concrete houses and the builders were slow; more progressive architects introduced by Hill pulled out when the company sought compromises. A shopping parade closed for lack of custom and in 1945 was converted into a masonic lodge, now demolished; Hill's intended hotel was never built.

Hill designed 12 houses, of which 10 remain. Most followed a standard moderne design with a curved front to the principal rooms, two-storeys save for a bungalow at No.10 Graces Way. The outstanding exception is the Round House, which was built as the show home and information bureau; a mosaic floor in its entrance hall depicting the intended layout was designed by Clifford Ellis and made by Poole Pottery. Other houses are by R.A. Duncan, Easton & Robertson, Frederick Etchells, Marshall Sisson, E. Wamsley Lewis and J.T. Shelton, a local architect who produced variations of Hill's designs.

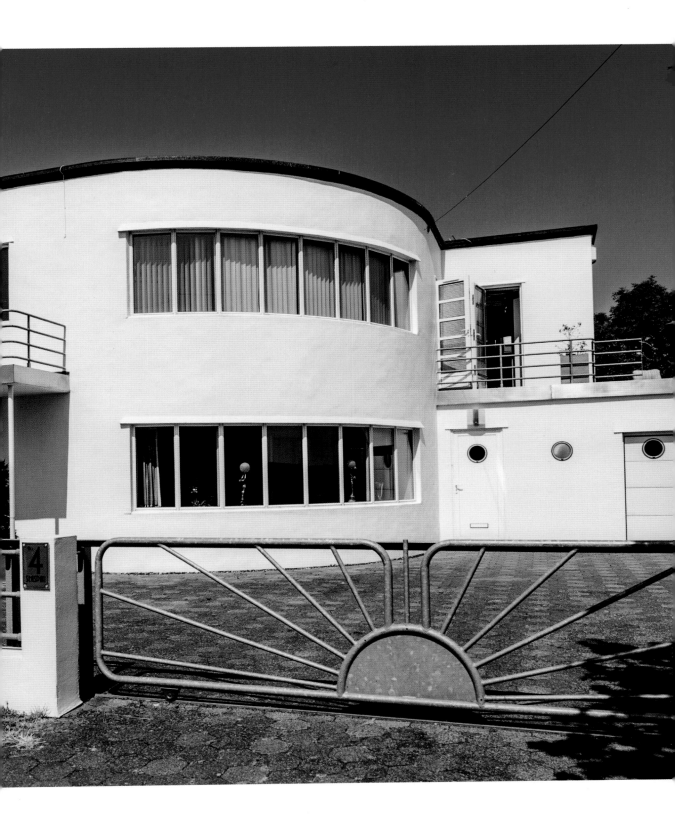

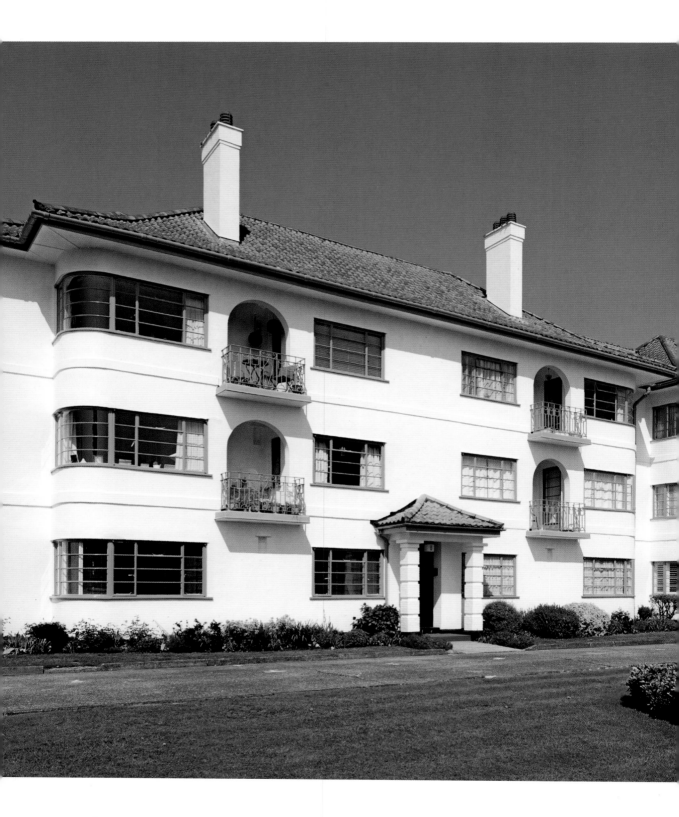

PINNER COURT

PINNER ROAD, NORTH HARROW, GREATER LONDON
1935–36; H.J. MARK
LISTED GRADE II

The late 1930s saw the settlements of Pinner and Harrow linked by new developments, a cemetery and fire station built by the borough council and between them, secluded and just a little exclusive, two enclaves of small flats. How bitterly the residents complained when the fire station was built within a year of their arrival.

Pinner Court displays the white rendered brickwork, green pantiled roofs and green windows with horizontal metal glazing bars deemed appropriate for private flats in the 1930s. It comprises two hook-shaped buildings, set back to back, with a central fountain and concrete lamp standards that are included in the listing. It lurks behind a crescent-shaped garden that is semi-public but secluded, adding to the privacy of the blocks. It is all a little better done and more complete than is found elsewhere: the inset balconies are more carefully composed, the detailing a little richer with its rounded corners and deep eaves.

The difference can be seen by comparing Pinner Court with the slightly simpler and later Capel Gardens next door, both designed by H.J. Mark for the Courtenay Property Company. Mark was a local architect who designed much of Eastcote town centre and buildings in nearby Rayners Lane. Another nearby development in Harrow, Elm Park Gardens by H.J. Webb, is delightful for featuring a small canal but is rather less architecturally assured.

MARINE COURT

MARINA, ST-LEONARDS-ON-SEA, EAST SUSSEX
1936–38; KENNETH DALGLEISH AND ROGER K. PULLEN
LISTED GRADE II

It is from out to sea that Marine Court's 14 storeys and 416ft (127m) length stand out most dramatically. Built on a steel frame clad in brick and concrete, the model for what was then Britain's tallest residential building was – claimed the developers – Cunard's RMS *Queen Mary*, launched in 1934. The two restaurants in its eastern prow resemble the fo'c'sle deck, from which rises the curved bridge with behind it the main block containing small serviced flats and studios all with sea views, its stepped section and balconies completing the illusion.

St Leonards was developed as a speculative resort town in the 1830s but a century later was in decline. An ambitious estate agent, Commander Bray, bought up 14 seashore properties when the borough engineer, Sidney Little, conceived a maritime metropolis along the foreshore, his ambitions extending from an Olympic-size lido (long demolished) to a car park beneath the esplanade to which Marine Court has its own access. On 30 November 1936 the block's foundation stone was laid by Robert Holland-Martin, chairman of the Southern Railway, whose electrification was planned to bring commuters to the town. But there was little interest and the South Coast (Hastings and St Leonards) Properties Company folded with debts of £333,000. Marine Court was repaired in 1949–50 after war damage but subsequently became very run-down, until it was discovered by writers and filmmakers in the 2000s. A residential buy-out of the freehold in 2010 has led to a slow and costly programme of restoration.

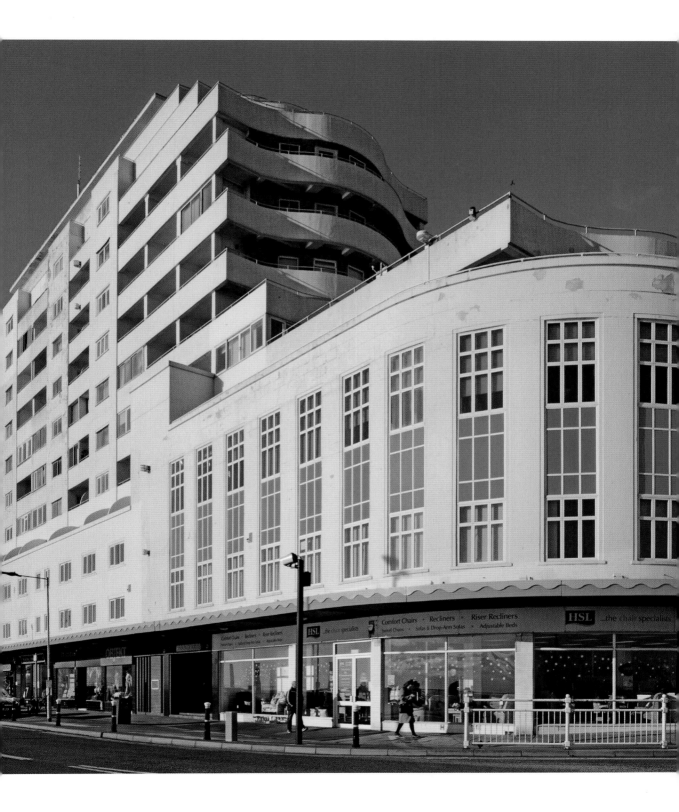

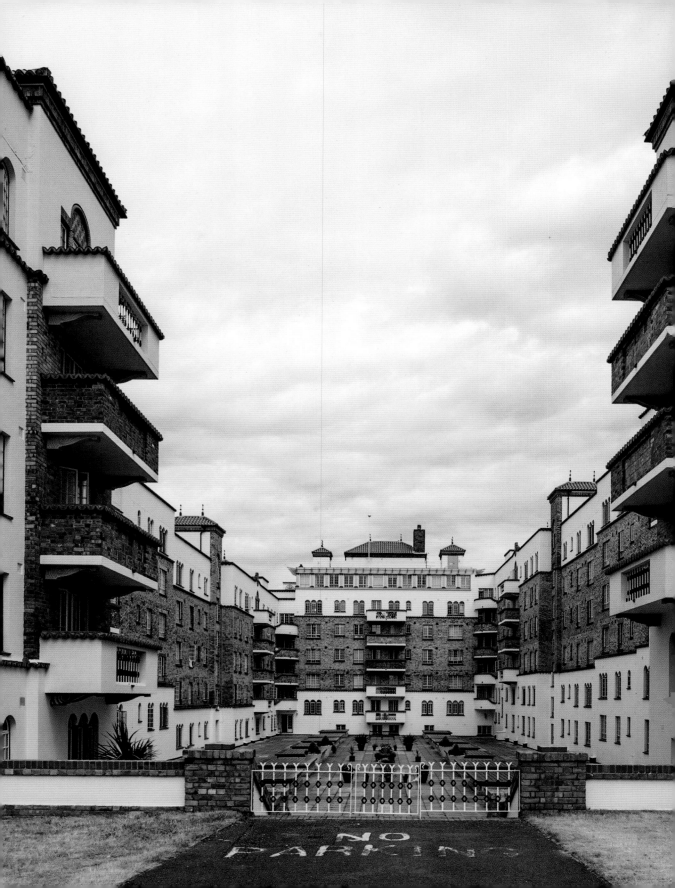

SAN REMO TOWERS

MICHELGROVE ROAD, BOURNEMOUTH
1936–38, HECTOR O. HAMILTON
LISTED GRADE II

A brochure in 1940 described San Remo Towers as 'a magnificent block of 164 superior flats, £96–260 per annum rental'. The deal included central hot water and heating, a telephone service and 'auto vac' cleaning system, a resident manager, porter, daily maid, boot cleaning and window-cleaning services. There was a residents' club with a reading room, card room, billiard room and library, and children's recreation and games rooms. Kiosks in the entrance lobbies sold convenience items like tobacco and took orders for the local tradespeople, while the fifth-floor restaurant offered à la carte meals for 38s a week, or simpler dinners at 2s/6d each. Hamilton had worked in America, so understood planning for such services and included a grand underground car park accommodating 130 vehicles, all unusually ambitious for the Guildford developers Armstrong Estates.

American influences may also have determined the Spanish Mission style, considered in 1940 as 'dignified and select, and [to] harmonise with the general surroundings'. Today it looks thoroughly eclectic. The flats are set in five blocks, five storeys high, each finished with white render, patterned brickwork and pantile roofs, with coloured faience to the topmost windows and balconies, and to the entrance doors, each set between barley-sugar columns. The styling is all very different from the block's more sophisticated namesake in New York, though the comparison was intended. The flats have been modernised (and the club is now a penthouse) but there remain the original staircases; jazz modern for the residents and plain ones for the tradespeople.

APPLEBY LODGE

WILMSLOW ROAD, MANCHESTER
1936–39; GUNTON & GUNTON WITH PETER CUMMINGS
LISTED GRADE II

Appleby Lodge is an exclusive cul-de-sac for Manchester sophisticates, promoted on opening in 1939 for its 'quietness and privacy' and today as an 'urban oasis'. The 102 flats are arranged in a 'U' around gardens in five main ranges, Manchester's typically red brickwork enlivened by curved corners and eight glazed staircase towers that punctuate the development. Otherwise the emphasis is firmly on the horizontal, for all the flats on the upper floors have white rendered balconies, above which are bold cornices and rooftop balustrading. The flats are accessed from eight communal hallways, which feature acid-etched glass, terrazzo floors and steel staircase balustrades.

Peter Cummings (c.1879–1957) was born Peter Caminesky in Minsk, Russia, but came in the 1880s with his parents to Cheetham Hill, Manchester, where his father was a rabbi. From working as an architectural assistant from his teens, he secured naturalisation and anglicised his name in 1928, and in 1939 he and his new wife Esther (20 years his junior) were the first residents of No.41 Appleby Lodge. By then he had become the city's leading Art Deco architect, designer of the Apollo Ardwick (1938) and the Cornerhouse (1934, originally the Tatler) cinemas and later of the Reform Synagogue (1953). Other residents of Appleby Lodge included John Barbirolli, conductor of the Hallé Orchestra, who is commemorated by a plaque on the building. Gunton & Gunton designed large numbers of Art Deco flats in London, and their Barons Keep, Hammersmith, built in 1937, is a grown-up, London version of Appleby Lodge.

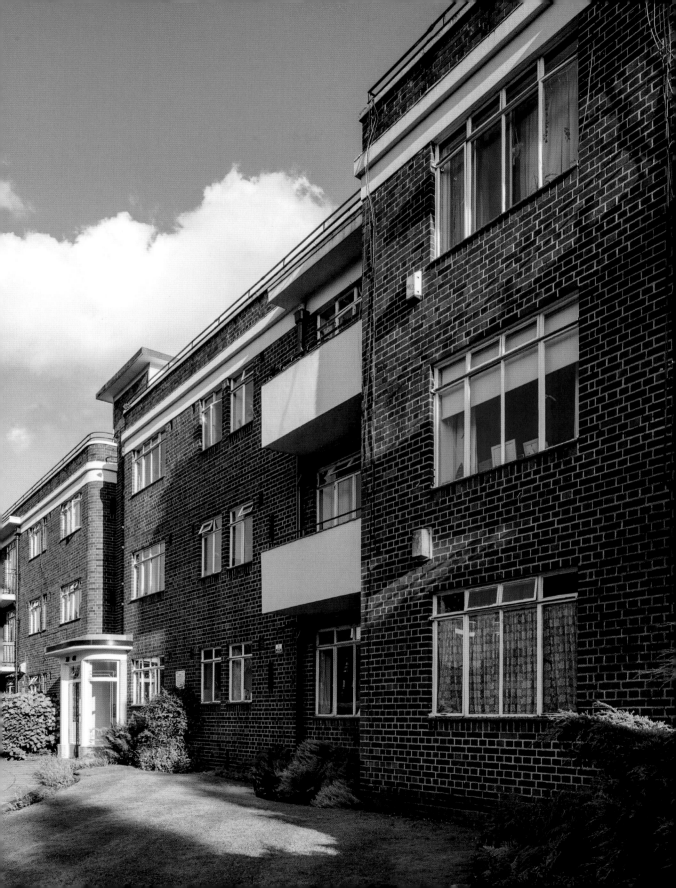

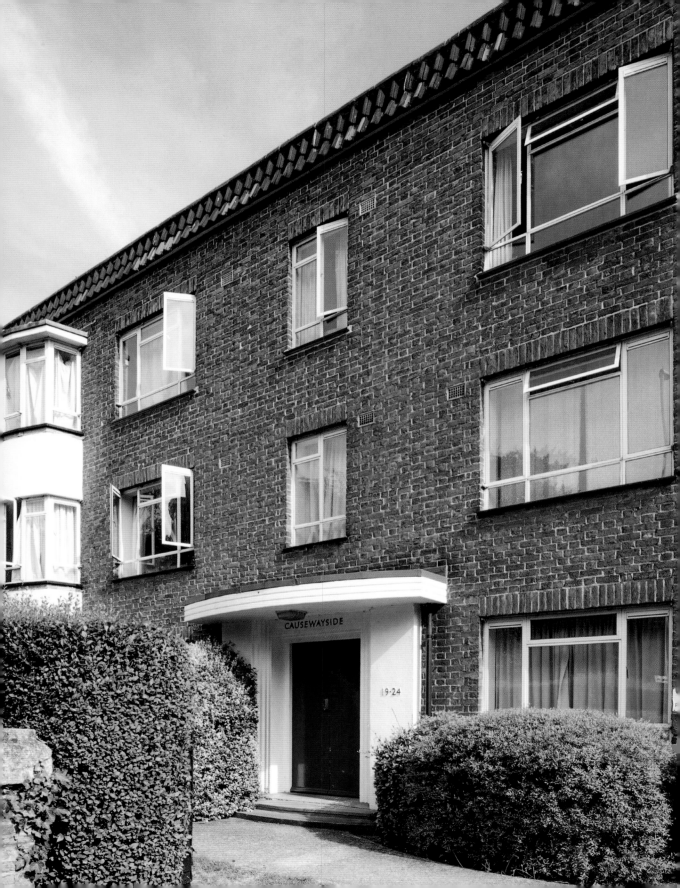

CAUSEWAYSIDE

FEN CAUSEWAY, CAMBRIDGE
1938; WALLACE J. GREGORY

The Fen Causeway was built in 1928 to relieve Silver Street and the city centre, and to better link the village of Newnham to the city of Cambridge. The new road spawned a flock of modern flats, contributing to the suburbanisation of Newnham as well as the development of the Fen Causeway.

The site of Causewayside only became available once the roundabout at Newnham Lane was completed in 1936. Gregory, a London architect with his own construction company based on Millbank, accordingly made his application in 1937. Causewayside comprises two blocks, one long and prominent, slightly staggered, and a shorter one at right angles facing the Newnham mill race and Coe Fen. The largest of the 43 flats – now accommodation for graduate students – are on the corner where the blocks meet. The brown brick walls are contrasted with rendered projecting bays and door surrounds that retain original lettering and blue doors, while a cove of pantiles artfully disguises the flat roofs. Gregory converted stables into rear garages and the caretaker's accommodation.

Flats from the 1930s also survive along Barton Road, notably Maitland House, which fills the block between Grantchester and Derby Streets. It was built in 1932–35 by local builders Bidwell & Sons on the site of a single villa, also Maitland House, itself built following an agreement with King's College only in 1901. Only three years older than Causewayside, the flats are more conventionally Art Deco with their black windows and large first-floor balconies – an engaging mixture of sophisticated planning and thick horizontal piped mouldings.

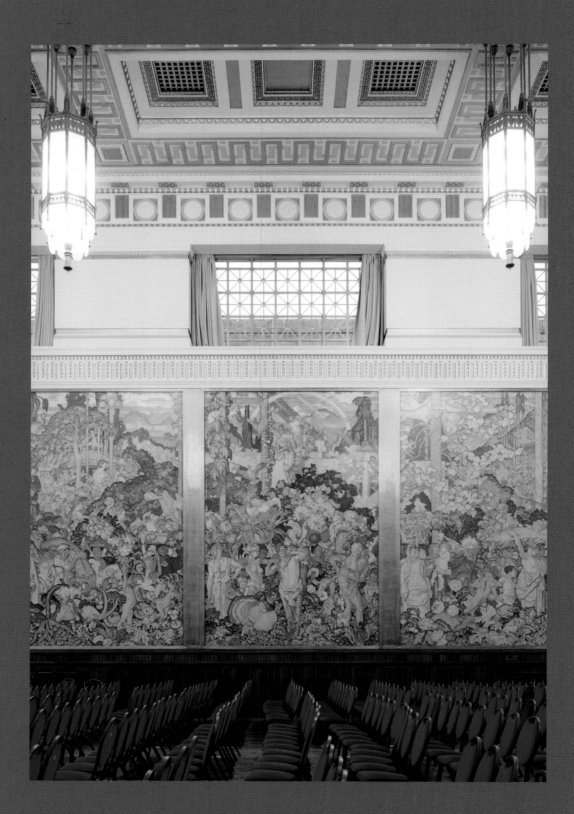

CHURCHES AND PUBLIC & INSTITUTIONAL BUILDINGS

COUNCIL HOUSE

OLD MARKET SQUARE, NOTTINGHAM
1924–29; T. CECIL HOWITT
LISTED GRADE II*

Nottingham's central landmark is not obviously Art Deco externally. Its giant portico and top-heavy dome, whence the Little John bell sonorously chimes the hour, share the grandiose mix of Roman and Greek motifs deemed an essential expression of civic valour in the 1920s. But look at the stylised lions, Leo and Oscar, guarding the entrance. They are by Joseph Else, principal of the local School of Art, who with former pupils also created the pediment frieze.

Howitt was the city's housing architect when he designed Nottingham's Council House, with a shopping arcade behind it, whose income maintains the immaculate interior. From the low, dark entrance an imperial marble stair ascends to a *piano nobile* of reception hall and dining room. The amber glass over the stairwell, highlighted with blue, red and gold, illuminates William Reid Dick's *Spirit of Welcome* – presented by local benefactor Julius Cahn – and a mural by Noel Denholm Davis depicting medieval traders in cinematic technicolor. Davis and E. Hammersley Ball also painted four frescoes under the dome depicting the city's history. The reception hall with its giant Greek Ionic order and minstrels' gallery reflects the tradition of the Egyptian Hall for civic buildings established by Lord Burlington in 18th-century York, but the colour, quality and completeness of the furnishings make it a 1920s time capsule. The Lord Mayor and Mayoress's suites (the latter now occupied by the Sheriff of Nottingham) have palatial bathrooms tiled by Carter's of Poole, complete with the biggest brass taps ever seen.

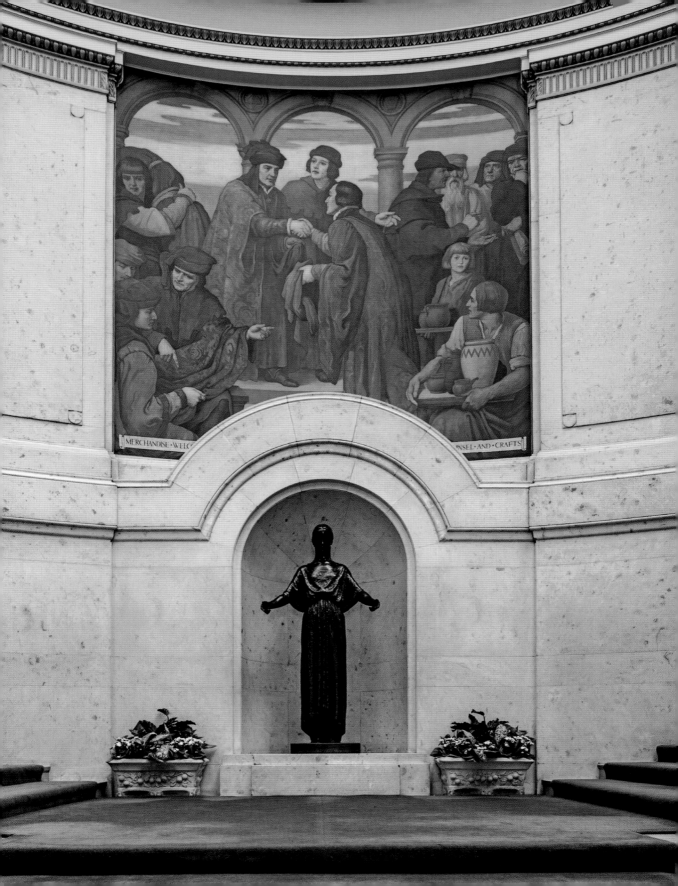

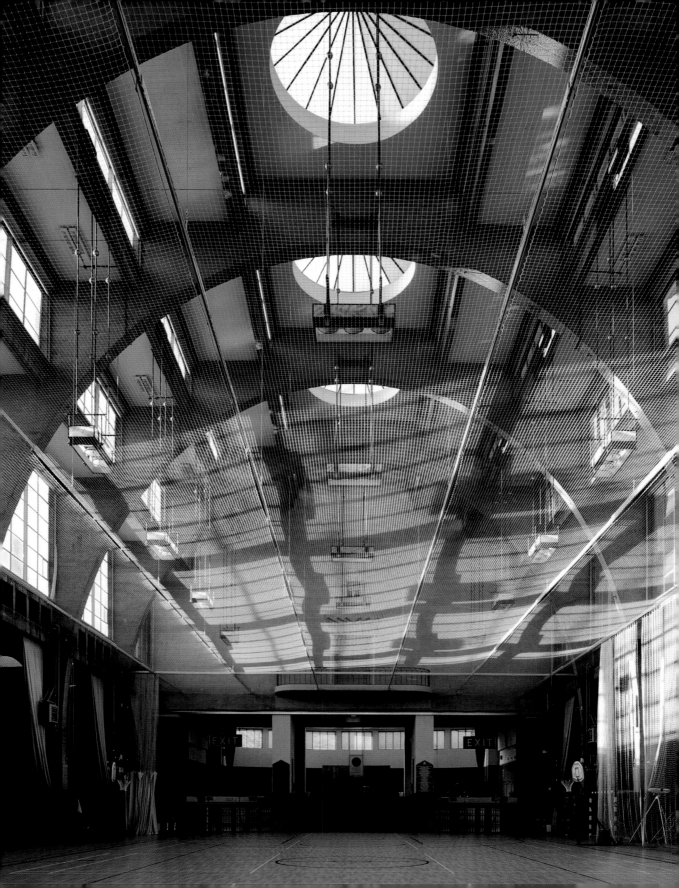

NEW HORTICULTURAL HALL/WESTMINSTER SCHOOL SPORTS CENTRE

Greycoat Street, Westminster, London
1925–28; Easton & Robertson
Listed grade II*

This is a building of two halves: the urbane neo-Georgian facade with its touches of Art Deco or Swedish detailing belies the originality of the hall behind, 150ft (45.72m) long and 72ft (23m) wide. It is a symphony of brown brick and concrete, where reinforced concrete parabolic arches begin as square piers then soar as a series of blades, permitting four clerestories of diminishing size between them. Aisles provide additional support. Central domes add still more illumination for the flower shows for which the hall was built. The engineer was Oscar Faber.

Such a hall was unique in England, but had precedents in Europe, particularly in Germany. In Breslau, now Wrocław, Poland, Heinrich Kuster's market hall used elliptical concrete arches supporting a stepped clerestory, as early as 1906–08. It led to a similar design in laminated timber for a temporary exhibition hall built for the Gothenburg Exhibition of 1923, the immediate precursor of Murray Easton's design. 'Swedish Grace', the term given to that country's understated yet skilful classicism, was *the* fashion among cognoscenti architects in the mid-1920s. Yet the design also harks back to the stepped section of the Crystal Palace, begetter of all great exhibition halls. The progeny of the New Horticultural Hall was more prosaic, when in the 1930s the combination of concrete parabolic arches and clerestory glazing was used to serve a string of major public baths in Britain, while Faber used the technique for a market hall in Nairobi.

Olympia Empire Hall/ Olympia Central

Hammersmith Road, London
1929–30; Joseph Emberton
Listed grade II

The first 'Grand Hall' at Olympia was conceived in the early 1880s as the National Agricultural Hall, a larger version of the Royal Agricultural Hall in Islington intended for military tournaments. Seating 9,000, it was a triumph but was still more successful as an exhibition hall. A second phase followed in 1923. Then, in 1929, a newly reconstituted company, Olympia Ltd, commissioned Emberton to design a major new hall and a multi-storey garage (added in 1937). It was designed for exhibitions from the first, with four storeys of floor space rather than a grand hall for spectacular circuses and tournaments, as indicated by the strips of horizontal windows across the street facade.

Emberton had visited the Paris Exhibition and designed several West End shops and exhibition stands in the Art Deco style. But for a shop selling welding equipment and cutting tools he produced a simpler, stronger design, and the massive Empire Hall at Olympia prompted a change of direction, leading Emberton into modernism and the moderne, graphically seen in the giant incised lettering on the Hammersmith Road facade. The facade is actually made of brick, cut and rendered, over a steel frame, and perhaps owed something to a visit he made to Amsterdam ahead of preparing the design, and particularly to Jan Wils's Olympic Stadium of 1928. It personified the 'style for the job', which is so important to understanding the variety of 1930s architecture.

The interior has been altered but the exterior remains a powerful, early example of the moderne style, now being converted to flats.

56

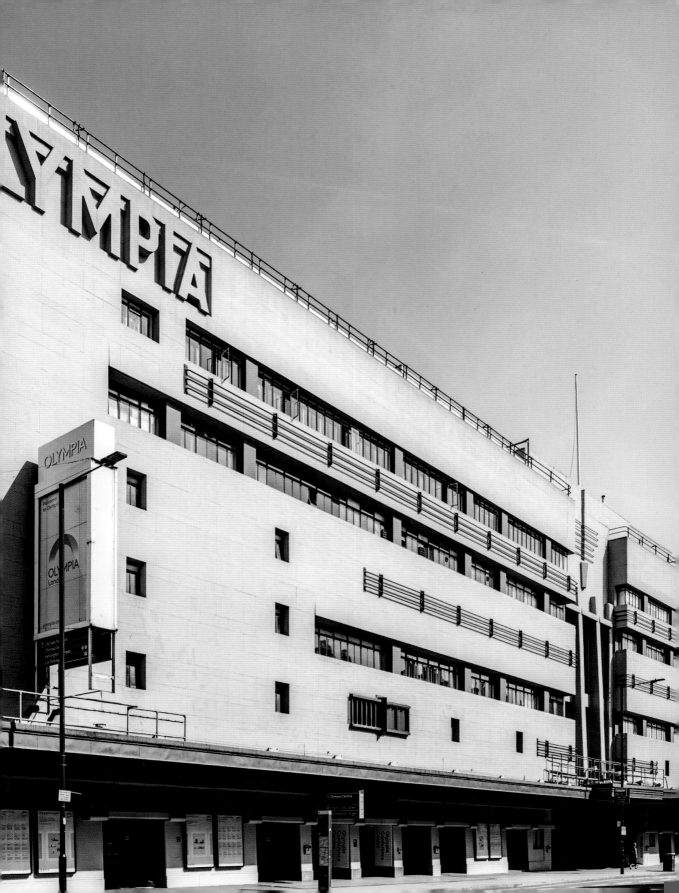

ROYAL MASONIC HOSPITAL

RAVENSCOURT PARK, HAMMERSMITH, LONDON
1929–33; THOMAS TAIT OF BURNET, TAIT & LORNE
LISTED GRADE II*

When, in 1929, Thomas Tait won a competition for a Freemasons' hospital and nursing home, it was with a neo-Georgian design replete with pedimented portico and bellcote. Yet the realised building had no traditional mouldings and was acclaimed by *Country Life* for its functionalism, the ward blocks framed in welded steel that permitted big windows and balconies to their curved ends.

The entrance remains grand. Instead of capitals, the pylons flanking the entrance are topped by figures symbolising health and charity. The entrance hall is lined in marble, with a figure of the god Aesculapius surrounded by the signs of the zodiac etched onto the grand staircase window. To either side are the panelled boardroom and conference room, made opulent so they could double for masonic functions. Nevertheless, it marked a sea-change for Tait, leading to hospital commissions that were truly modern and a reputation for realising public buildings that balanced modern designs with traditional materials and elegant details.

The hospital was run privately by freemasons for their brethren, and replaced a small hospital opened in 1916 for those in the armed forces. A nurses' home and boiler house were added in 1936. It began to lose money in the 1980s and closed amid controversy in 1994. After a decade in both private and National Health Service hands, it closed again in 2006 and has been empty ever since; it is on Historic England's register of 'buildings at risk'. The nurses' home has been converted to flats.

BROTHERTON LIBRARY

**Parkinson Building, Leeds University,
Woodhouse Lane, Leeds
1929–36; Lanchester and Lodge
Listed grade II**

Britain's universities grew only slowly in the interwar years. The exception was Leeds, an independent university from 1904, which held a limited competition for a master plan to bring civic dignity to its piecemeal Victorian buildings. The winners were Lanchester, Lucas and Lodge, who proposed an imposing clock tower on the curve of Woodhouse Lane. In 1927 the chemical manufacturer Sir Edward Brotherton offered £100,000 towards a library, and promised his extensive book collection on his death (duly donated in 1935). Thus the back part of the building was constructed first. It is a round drum significantly larger than that of the British Museum's Reading Room, supported on 20 columns of Swedish marble formed of three sections each weighing three tons, with composite bronze capitals and bases, and in the centre a giant Art Deco electrolier. Thomas Geoffry Lucas left the practice in 1930, while Henry Vaughan Lanchester, the senior partner, concerned himself in these years with building the sumptuous Umaid Bhawan Palace (1930–43) in India, a marriage of Buddhist and Hindu traditions with western classicism and Art Deco. It was thus left to the junior partner, Thomas Lodge, to build the Brotherton Library and the frontage of the Parkinson Building, its entrance hall and showcase tower, completed only in 1951. The result of another bequest, from alumnus Frank Parkinson, it has the grandeur of Senate House in its formal entrance hall – in which details such as the light fittings are delightfully Art Deco within a classical shell – and stripped-back tower, a landmark across the city.

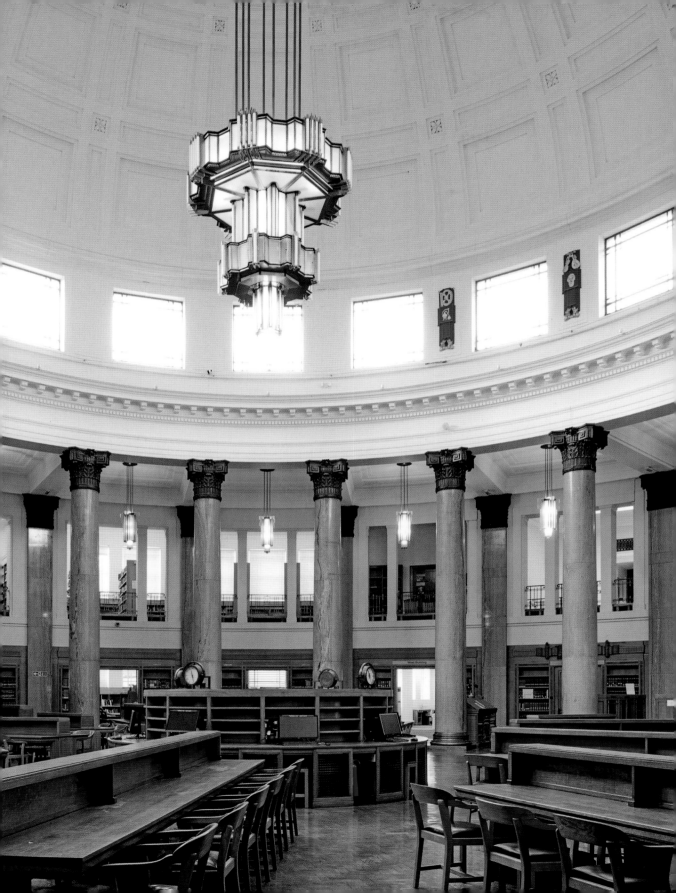

ST CHRISTOPHER

Lorenzo Drive, Norris Green, Liverpool
1930–32; Bernard Miller
Listed grade II*

St Christopher was the 'Children's Church', supposedly paid for with contributions from Liverpool's schoolchildren, and children appear with doves and angels in the four sculpted plaques by H. Tyson Smith in the nave. The austere facade belies the scale of the complex, with a large church hall linked by a cloister, where a giant outdoor pulpit with more cherubic figures by Bainbridge Copnall commemorates the children's surrendered pocket money.

But what surprises is the cinematic quality of the interior. The high, narrow parabolic arch is the natural form taken by a hanging rope, and became a popular motif for Seely & Paget, and brothers Giles and Adrian Gilbert Scott. But Miller – equally a specialist church architect – did it first, and with greater theatricality, plaster coves at the east end of the church creating an illusion of continuing space and providing troughs for concealed lighting in the manner perfected by the local Ritz. This wall was originally a deep violet blue, but is now the colour of Wedgwood porcelain, prompting the critic Nikolaus Pevsner to proclaim it as 'chi chi'. The young Miller would not have cared. This was one of his first and most imaginative works; his later churches are closer to the Arts and Crafts tradition although they are very beautiful.

St Matthew's, Jersey (see page 73), claims to have the only glass font. Its parishioners have clearly not been to Norris Green, where you can be anointed from an eight-pointed vessel of peach mirror glass, now shamefully concealed behind the pulpit as the clergy consider it embarrassing.

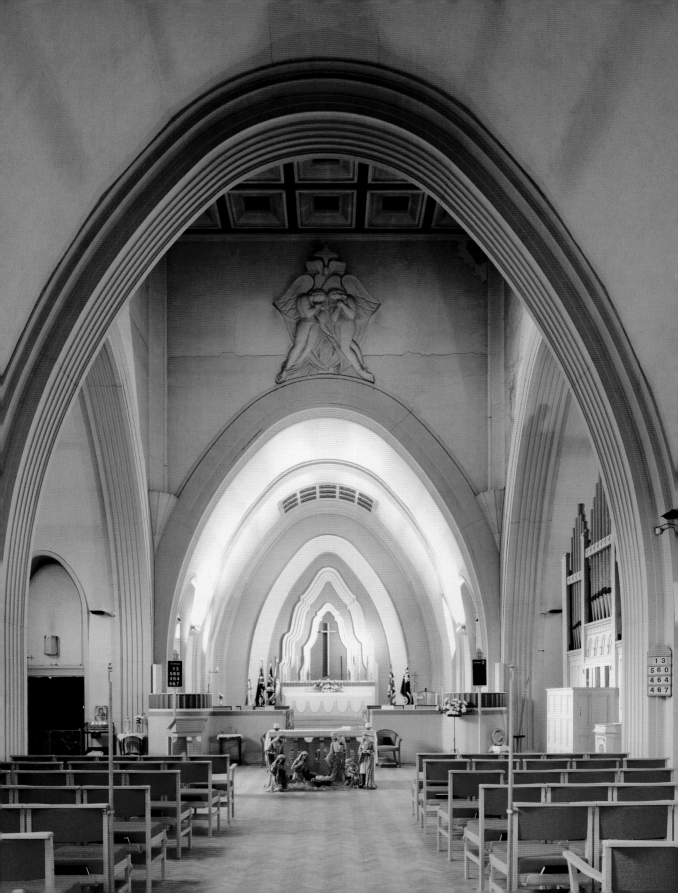

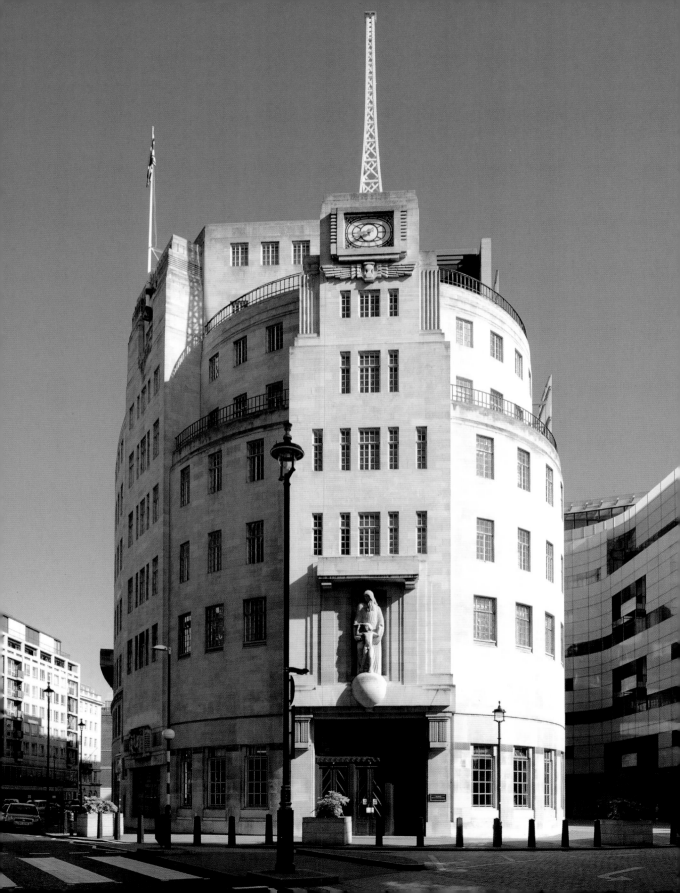

BROADCASTING HOUSE

PORTLAND PLACE, WESTMINSTER, LONDON
1930–32; G. VAL MYER AND WATSON HART
LISTED GRADE II*

Broadcasting House, a bull-nosed minesweeper bearing down on Regent Street, presents a challenging mix of old and new. This architectural balance befitted a client at the cutting edge of technology that was also a government corporation. The remarkable studios, each one furnished by pioneering young modernists Raymond McGrath, Wells Coates and Serge Chermayeff, with Edward Maufe contributing the religious studio, did not survive rapid changes in the industry and wartime bombing.

So many remarkable names overshadowed that of Val Myers, a commercial architect already contracted to design speculative offices for the site. Myers rose gamely to his unexpected opportunity, producing a compact design that pushed a stack of recording studios into the heart of the site and surrounded them with offices. The Portland Place elevation is higher because objections from the residents of Langham Street imposed restrictions on that side. At the prow, Eric Gill carved a giant Prospero sending into the world a naked young Ariel, the BBC's chosen symbol of the airwaves but whose genitalia had to be reduced to placate the director general, Lord Reith.

Myers's entrance hall and concert hall are the main surviving interiors, both with heavy coves relieved by boxy mouldings and strips of light. The entrance hall features another sculpture by Gill, *The Sower*, his seeds symbolic of those cast by broadcasting. The building was refurbished and extended in 2003–06, and again for television in 2010–13.

THE BRANGWYN HALL

**SWANSEA NEW GUILDHALL, GUILDHALL ROAD NORTH, SWANSEA
1930–34; (SIR) PERCY THOMAS AND FRANK BRANGWYN
LISTED GRADE I**

In 1924 the House of Lords voted to commemorate the First World War by
completing the Victorian decorations in its Royal Gallery. Lord Iveagh offered
£20,000 and the Lords commissioned Frank Brangwyn (1867–1956), then at the
peak of his fame as a muralist and who had served as a war artist. The Lords
preferred an optimistic theme to representations of war, and Brangwyn produced
a set of decorative fantasies depicting 'various Dominions and parts of the British
Empire', an unusually humane interpretation based on extensive travels and studies
at London Zoo. But by 1930 Iveagh was dead, and the Royal Fine Art Commission
demanded that Brangwyn exhibit the five completed panels for its approval. It and
their lordships found their flat planes of radiant colour too bright and rejected
them. Nevertheless Brangwyn completed the job and Iveagh's son paid up; they
exhibited 16 panels at the *Daily Mail* Ideal Home Exhibition in 1933 in the hope of
finding them a new civic home.

Brangwyn's parents had Welsh origins, and both Cardiff and Swansea
expressed interest in the panels. The building of the starkly classical Guildhall
in Swansea ensured the latter won out, when councillors offered to raise the
ceiling of its proposed assembly hall especially for the panels. Percy Thomas
was South Wales's leading architect, a maestro of Beaux Arts classicism. The
Guildhall complex is a statement of civic grandeur and an act of defiance against
unemployment that retains a remarkably intact sequence of public interiors.

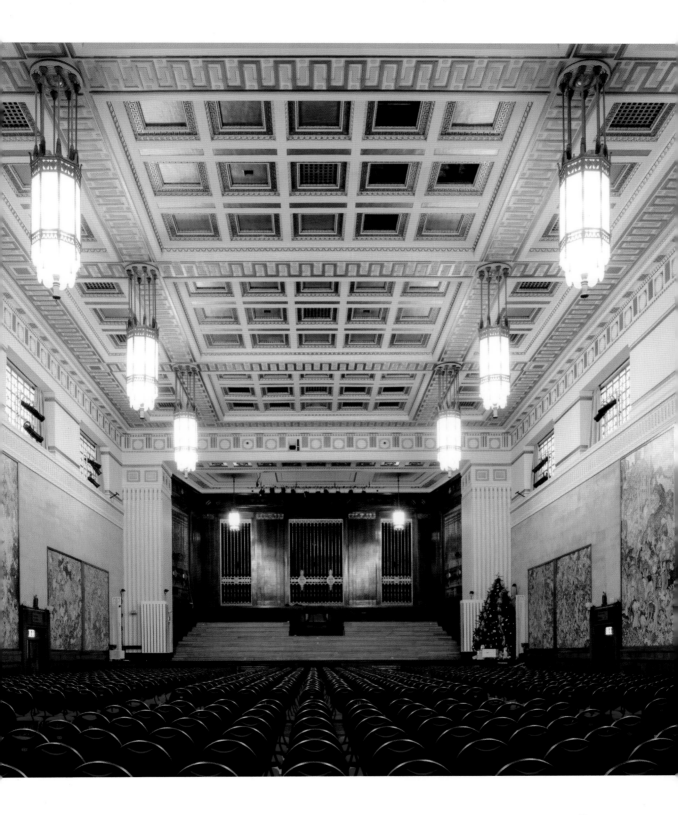

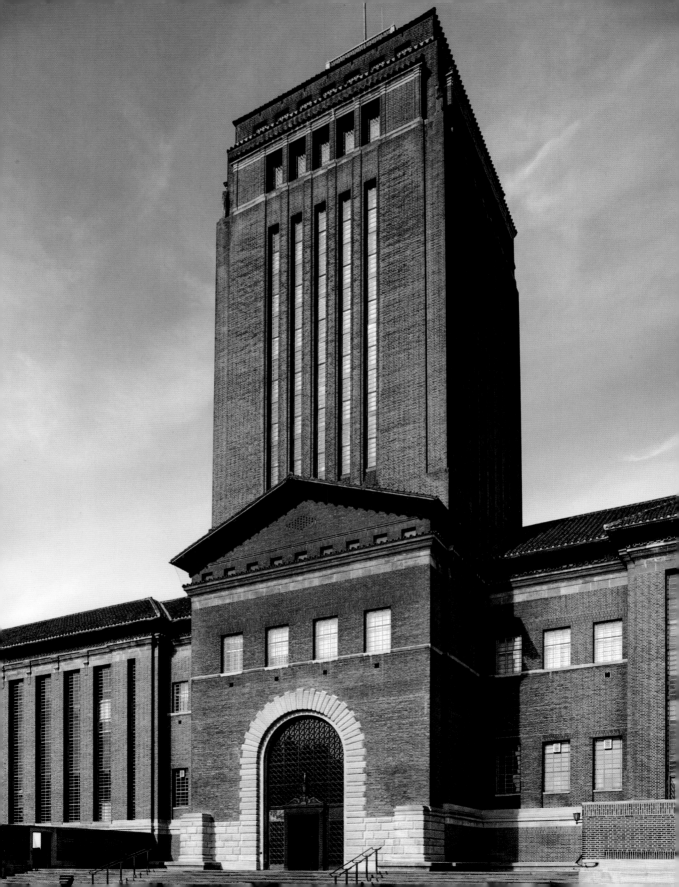

CAMBRIDGE UNIVERSITY LIBRARY

WEST ROAD, CAMBRIDGE
1931–34; SIR GILES GILBERT SCOTT
LISTED GRADE II

'A cross between a jam factory and a crematorium', complained the film critic Leslie Halliwell on seeing the new Cambridge University Library, typifying the self-righteous disdain felt for modern architectural detailing in the 1930s, particularly when applied to major public buildings. There are fine jam factories and crematoria, but none can match Scott's dignified pile for scale, its 157ft (48m) tower housing a 17-storey bookstack and still Cambridge's tallest building.

Cambridge University had a small library in the Old Schools behind Senate House by the mid-15th century. It contained fewer than a thousand volumes until the late 16th century, but the shelves were overflowing by 1918 when the site for the new library was identified. The university invited Scott to produce a design in 1923. He had just designed Clare College's neo-classical war memorial court on the adjoining site towards the river, and conceived the library to close its long vista (blocked since the 1980s by the college's library). Scott and members of the university visited libraries in Washington, Harvard and Yale on a tour sponsored by the Rockefeller Foundation, which funded the building, and the resulting building is a mix of American monumental classicism with his favoured red brickwork inspired by Dutch buildings of the 1900s. How far the American tour influenced Scott's later buildings is unclear. He claimed that the long windows were determined only by the six storeys of bookstacks set behind them, but there are similarities with his later Bankside Power Station (Tate Modern).

SENATE HOUSE AND INSTITUTE OF EDUCATION

MALET STREET, BLOOMSBURY, LONDON
1931–37; CHARLES HOLDEN
LISTED GRADE II*

The University of London sought a landmark. A degree-granting institution serving a group of independent colleges, it had no physical presence until William Beveridge, vice-chancellor in 1926–28, secured land in Bloomsbury for its central administration and the smaller institutions gathered within it. The tower was to symbolise its work, clad in Portland stone to harmonise with the British Museum. Holden secured the commission in 1931 thanks to his headquarters for London Transport, 55 Broadway (1925–29), a sublime building at the interface between the Arts and Crafts, classical and modern architecture. He recognised that he was stylistically in 'rather a curious position, not quite in the fashion and not quite out of it; not enough of a traditionalist to please the traditionalists and not enough of a modernist to please the modernists', but Senate House has a massiveness and directness not found elsewhere. Holden conceived it as a single structure, the core containing the Senate House with a northern spine and wings for the constituent colleges. The entrance maintained a public route through the building, with ceremonial halls to the south. The foyer to the Beveridge and MacMillan Halls is the grandest space, finished in polished limestone and bronze. The tower, containing the university's substantial library, was completed and floodlit in 1937.

The war ended any hope of Holden completing his megastructure. Yet already the School of Oriental Studies and Birkbeck College were demanding their own buildings, replanned by Holden as freestanding blocks around a square but only partly realised.

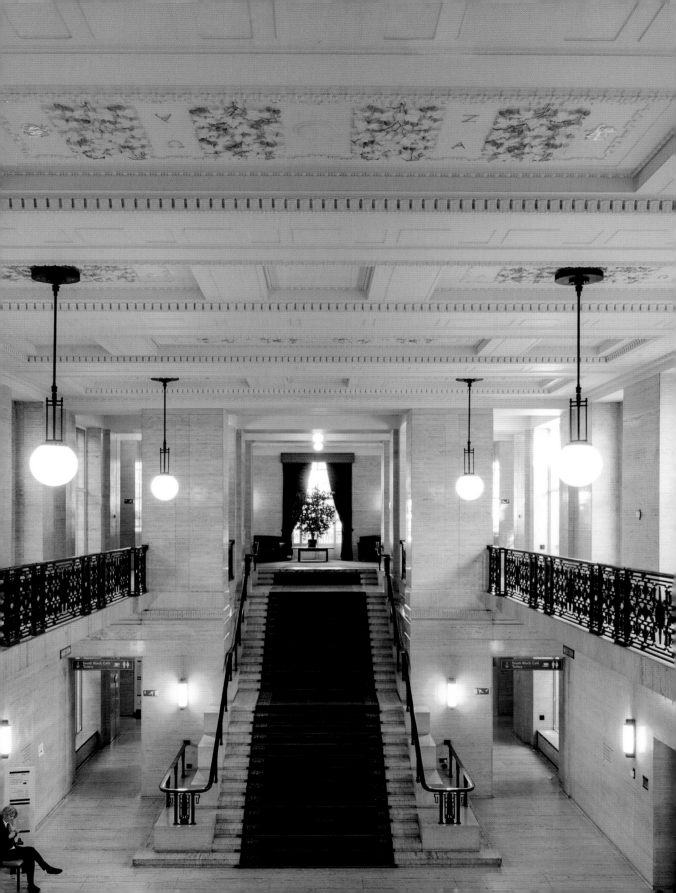

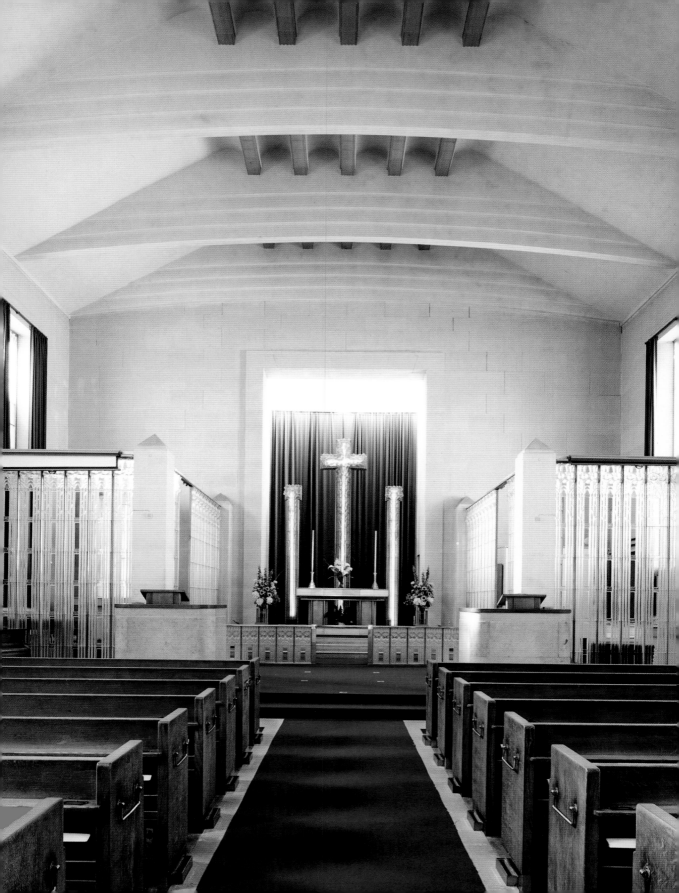

ST MATTHEW'S
(THE GLASS CHURCH)

La Route de Saint-Aubin, Millbrook, Jersey
1932–34; A.B. Grayson and René Lalique
Recommended for listing

Jesse Boot, Lord Trent, the Nottingham-born magnate of chemists' shops, had met his wife Florence in Jersey and in retirement they settled there in leafy Millbrook. The couple had earlier owned a villa in the south of France adjoining that of the glass maestro René Lalique, who had made them a pair of doors; so following Boot's death in 1931 Lady Trent commissioned him to remodel Millbrook's chapel of ease (built c.1840) in his memory. Lalique was then experimenting with large-scale glasswork. That for the SS *Normandie* and Orient Express railroad cars has long gone, but in 1931 he exhibited church fittings in Paris and decorated a chapel at Notre Dame de la Fidélité at Douvres-la-Delvrande, Normandy, which survives.

St Matthew's thick, frosted glass set in steel is moulded with the *Amaryllis belladonna* or Jersey lily. The centrepiece is a cross, flanked by pillars and framed by a glass altar rail and four screens that shimmer like walls of ice. There is a frozen frenzy caught within Lalique's most interesting work, here like Jersey itself balancing modern luxury with a wildness when the elements take hold. Four sultry crystalline ice maidens with film-star hairdos overawe worshippers in the tiny Lady Chapel, while the fluted font is the one element to include clear glass and to bear Lalique's signature.

Arthur Grayson, the son of a Liverpool architectural dynasty who had settled in Jersey, rendered the church and provided the calm interior with its curved concrete trusses, oak pews and ambos of Derbyshire stone.

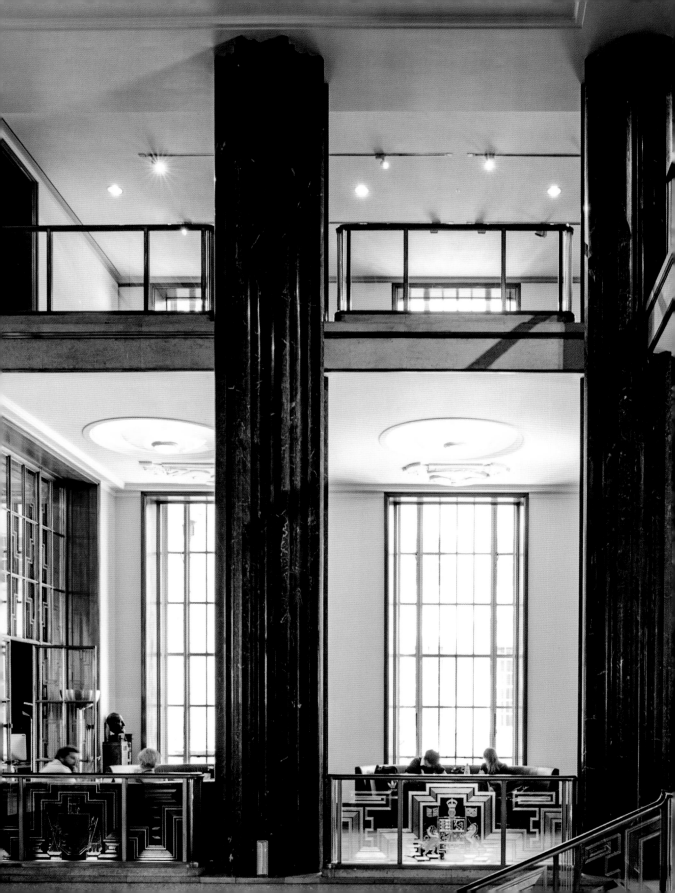

ROYAL INSTITUTE OF BRITISH ARCHITECTS (RIBA)

66 PORTLAND PLACE, WESTMINSTER, LONDON
1932–34; GEORGE GREY WORNUM
LISTED GRADE II*

In the recession of 1931, a competition to build headquarters for the British architectural profession ahead of the institute's centenary aroused immense activity. There were 284 entries. If there were few modern designs, few were wholly traditional: those commended chose a fashionably Swedish-inspired middle ground. The winner, Grey Wornum, had led an excursion to Stockholm in 1930 and had met Ragnar Östberg, architect of Stockholm Town Hall.

The RIBA's severe facade is dominated by a great window that cuts awkwardly through two floors; far jollier are the depictions of the architect amid his building tradespeople on the side elevation. Wornum won because of his planning. He gave equal weight to a lecture theatre and Henry Florence Exhibition Hall, though by day the grand staircase with its giant, black marble columns draws the eyes upward into the light of the hall. Higher still is the library, the three double-height spaces producing a scheme requiring few corridors. Wornum and his wife, Miriam, installed their young artists and craftspeople in lodgings next door, just as Östberg and his wife had nurtured a similar team. Bainbridge Copnall produced the external reliefs and the refined sequence in the exhibition hall depicting building through the ages, while James Woodford carved the pylons and designed vignettes of London buildings for the elaborate bronze entrance doors. Jan Juta etched the glass staircase balustrading, but far finer are the etched and opaque glass doors by Raymond McGrath on the fourth floor, which depict the six great periods of architecture.

HORNSEY TOWN HALL

**BROADWAY, CROUCH END, GREATER LONDON
1933–35; REGINALD UREN
LISTED GRADE II***

Hornsey demonstrates the massing and clean brick lines of Willem Dudok's Hilversum Town Hall like no other public building in Britain. Uren, a New Zealander, won a competition in 1933 because his design perfectly fulfilled the need for a municipal style that was modern yet monumental, dignified without being aggressive. Hornsey's tower permitted the etched glass, heraldic sculpture, bronze fittings and flagpole still thought essential to a display of civic pride. It perfectly suited a prosperous Conservative borough that was trying to assert its identity in the face of advancing London and a bevy of solidly Labour neighbours.

The town hall sits behind a little garden, surrounded by buildings in a similar style that show the importance of gas and electricity undertakings in the 1930s. After Hornsey was merged into the larger (Labour) borough of Haringey in 1965, the building was not much used, so survived little altered until its closure in 2004. There is carved Portland stone decoration by sculptor Arthur J. Ayers on the tower and a bronze grille featuring woodland birds and animals over the main door. The entrance hall has walls and floors finished in Ashburton marble, while the main offices and the ghostly council chamber are lined in Australian walnut and Indian laurel, with etched glass screens and bronze staircase balustrading. The assembly hall facing the garden has had a series of arts uses, but in 2017 the council approved the conversion of the rest of the town hall into a hotel and its neighbours into flats.

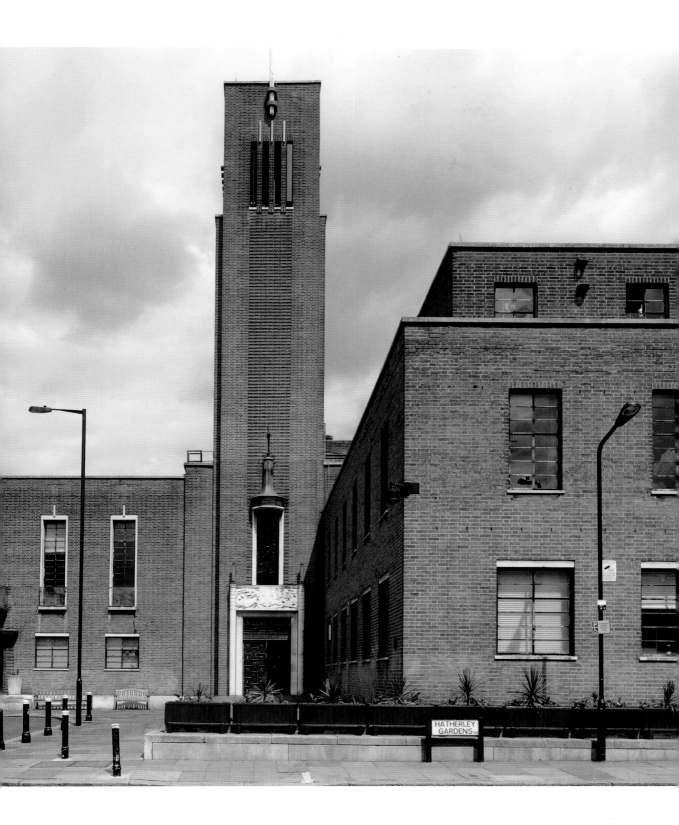

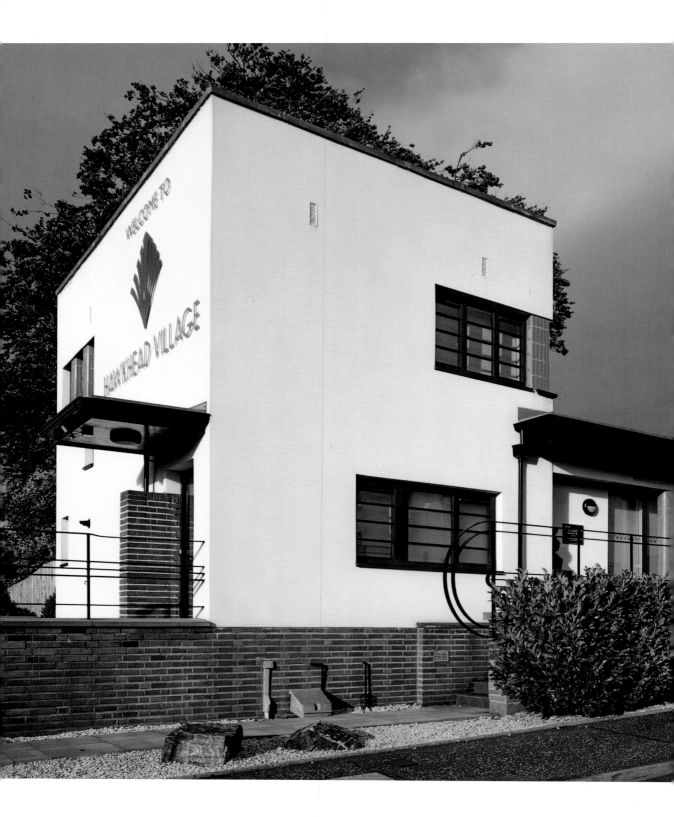

HAWKHEAD HOSPITAL/ HAWKHEAD VILLAGE

HAWKHEAD ROAD, PAISLEY
1933–36, THOMAS S. TAIT OF SIR JOHN BURNET, TAIT & LORNE
LISTED GRADE B

Tuberculosis, polio and diphtheria were among the most common causes of death in the 1930s, their impact devastating because they could attack people of any age. Before vaccination became routine under the National Health Service, the only treatment was in special isolated hospitals, built in large numbers after the repeal of the 1834 Poor Law Amendment Act in 1929 pushed health provision into the hands of local authorities. The moderne style was universally chosen for its simple imagery of clean lines, large windows and rigorous economy, but so few examples survive that the genre is almost entirely forgotten.

This is why Hawkhead Hospital is important. Paisley Burgh Council acquired the site in 1932 and held a competition. When it was won by Thomas Tait, he was looking to build on the acclaim awarded to his Royal Masonic Hospital, and produced one of his most modern designs. Like most isolation hospitals, Hawkhead was conceived as a series of small blocks, but here they are streamlined and flat-roofed with sun balconies, nautical railings and coloured tiles contrasting with the Brizolit white render.

The hospital closed in 2005 and the buildings were slowly converted into flats by Keir Homes following a conservation plan of 2007 by Elder & Cannon. Something of the original character can be seen in individual blocks such as the lodge with its curved railings and turquoise tiles, but new blocks now fill in the gaps between Tait's free-standing symmetrical pairs of wards.

LADY BANKES SCHOOL

Dawlish Drive, Ruislip, Greater London
1935–36; W.T. Curtis and H.W. Burchett,
Middlesex County Council
Listed grade II

Middlesex County Council defined a strong, personal identity as the principal authority responsible for public works in John Betjeman's Metroland until 1965. Its first schools were in a free Edwardian baroque style, while those from the early 1920s are quietly classical. But enormous numbers were needed as housing consumed the area, and William Thomas Curtis's arrival as county architect in 1930 coincided with a financial crisis. Charged to cut costs by 30 per cent, Curtis and his assistant for educational buildings, Howard William Burchett, looked to build more simply. Their model was Willem Dudok, the Dutch follower of Frank Lloyd Wright who had faced a similar problem as city architect for the new town of Hilversum. He developed a distinctive idiom in 1925–27 that married the fine brickwork of the Amsterdam School with simplified, strong horizontals and vertical elements, made possible thanks to concrete floors and stair towers, giving maximum expression to the school's simple elements. Dudok's Bavinckschool and Julianaschool directly inspired Curtis and Burchett.

Curtis and Burchett's flat roofs and low ceilings, coupled with wider windows thanks to the framed construction, produced a strong horizontal emphasis for the long classroom wings. Staircase towers were pushed outwards and upwards, given long, vertical windows. They first used a steel frame at Uxendon Manor School, Wembley, followed by exposed concrete floors at Pinner Park School, both in 1934. But the queen of the crop was Lady Bankes, where the central tower was first made curved and given emphasis by using two colours of brick.

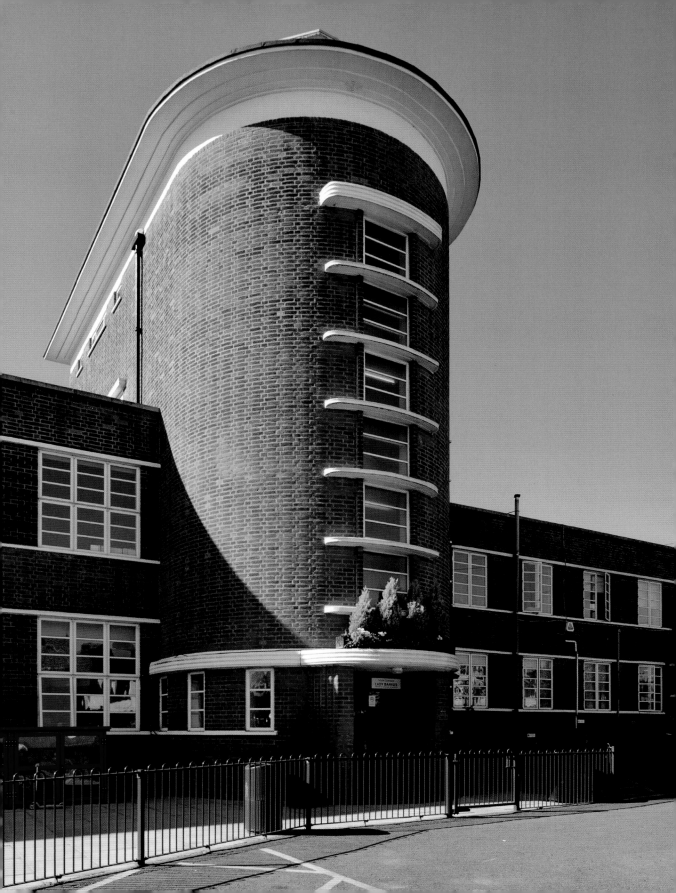

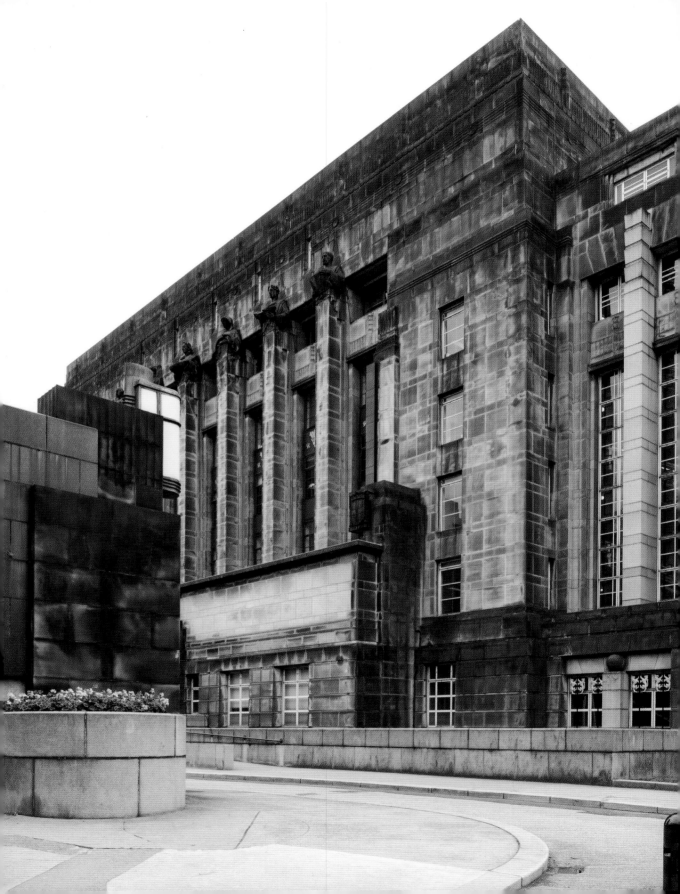

ST ANDREW'S HOUSE

REGENT ROAD, CALTON HILL, EDINBURGH
1935–39; BURNET, TAIT & LORNE
LISTED GRADE A

St Andrew's House can be appreciated as a monumental piece of late classicism. But its massing and detailing bring the greatest public building of the age in Britain into the Art Deco canon.

Thomas Tait was appointed in late 1934 after a series of schemes by the Office of Works for administrative offices on the prominent site of the Calton Prison had been rejected on grounds of cost and quality. The building steps down Calton Hill, a neat massing first designed in 1933 by a retired architect, Sir George Washington Browne, but Tait added a higher north block and 'L'-plan wings.

Tait considered this elevation 'simple and sculpturesque', carried out with 'strength and refinement', a good description of the centrepiece of dark Northumbrian Darney stone with its American-style set-backs. Seven piers are topped not with capitals but with figures carved by William Reid Dick, who suggested that their arms and symbols should extend beyond the width of the shaft, unlike at the Royal Masonic Hospital. The source for such figures may have been projects by Eliel Saarinen or Michel de Klerk, or more probably Gilbert Underwood's Omaha Union Station of 1929–30. The lighting pylons in front of them have something of Tait's work at the Glasgow Empire Exhibition in 1938. They were planned from the beginning but in 1939 were appended with flagpoles.

Within there are no large spaces beyond the entrance hall, since the function of the building was purely administrative, with many finely panelled offices.

HESTON AND ISLEWORTH FIRE STATION

LONDON ROAD, ISLEWORTH, GREATER LONDON
1936–37; J.G. CAREY, BOROUGH SURVEYOR

The former county of Middlesex is the best place to enjoy the public architecture of the 1930s, and fire stations are particularly varied and well preserved. They also demonstrate the slow development of fire-fighting, for it was only in 1938 that an Act of Parliament required every local authority to provide a fire service. Heston and Isleworth had already celebrated their elevation to borough status in 1933 by recruiting a professional force.

The firemen and new engines needed accommodation. The council already owned a site at the corner of London Road and Spring Grove Road; it was on a major road, yet near Isleworth village where fires were most common. The chief officer, J. Caceres, demanded a five-bay engine house and rear exercise tower. Carey followed the curve of the site, and produced a strikingly long, horizontal design in a simplified Dutch style for 20 flats, in the midst of which the fire station makes an unusual feature. Each flat had a living room, small kitchen, bathroom and bedrooms, with Caceres given the largest unit at the furthest distance from the engine house, with a balcony and a roof garden. A recreation room and parade room were set over the engine house. The station opened in March 1937, when it was reported that the firemen, who had been granted free electricity for lighting only, were running irons and wireless sets from the light sockets; unusually for the times, the council decided to overlook the modest misdemeanour.

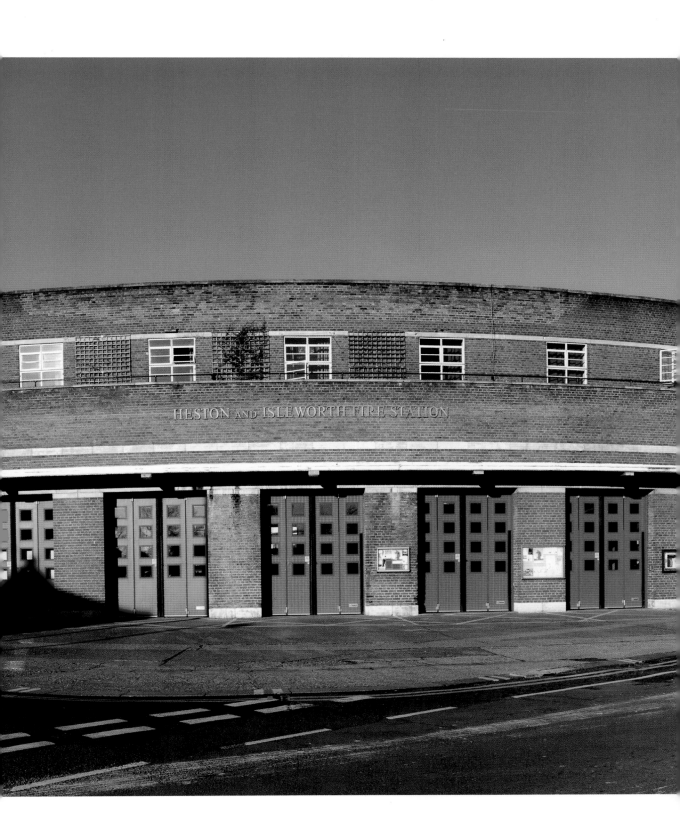

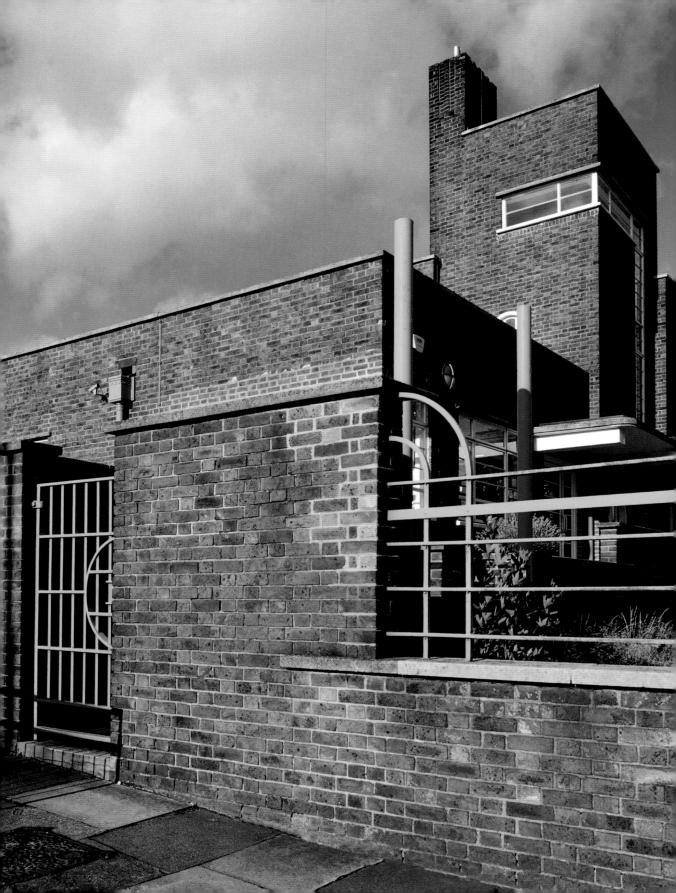

BRENTFORD HEALTH CENTRE/ ALEXANDRA HOUSE

ALBANY ROAD, BRENTFORD, GREATER LONDON
1937–38; L.A. COOPER AND K.P. GOBLE
LISTED GRADE II

The National Health Service, introduced in 1948, took on a patchwork of institutions, mostly Victorian hospitals and Poor Law institutions. Less well-known are a crop of interwar health centres, mostly caring for mothers, infants and young children. That built by the dynamic borough of Brentford and Chiswick was on the site of an 1830s school at the heart of Brentford's worst slums just off the High Street. Most inner London boroughs adopted a simple, stripped classical style – save for Finsbury, builders of the most progressive pieces of modern architecture in Britain and a model for the NHS health centres built in the 1960s. However, Brentford's borough engineer and his architectural assistant chose the Dudok style being adopted by Middlesex County Council in the surrounding districts.

The building looks complicated, set on a rising site with single-storey buildings behind a tall frontage that includes a caretaker's flat on the upper floor. It actually comprises a simple plan of consultants' rooms set off a large central waiting area. The dominant features are the glazed staircase tower with a horizontal slit and porthole window, a 'tower of health' surmounted by the boiler chimney. Around it, high parapets conceal a series of flat roofs on various levels, and the perimeter walls retain the original railings and Art Deco gate.

The health centre was replaced by new facilities up the road in 1996. Part is now a centre for Age UK but some of the building remains unused.

KENTON LIBRARY

KENTON LANE, HARROW, GREATER LONDON
1939; W.T. CURTIS AND H.W. BURCHETT,
MIDDLESEX COUNTY COUNCIL
LISTED GRADE II

Kenton Library gives unexpected drama to a suburban corner in the heart of semi-detached Metroland, far from shops and other public buildings. A clinic planned to share the site never happened, unlike the dual premises Middlesex built in Arnos Grove. Public libraries opened in suburbia only after 1918, when Middlesex County Council began running a service from rented premises and mobile vans before Curtis and Burchett built a series of permanent branch libraries.

The library appears larger than it is thanks to a corner tower, where the librarian's office and a committee room are stacked over the entrance. Otherwise this is a single-storey building, the long wing containing the main library and the short one the children's library, with an information counter replacing the issue desk set in the curved angle between them (moved into the adult library only in 2018). The interior is otherwise a rare survival among interwar libraries, for original bookcases have been restored and other fittings revealed. The adult library bookcases are particularly fine with bowed ends that bestow a calm refinement reminiscent of the library at the RIBA or a gentleman's club. In the children's library, the cases are set into richly panelled walls, with windows only to the road frontage, so it feels more complete. Both libraries are additionally naturally lit by domes filled with sparkling glass lenses, somewhat reminiscent of Alvar Aalto's ground-breaking library at Viipuri (now Vyborg, Russia). Kenton shows how a modern library service can operate happily in a historic interior.

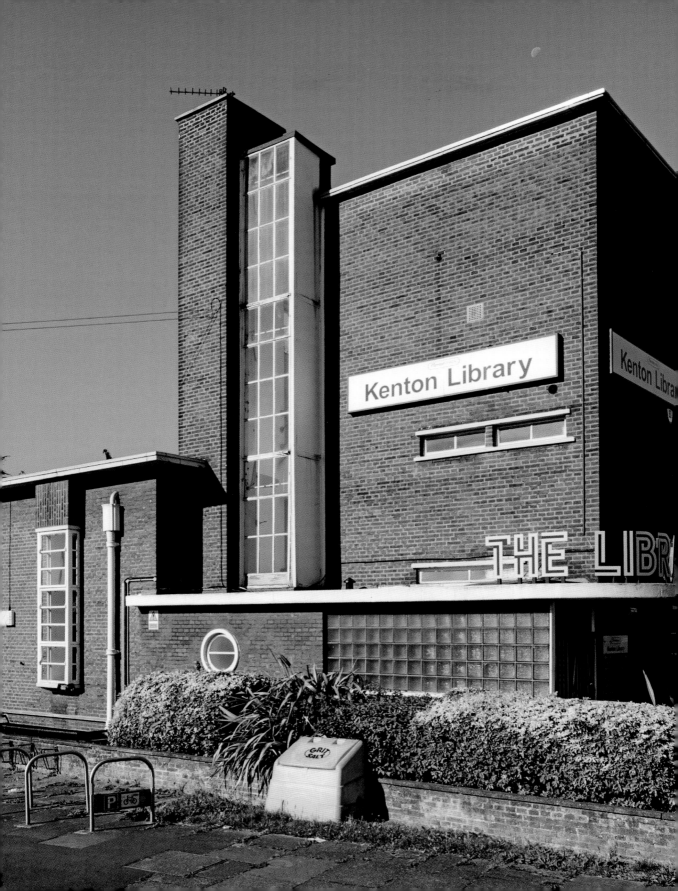

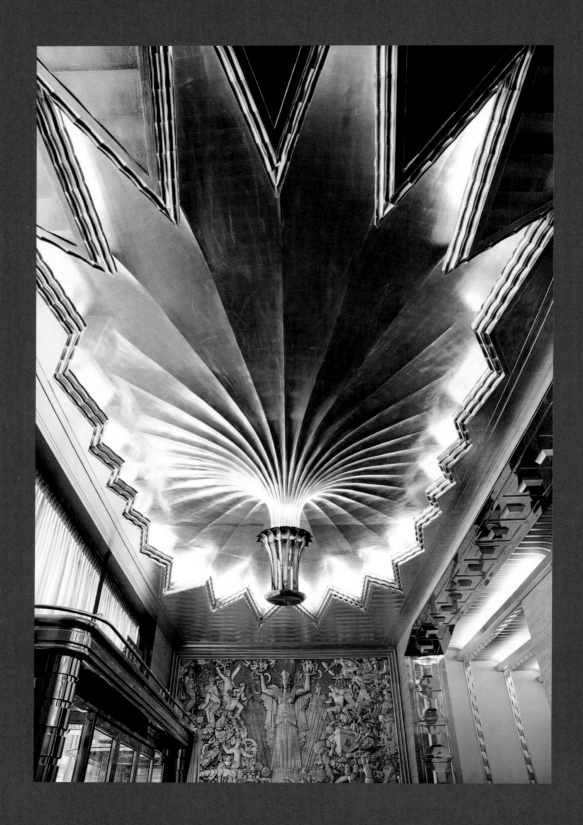

OFFICES

ADELAIDE HOUSE

KING WILLIAM STREET, CITY OF LONDON
1921–25; SIR JOHN BURNET, TAIT & PARTNERS
LISTED GRADE II

Thomas Tait had made his reputation with the clean lines of the steel-framed Kodak House, declared the 'prototype of a new movement in architecture' by the *Architects' Journal* in 1922 as the building trade struggled to revive after the First World War. In the 1900s Burnet had proclaimed his Beaux Arts credentials; a war graves commission in Egypt was an excuse to pack off Tait to investigate the local architectural traditions.

The entrance to Adelaide House on London Bridge has a stripped Doric order in black stone, but the overall battered facade and sweeping cornices, with an implied order and spandrel rosettes, offer a simple form that elegantly catches the light. The taut rhythm is similar to that of H.P. Berlage's Holland House of 1916, also in the City of London. At 11 storeys, two below the level of London Bridge, faced in grey granite in contrast to the Portland stone above, it was then the tallest office building in the City. It featured air-conditioning and an internal mail system, with beehives and a putting green on the roof. The building recalls Queen Adelaide (1792–1849), consort of William IV, who opened the previous London Bridge in 1831 and gave her name to an earlier building on the site; coats of arms from Australian states acknowledge the city that also perpetuates her memory. The figure above the entrance is by William Reid Dick.

Adelaide House belongs to the world of proto-Art Deco for its overall form and the details of the bronze gates and lamps at the entrance.

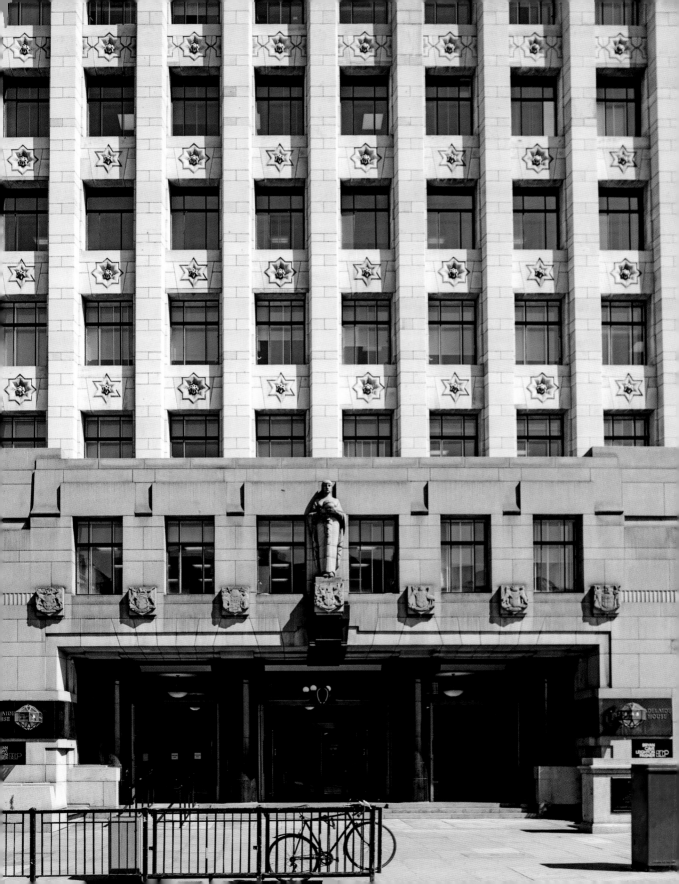

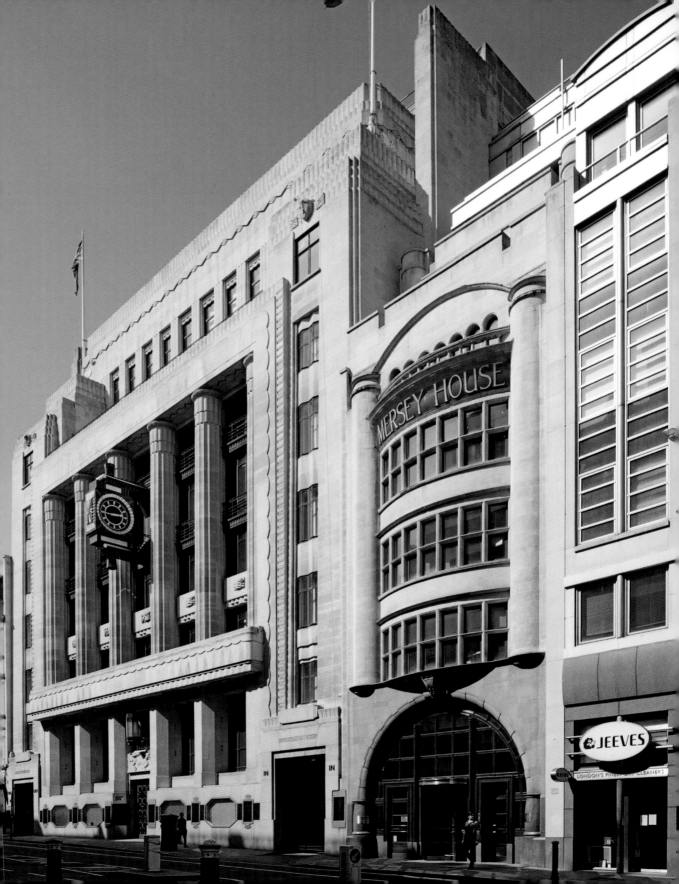

PETERBOROUGH HOUSE (DAILY TELEGRAPH)

134–41 FLEET STREET, CITY OF LONDON
1927–31; CHARLES ELCOCK WITH THOMAS TAIT OF SIR JOHN
BURNET, TAIT & PARTNERS
LISTED GRADE II

The dominating feature of this former newspaper giant is its massive and colourful clock, the supreme example of a long Fleet Street tradition. Otherwise, the monumental classicism is enlivened by bold, fashionable Egyptian motifs, from the tulip capitals of its giant fluted columns to the chunky reeds of its parapets. Above a base of marble and granite, bronze showcases line the ground floor, with bronze doors at its centre surmounted by figures of two Mercuries by Alfred Oakley. Two winged masks high up on the ends of the building by Samuel Rabinovitch depict 'The Past' and 'The Future', reflecting the newspaper's motto of 'was, is, and will be'.

The *Daily Telegraph* was the most enduring of a crop of newspapers founded following the lifting of stamp duty in 1855, thanks to excellent advertising and middle-brow politics. It built impressively on Fleet Street in 1882 to designs by Arding, Bond & Buzzard with a 'pillar hall' to which advertisers flocked to deliver their copy and a clock to rival that of *The Times*. It built a new press hall in the 1890s, and sections of these older buildings lurk behind the rebuilt frontage, erected in two stages after the paper was acquired by new owners, Welshmen William and Gomer Berry and Lord Iliffe. The trio's financial holdings went well beyond the *Telegraph* itself, and the one major new interior was a fifth-floor directors' suite, with three panelled offices, a private dining room and smoking room. The building is now occupied by Goldman Sachs International.

ST OLAF HOUSE
HAY'S WHARF

27 TOOLEY STREET, SOUTHWARK
FIRST DESIGN 1927, EXECUTED 1930–32; H.S. GOODHART-RENDEL
LISTED GRADE II*

Goodhart-Rendel met Owen Hugh Smith when in 1926 he extended the 17th-century Langham Old Hall in Rutland. The chairman of the proprietors of Hay's Wharf operating near London Bridge, Smith commissioned a new headquarters building for a narrow Thames-side site previously occupied by St Olave's Church. Goodhart-Rendel began with a classical design, then stripped it back to express the open ground-floor (required for car parking), the sloping windows of a rooftop drawing office and the luxury of the boardroom and directors' common room that dominate the river frontage.

A curved, 'H'-shaped building, the sturdy street facade clad in Portland stone belies the openness of the wider riverside block where the steel frame is easily read. The angled windows were originally gilded (like the giant gold lettering) and are angled to give the best views and so they can be opened away from the prevailing wind. Central bays housing the boardroom and common room have large windows framed by 39 panels in gilded metal and terracotta by the sculptor Frank Dobson with dockland scenes entitled *Capital, Labour and Commerce*, edged in black granite. Dobson also produced the mosaic of St Olaf of Norway facing the street. But what really impresses is the quality of decoration throughout the building, including staircase balustrades, granolithic floor patterns and the lift doors. The double-height boardroom has pilasters and coffered beams in grey scagliola, while the common room is panelled with veneered hardwoods. Goodhart-Rendel even designed the furniture, made by Betty Joel, which survived into the 1980s.

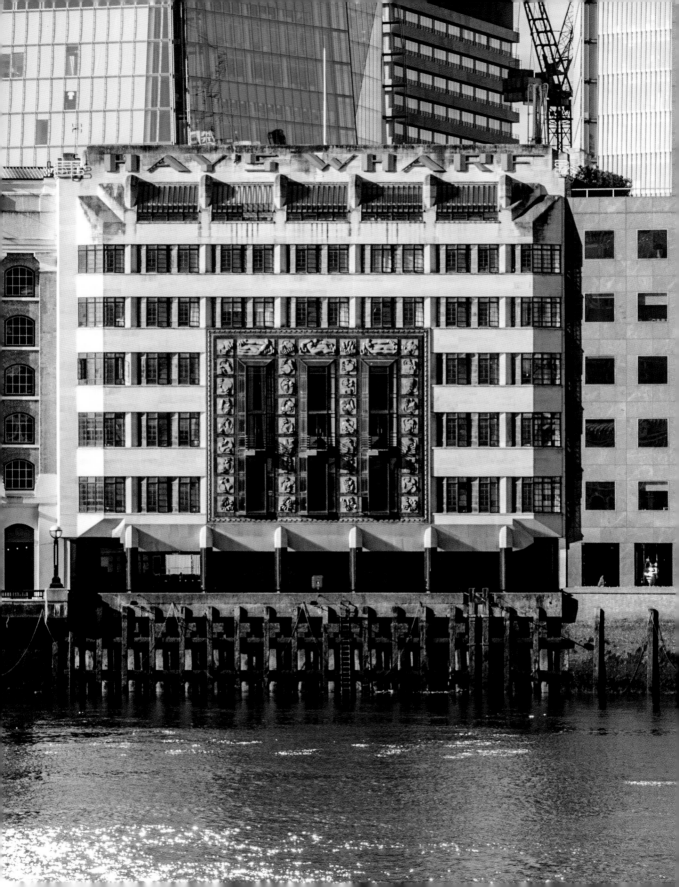

DAILY EXPRESS BUILDING

120–29 FLEET STREET, CORNER WITH SHOE LANE, CITY OF LONDON
1930–32; ELLIS & CLARKE WITH E. OWEN WILLIAMS
LISTED GRADE II*

Owen Williams was the engineer for the new *Daily Telegraph* offices, but a greater challenge came at the *Daily Express* a few doors down. When in 1923 its owner Lord Beaverbook bought *The Standard* he needed larger premises for his presses. Architects Ellis & Clarke squeezed in a narrow printing building in Shoe Lane, but a greater opportunity came with the acquisition of the *Morning Advertiser* on the Fleet Street corner. Ellis & Clarke produced a classical scheme in weak emulation of the *Telegraph*, and Williams saw an opportunity not only for his exceptional engineering skills but to assert himself as an architect also. He produced a complex yet elegant concrete frame that offered unimpeded space to extend the press lines through the basement, then imposed a dramatic, functional facade on to the offices. The front, built in 1931–32 and London's first proper instance of curtain walling, was not entirely of Williams's devising. He had wanted the concrete frame to show through, and the choice of shiny black Vitrolite contrasted with strips of chromium and glass is thought to have been the brainwave of Ellis & Clarke's future partner Bertram Gallannaugh.

In total contrast to this streamlined facade is the entrance lobby, perhaps the most sophisticated Art Deco work of Robert Atkinson. The covings and sunburst of the ceiling and rippling floor patterns are Atkinson's, but the most dramatic features are Eric Aumonier's reliefs of a shining 'Britain' and 'Empire'. The building was restored by John Robinson Architects in 2001.

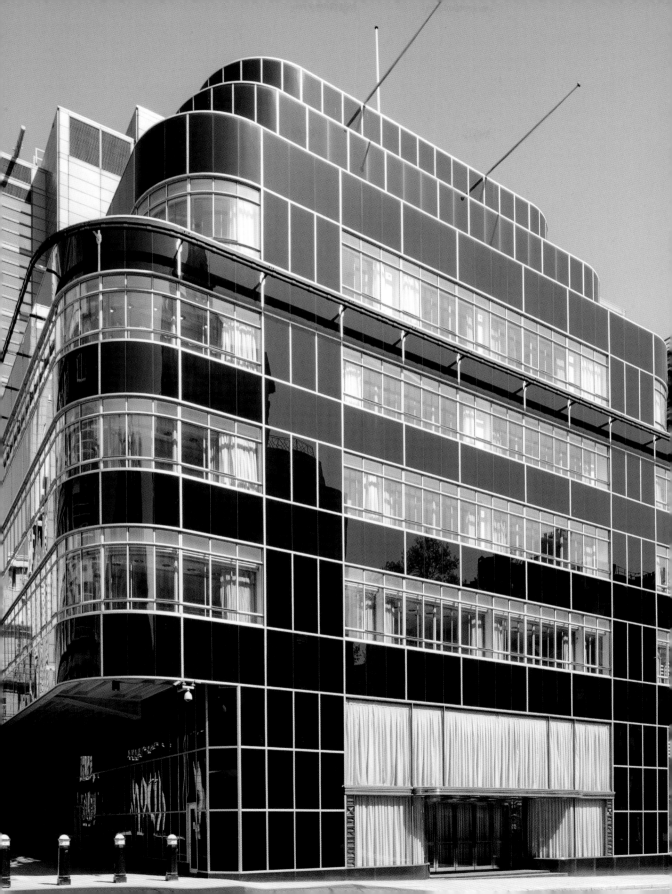

BOURNEMOUTH ECHO OFFICES

RICHMOND HILL, BOURNEMOUTH
1932–34; SEAL & HARDY
LISTED GRADE II

Unusually among seaside resorts, Bournemouth developed its own architectural idiom in the 1930s when its population soared to 130,000. This was thanks to local architect Arthur John Seal (1886–1970), whose moderne style embraced public buildings such as the electricity showrooms in Boscombe as well as the Palace Court Hotel in Westover Road and the Harbour Heights flats overlooking Poole Harbour. Until 1934 he worked in partnership with Philip Hardy, designing the Westover Ice Rink and – perhaps the best of all today – the offices of the *Bournemouth Echo*.

The *Evening Echo*, later the *Bournemouth Daily Echo,* first appeared in 1900 and grew with the town. When, by the 1930s, it sought its own showcase premises, who better than Seal & Hardy to design it? Bath stone gave dignity, while the stepped profile rising to a central staircase tower with chevron glass rising through three storeys offered a fitting modernity. Fifteen 2-ton linotype machines were moved overnight from its old premises in Albert Road on 13 and 14 January 1934, together with the telegraph and telephone systems on which the paper depended for its news, so that not an issue was missed. An addition at the rear in 1961 housed still heavier presses and the paper's delivery vans. Digital processes replaced the presses in 1987, when the front print hall became a bar. The newspaper is still published from part of the building, but in 2018 there are proposals to rebuild the 1961 extension and adapt much of the rest to new uses.

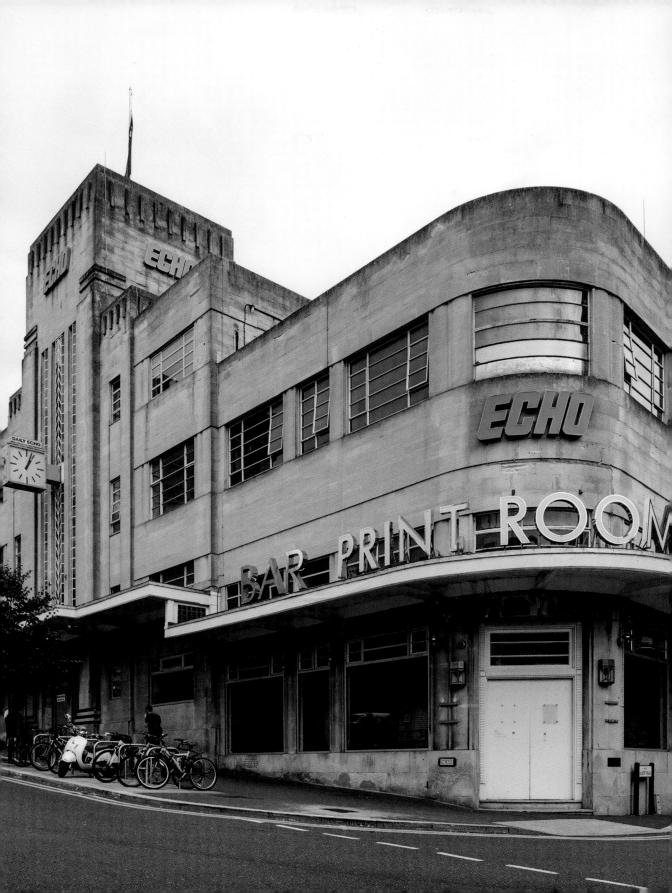

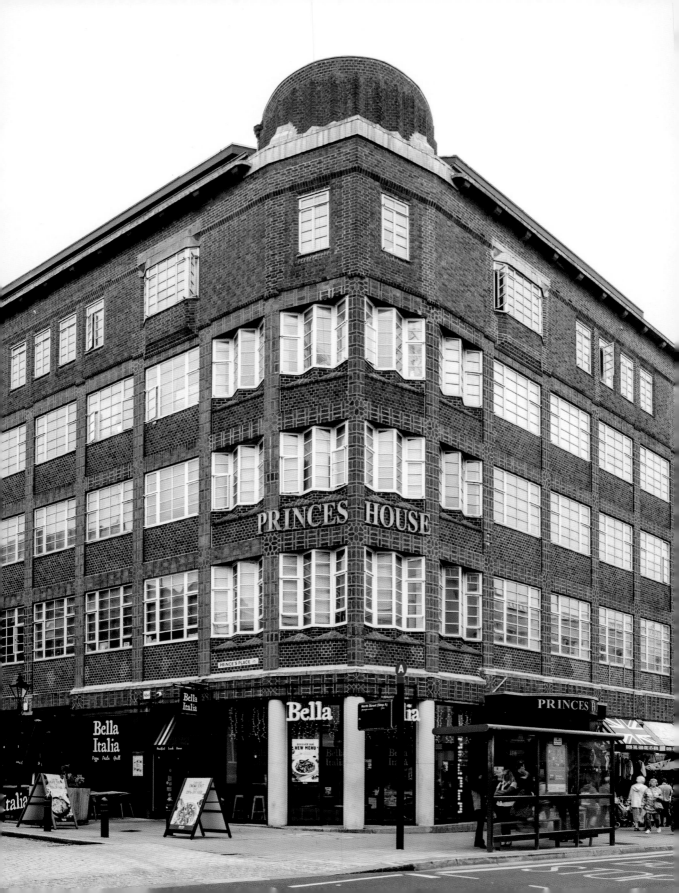

PRINCES HOUSE

166–69 NORTH STREET, BRIGHTON
1935–36; H.S. GOODHART-RENDEL
LISTED GRADE II

Goodhart-Rendel inherited his grandfather Lord Rendel's estates in Brighton, which may explain the commission to build these offices for the Brighton and Sussex Building Society, originally called Prince House. A church he designed in the city, St Wilfrid's, has been crudely converted into flats. In the mid-1920s he was introduced to expressionist brick buildings in North Europe through F.R. Yerbury, secretary of the Architectural Association and an intrepid photographer. Goodhart-Rendel became obsessed with brick patterns, some inspired by music notation, which he drew out on large, gridded sheets.

Sited on Brighton's most distinguished shopping street, close to the Pavilion, the building's steel-framed structure is readily discernible, punctuating the bands of metal windows on the middle floors. Contrasting bands of handmade red bricks are laid in soldier courses, indicating that they have no structural function, or in diaper patterns with blue glass and tiles. Where the two long elevations meet it is as though two continental plates have collided, pushing the corner windows into unusual pleats. There is also a shallow corner dome, a reminder of Goodhart-Rendel's interest in Indian architecture; his first building, designed while he was reading music at Cambridge, was an office block in Calcutta. Whereas Hay's Wharf (see page 96) was a one-off design within his oeuvre, Princes House's mix of structural reason and Arts and Crafts sensibilities was more consistent with his later career. It was later occupied by Norwich Union, insurance brokers, and was converted into a restaurant and 34 flats in 2002.

IBEX HOUSE

42–47 MINORIES, CITY OF LONDON
1935–37; FULLER, HALL & FOULSHAM
LISTED GRADE II

Ibex House is deceptively large, for it presents only a side elevation to Minories. It was the first building in the City of London built of flat slab concrete construction, after the London County Council belatedly relaxed its legislation. It is still more remarkable in being a moderne building in the heart of the City, elsewhere a bastion of traditional design.

Ibex House claimed the longest strips of windows in Britain when constructed, their horizontal bands contrasting with biscuit cream faience tiles. The black of their predominantly horizontal glazing bars is repeated in the base of black faience. More distinctive still is its projecting stair, a vertical interruption that is fully glazed; it punctuates a sense of movement perhaps ultimately derived from Erich Mendelsohn's series of Schocken stores built in Germany in the late 1920s and featured in the exhibition on the International Style held at New York's Museum of Modern Art, along with its very influential catalogue.

Fuller, Hall & Foulsham was a prolific commercial practice in the 1930s that was experimental in its use of flat-slab concrete and deserves to be better known. It re-established itself in Hemel Hempstead in the 1950s, where it built many of the new town's most important buildings.

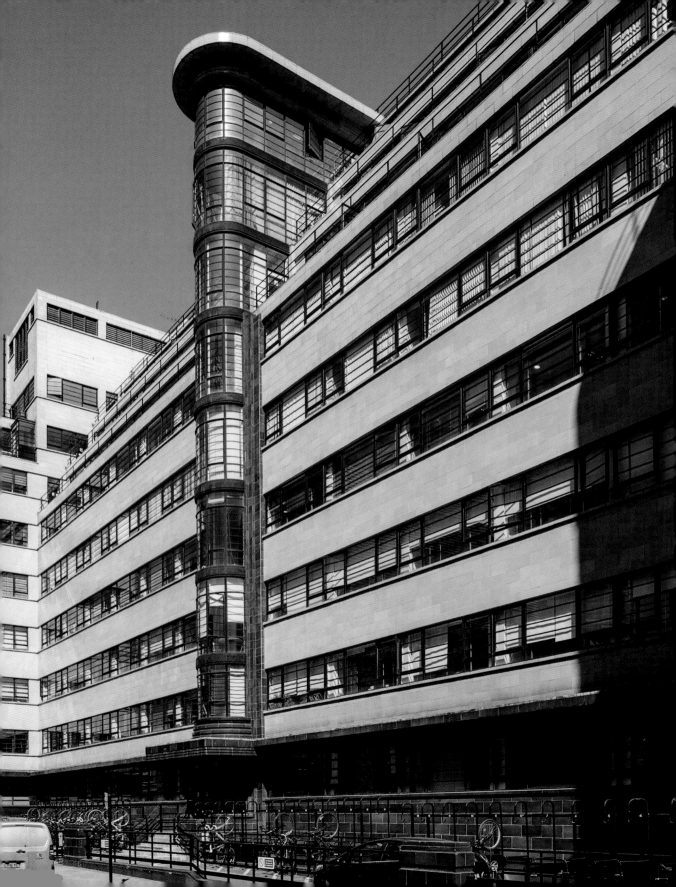

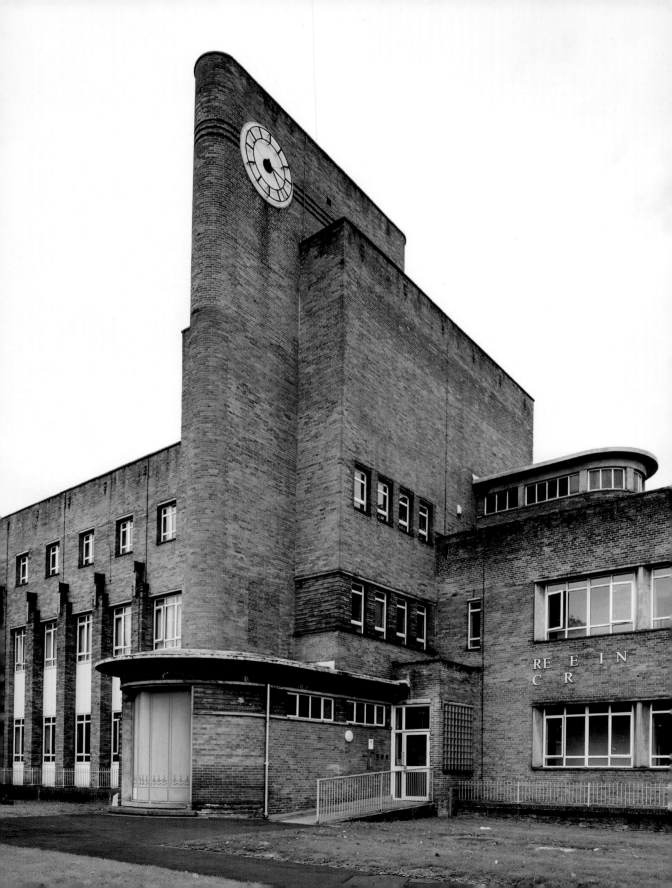

PILKINGTON OFFICES/ REFLECTION COURT

GROVE STREET, ST HELENS, MERSEYSIDE
1938–41; HERBERT J. ROWSE
LISTED GRADE II

Pilkington's was Britain's leading glass manufacturer, licensees of opaque Vitrolite cladding and the developer in the 1930s of toughened glass. Its advertising, showrooms and exhibition stands were among the best examples of contemporary design and in 1933 the company established an architect's department under Kenneth Cheesman. The next year it rejected a neo-Georgian scheme by Arnold Thornely for prestige offices and commissioned a modern design from Rowse.

The new block provided an executive suite in an extension to offices of 1886–88 by J. Medland Taylor. The canteen was built first, followed by the offices, arranged on a horseshoe plan around a central garage. The projecting entrance hall was lined in white glass and the corridors in pink Vitrolite, with glass bricks to maximise borrowed light; balustrading to the staircase included panels of clear Armourplate, another Pilkington product. All this has gone in a conversion to flats after years of dereliction, along with Taylor's block and the canteen, but the exterior remains one of Britain's most impressive essays in the Dudok style, the lofty, asymmetrical staircase tower supporting a clock and flanked by thin piers. The garage has lost its roof of glass lenses.

The son of a builder, Herbert Rowse (1887–1963) was the greatest of the coterie of architects who trained under Charles Reilly at the Liverpool School of Architecture. He practised in Winnipeg in 1913–14 and his early buildings exhibit a mastery of North American classicism, which he brought to his later understanding of the moderne.

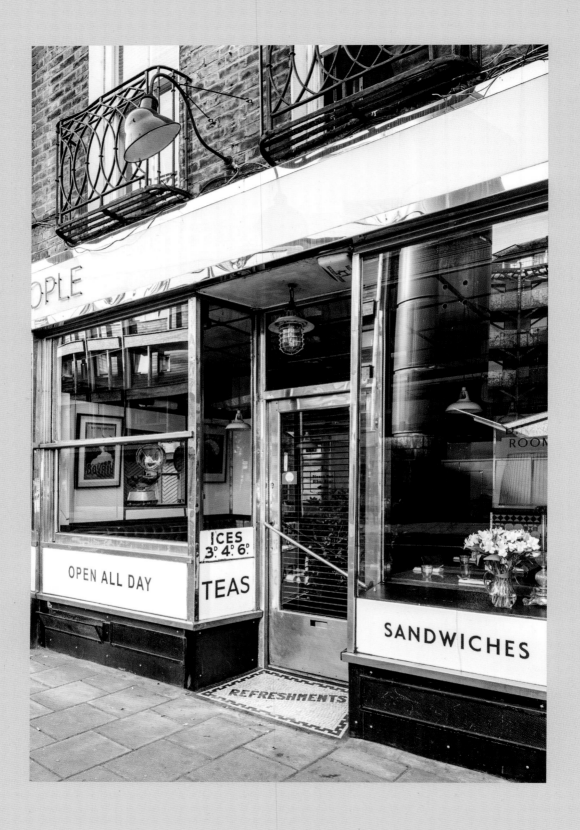

SHOPS, SHOWROOMS AND CAFÉS

THE WOLSELEY

PICCADILLY, LONDON
1921–22; WILLIAM CURTIS GREEN OF DUNN & WATSON
LISTED GRADE II*

Curtis Green acknowledged that his showroom for Wolseley Motors was in the 'Big Bow Wow' style of New York's Charles McKim. He admitted that he had never been to America and had taken the style from books, making the sheer size of his classical orders the overall determinant but detailing them with discipline and some delicacy. The result in 1922 was the inaugural winner of RIBA's bronze medal for 'excellence in design in Street Architecture'. Inside, the elegant vault, based on Brunelleschi's Santo Spirito in Florence, is supported on Tuscan columns (originally lacquered a brilliant red) and the marble floor is patterned in chevrons. Wall panels and wooden screens were finished in black and gold Japonaise lacquer by F. Geere Howard, and the movable furniture was similarly lacquered. The theatrical twin stairs at the rear were embellished with brass handrails. The black Wolseley motors surely looked resplendent in these surroundings.

The Wolseley Motor Car Company had a profitable First World War supplying the British army, and looked to take over the civilian market in peacetime. The company entered cars in races at Brooklands, built a factory in Oxford and opened a garage in the King's Road, in addition to its prestigious Piccadilly showroom. But the company over-reached itself and was declared bankrupt in November 1926. Barclays Bank acquired the showroom as its showcase Piccadilly branch, and Green made alterations without changing the oriental style, even adding some 'real' furniture. In 2000–03 the building was converted again, into a classy restaurant, but with black columns.

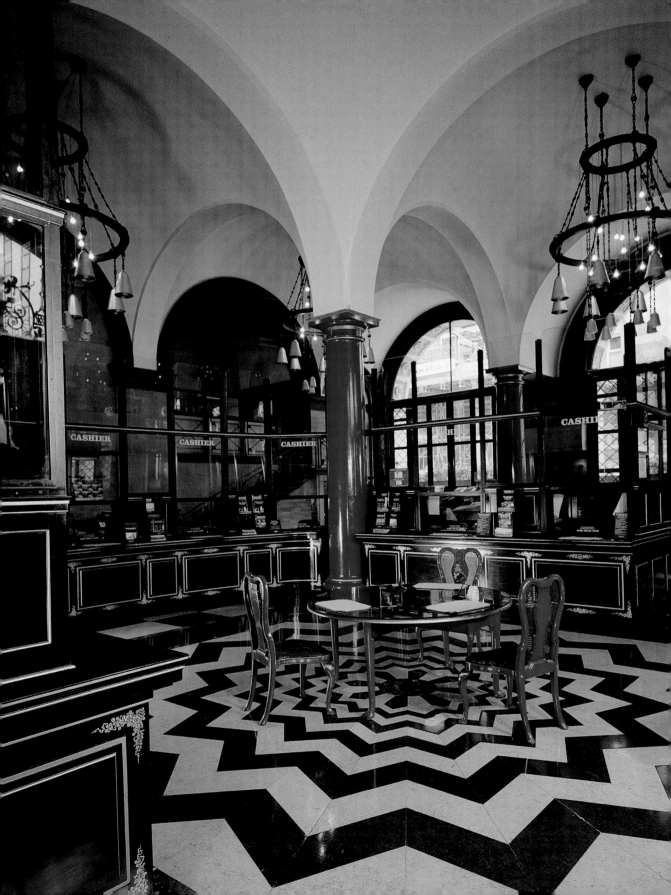

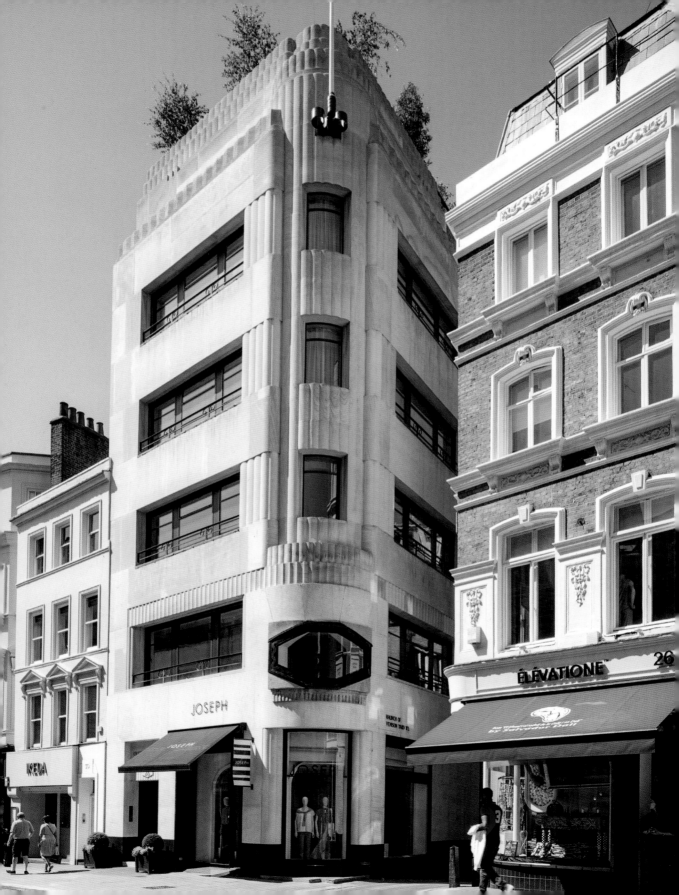

GREYBROOK HOUSE

28 BROOK STREET
1928–29; SIR JOHN BURNET & PARTNERS
LISTED GRADE II

German companies had a bad time in London in the First World War. The piano manufacturers Bechstein, founded by Carl Bechstein in Berlin in 1853, had sold 2,500 pianos a year in Britain before 1914 but even the renaming of their popular recital venue as the inoffensive Wigmore Hall could not save them. The firm was wound up by the Board of Trade, which sold the entire business at auction to Debenhams. Bechstein re-established itself after the war and in 1928 commissioned a new showroom, with practice rooms and offices on the upper floors. In charge of the design was Burnet's partner, Thomas Tait, who had worked in New York and was acquainted with its monumental classicism as well as Art Deco; together with the Royal Masonic Hospital, Greybrook House marked the firm's growing progressive spirit ahead of the restructuring of the firm in 1930.

The building presents only a narrow front to Brook Street, but behind its bull-nosed corner extends down Haunch of Venison Yard. It is the treatment of the corner that is most impressive, with its reeded and fluted panels, a double set-back at the top and an octagonal, eye-like window to the first floor. Inside the staircase and central lift survive; the door to the ground-floor shop has been created from a showroom window.

The upper parts of the building were used as offices for many years, but in 2017 were converted by the residential developers Fenton Whelan into three multi-million pound apartments.

IDEAL HOUSE/
PALLADIUM HOUSE

ARGYLL STREET, LONDON
RAYMOND HOOD AND GORDON JEEVES, 1928–29, EXTENDED 1935
LISTED GRADE II

This is the one European building by Raymond Hood, cleverest of New York's skyscraper architects. Between winning the Chicago Tribune competition in 1922 and his death in 1934 he designed five great skyscrapers and many smaller commissions. Ideal House was a spin-off from Hood's second skyscraper, the American Radiator Building in Manhattan. There, as an experiment in urban colour and to advertise his clients' heating business, he clothed his building in black brick on a granite base with gold trimmings to symbolise coal and flames. The London building, designed as a showroom for the company's British subsidiary, combines Hood's enthusiasm for colour with two other preoccupations – how to handle corner sites and how to finish the tops of modern buildings. As first built, Ideal House was only four windows deep along Argyll Street, producing a square plan that Hood crowned with a recessed storey decorated in oriental motifs. Its impact was lessened when Gordon Jeeves, the architect who had supervised the original building work, added seven further bays along Argyll Street. The main doorway on Argyll Street is now in the Victoria and Albert Museum.

Hood realised that in smoky London town a building of black granite would look striking and be easily washed, and symbolise the firm's promise of clean heat. The critic Trystan Edwards dubbed it 'the Moor of Argyll Street', but although other black buildings followed – including several Burton stores – the presence of a real piece of American Art Deco in London remains underappreciated.

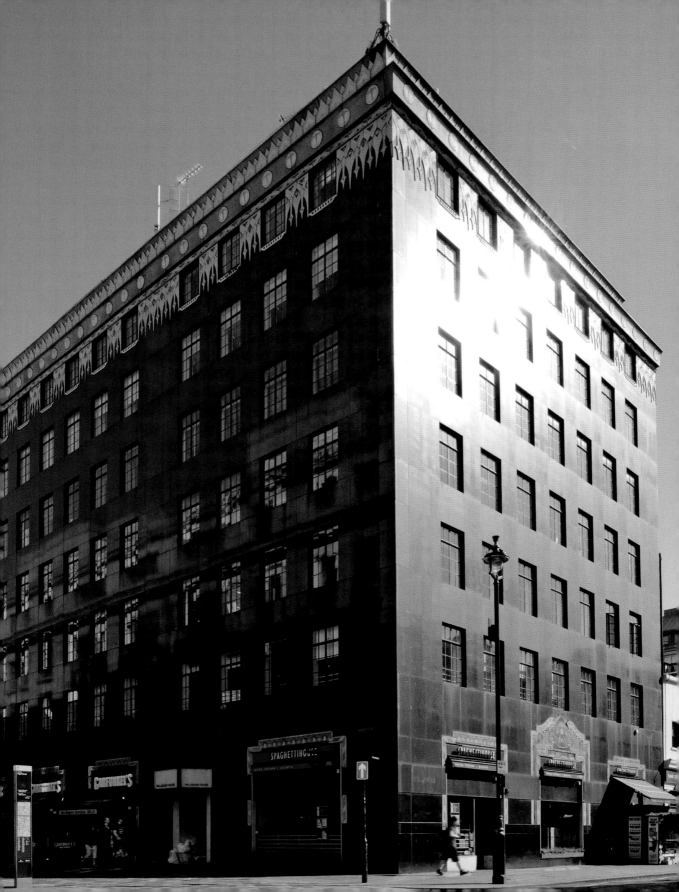

DERRY & TOMS AND BARKERS

KENSINGTON HIGH STREET, LONDON
1929–31, 1937–38 RESPECTIVELY; BERNARD GEORGE
LISTED GRADE II* AND II

The finest Art Deco shopping buildings are not in the West End but in Kensington.
Three great department stores followed the arrival of the Underground in 1868,
first Derry & Toms, then Barkers and Pontings. By 1920 John Barker & Co. owned
all three and in 1928 acquired land to rebuild the two main stores to the designs
of its in-house architect, Bernard George, recommended by Robert Atkinson, an
earlier consultant. Impressed by American stores, Barkers brought in C.A. Wheeler
of Chicago to produce the floor layouts.

Derry & Toms was one of London's first stores planned on the American
'horizontal' system, whereby each floor was open plan. Banks of lifts were faced in
onyx and black marble, with modest escape stairs at the edges. The classical facade
was enlivened with cast aluminium panels by Walter Gilbert and the Bromsgrove
Guild, while C.H. Mabey produced realistic bas reliefs depicting labour and
technology (high up so hard to see). Best of all was the roof garden, aimed to
surpass that at Selfridges and the largest in Europe. Derry & Toms closed in 1973
but the building flowered briefly as Biba, flagship of the 1970s Art Deco revival.

Barkers' own store (now subdivided) demonstrates how architectural fashion
changed in the 1930s. George emphasised the verticality of the stair towers – shafts
of light seen against the curve of the street and contrasted with a continuous
canopy. Cast reliefs included household goods obtainable in the store, a futuristic
jet engine plane, airship and locomotive.

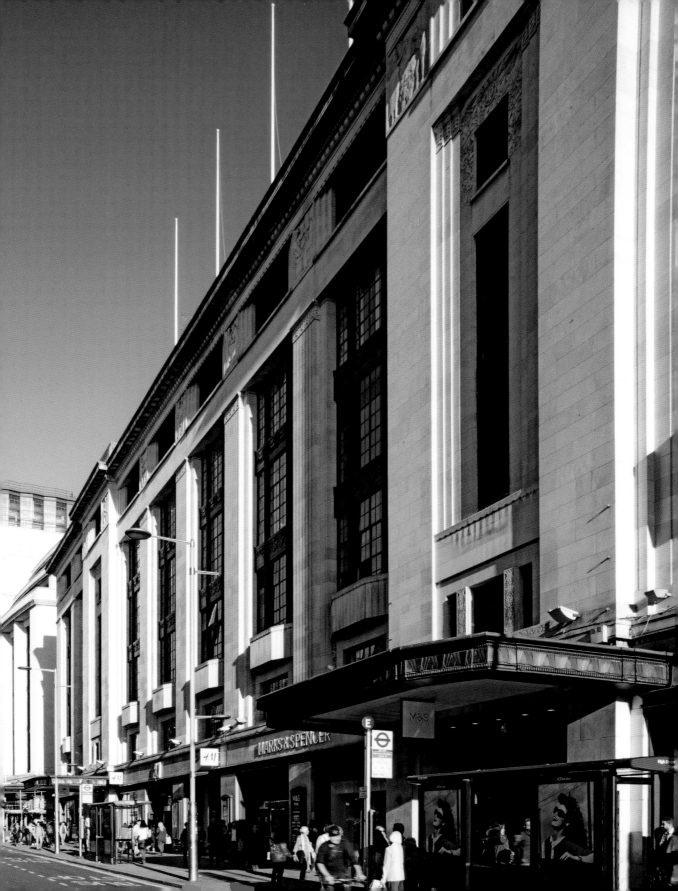

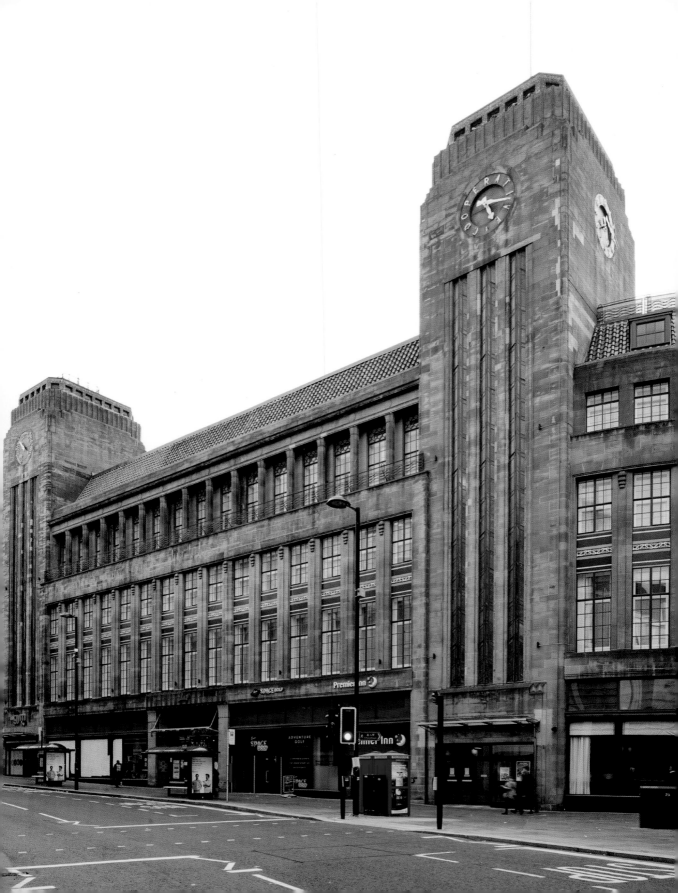

CO-OPERATIVE HOUSE

NEWGATE STREET, NEWCASTLE UPON TYNE
1931–32; LEONARD GRAY EKINS, CO-OPERATIVE WHOLESALE SOCIETY
LISTED GRADE II

There is no grander Co-operative department store than Newcastle's. It is dominated by two tall, glazed staircase towers topped by a barometer and clock, the latter with the letters 'cooperative' for the hours. Inside, the staircase balustrades were supported on a line of cast-metal men (now restored) straining under their weight and murals lined the walls. The General Co-operative Survey Committee, appointed in 1914, recommended the building of department stores and Newcastle's featured a suite of restaurants on the third floor, remodelled in the 1960s as the Rainbow Rooms.

Ekins (1878–1948) was the Co-operative movement's outstanding architect. He joined the Co-operative Wholesale Society in Manchester in 1898 and rose through the Newcastle sub-office to head that for London, the South of England and Wales. In December 1927 the Newcastle Society's finance committee interviewed Townsend Gray, his successor in the North East, then commissioned Ekins to design the central store. He later took Gray on a study tour of Holland and Germany. A three-bay addition matching Ekins's facade was added in 1959.

The Newcastle Society formed in 1860 and opened its first shop on Newgate Street in 1864. Ekins's store is a rebuilding of that of 1870 and retains a rear range from 1902. The store thrived into the 1950s but found itself in the wrong place as Newcastle's shopping district migrated eastwards; the department store closed in 2007 and its ground-floor supermarket in 2010. It was successfully converted into a hotel in 2015–16.

ROGANO

EXCHANGE PLACE, GLASGOW
1935; WEDDELL AND INGLIS
LISTED GRADE B

Rogano's facade is a rare original: primrose Vitrolite with black tiles banded
in chrome, beautiful inset windows in the doorway and a projecting sign lined
in neon. More unusual are the over-scaled lobster above the doorway and tiny
seahorses in the portal windows to the doors. There are cuts in the chrome trim on
the left-hand side where there was a second door for off-sales until the late 1960s,
so the rest is clearly genuine.

Rogano began life as a cheap Spanish wine cellar, opened in 1874 by James
Henry Roger and 'another', his silent partner Mr Anderson. It is set into a
large classical corner building of 1835 by Robert Foote. In 1935 Donald Grant
transformed the joint into an upmarket establishment based on champagne,
cocktails and seafood: the oyster bar had become fashionable in the United States
in the 1890s and – like the architecture – came to Britain via the liners.

The interior remains full of character, despite some remodelling. Its cue was
the RMS *Queen Mary*, launched on the Clyde by John Brown & Co. in 1934. Rogano
used the same dark burr walnut and birdseye maple panelling, most impressive in
the entrance lobby, with intricate plasterwork, peach mirrors and chrome to the
bar and restaurant. Intricately designed ventilator grilles form a frieze. Rogano was
renovated by the successor firm of Weddell and Thomson in the late 1960s. In the
1980s it was bought by Ken McCulloch who, when stripping out asbestos, halved
the size of the bar and increased the restaurant.

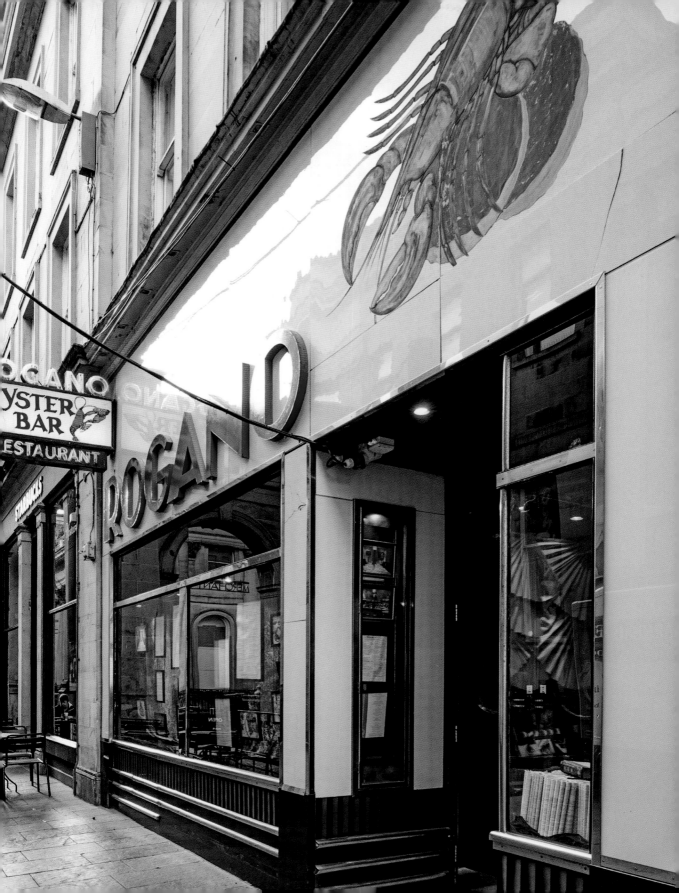

NARDINI'S

Nelson Street, Largs, North Ayrshire
1935; C. Davidson & Sons
Listed grade B

Nardini's is an iconic ice-cream emporium, its long 'Snowcrete' frontage visible from the daytripping steamers chugging 'doon the watter' from Glasgow. The interior has been remodelled but the vintage Lloyd Loom furniture gives just the right touch of authenticity and style.

Peter Nardini arrived in Scotland from Barga, Tuscany in 1890, and worked as a travelling salesman before running a fish and chip shop in Paisley with his wife Rosa. In 1931 they opened a second shop in Largs, run with their sons Sandrino, Nardino and Augusto. When, in 1934, a villa came up for sale on the seafront, Augusto saw the potential. He replaced it with a café and restaurant, bringing in architects from Paisley, where Charles Davidson had launched a successful practice designing commercial buildings and schools c.1880 that was continued by his two sons after 1925. The local paper reported 'an air of comfort and luxury', enhanced in the restaurant by a six-piece orchestra. A feature was a £300 soda fountain from the United States.

The restaurant was extended in 1950, and for two decades Nardini's thrived on frothy coffee and Knickerbocker Glories. Nardino's son Aldo opened an ice-cream plant at the rear in 1974, when he also remodelled the café entrance. But the family feuded and profits declined, and in 2004 Giuseppe Marini and David Equi, Scottish businessmen of Italian descent, formed a consortium to buy and restore Nardini's, reopening it in December 2008 thanks to building flats on the rear of the site.

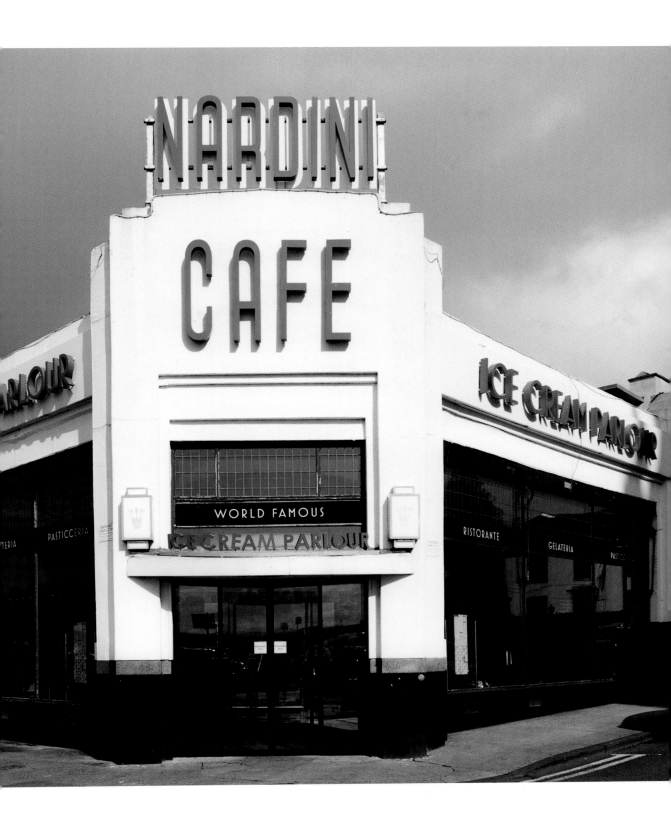

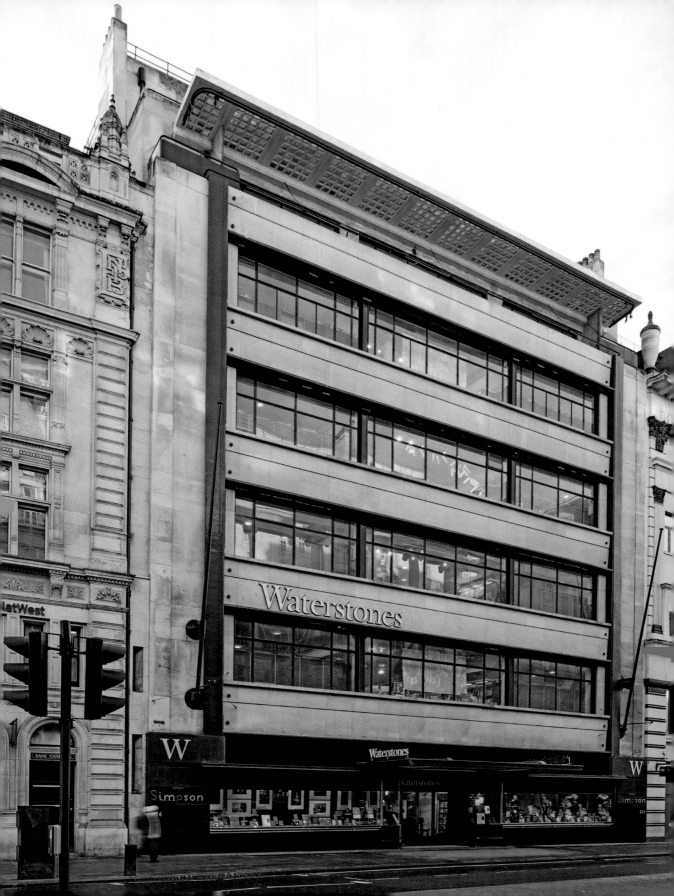

SIMPSON'S/ WATERSTONES PICCADILLY

203–206 PICCADILLY, LONDON
1935–36, JOSEPH EMBERTON
LISTED GRADE II*

So innovative is Simpson's that modernist purists have claimed it as their own, yet it is more decorative than they admit.

Simeon Simpson began tailoring in the 1890s, and his son Alexander made a fortune with DAKS casual trousers that were the first to require neither a belt nor braces. He commissioned a flagship store close to Savile Row and his rivals in readymade clothing, Austin Reed, already employers of Emberton.

Simpson's sophistication begins with its steel frame, designed by the émigré engineer Felix Samuely as London's first entirely welded structure before the LCC demanded extra supports. The elevations, to Jermyn Street as well as Piccadilly, are seemingly simple bands of Portland stone and glass, but each band has slight angles, slopes and set-backs to give shadows by day, and bronze troughs that conceal tubes of red neon, green and blue to floodlight the building by night. The ground floor has set back clerestories and deeply concave showcase windows so there is no reflection to distract the would-be shopper from the display. Ashley Havinden designed the original Simpson Piccadilly signage with one enlarged letter 'P' shared by both words.

Samuely's frame made the interiors exceptionally open for their day, enhanced by floors of travertine marble. Against the west wall is the gracious staircase, fully lined in ribbed, opaque glass, with rough-cast plate glass balustrading secured by aluminium balusters and surmounted by a handrail of orange vermillion.

Waterstones bought the premises in 1999 to become their flagship store.

BURTON TAILORS

WHITEFRIARGATE, HULL
1935–38; HARRY WILSON, BURTON'S ARCHITECT'S DEPARTMENT
LISTED GRADE II

No chain store in the 1930s produced such distinctive architecture as Burton's, the 'tailors of taste'. Wilson was the firm's architect from 1923, and headed its own architect's department by 1932, to be succeeded by Nathaniel Martin c.1937. Their buildings are distinctive for their simple capitals, with zigzag, shell or divider motifs in the spandrels between the upper windows. The buildings were usually clad in stone or render, but the most stylish featured black emerald granite, as at Hull where it is teamed with gold metalwork and balconettes. Black granite plinths incorporated at least one commemorative foundation stone laid by a member of the large Burton family. The mosaic pavement on one corner of the Hull store still begs 'Let Burton Dress You'. The most complete surviving facade until its closure in 2015 was at Abergavenny, featuring a 'chain of taste' – linked lozenge glazing panels featuring the names of major towns with a Burton's store. The shops carried little stock so could let their upper floors as offices (as at Hull) or as billiard halls – encouraged to attract passing trade and as a good temperance pursuit.

Between the 1920s and 1960s Burton was the leading high street tailor, offering bespoke suits manufactured in huge Leeds workshops. Meshe David Osinsky (1885–1952) arrived from Lithuania in 1900, renamed himself Maurice (later Montague) Burton and in 1903 opened a gentleman's outfitters in Chesterfield. Boosted by contracts for uniforms in the First World War, by 1929 he had 364 shops and an efficient publicity machine.

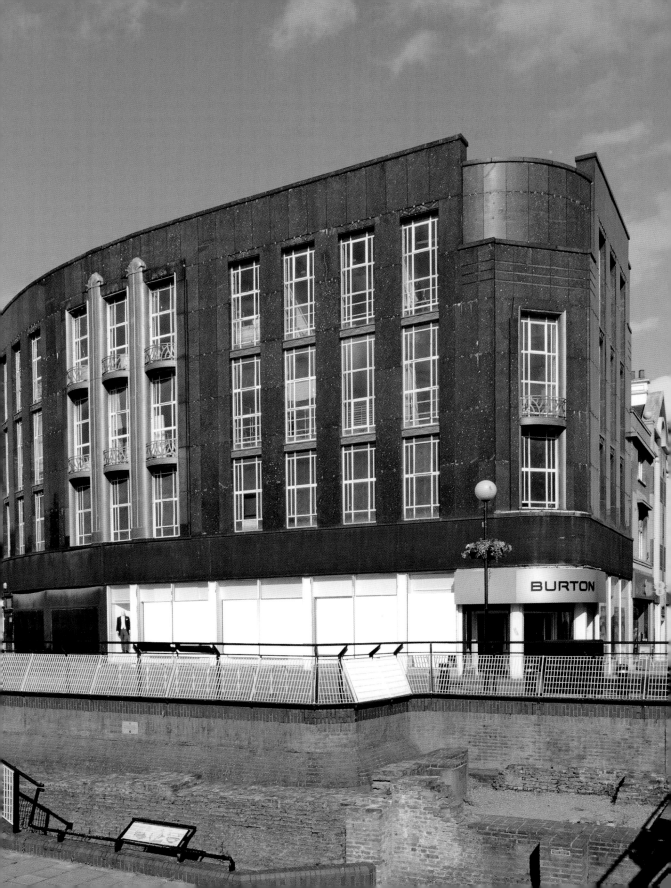

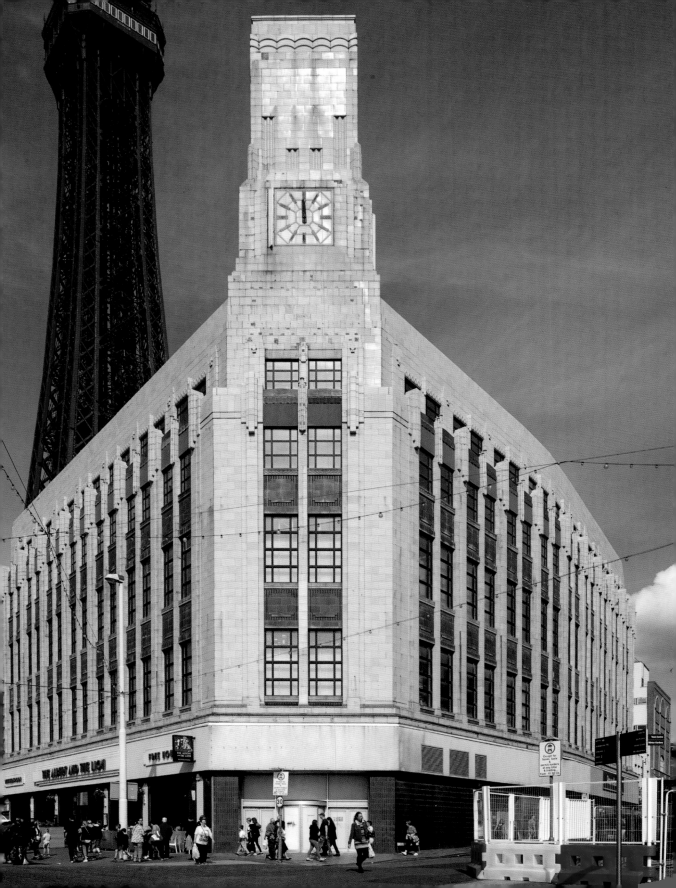

WOOLWORTH'S/ ALBERT AND THE LION

PROMENADE/BANK HEY STREET, BLACKPOOL
1936–38, WILLIAM L. SWINNERTON, CONSTRUCTION SUPERVISOR

Woolworth's was the most successful American company to use that country's sales techniques to push cheap household goods across Britain. It opened its first shop here in Liverpool in 1909. All goods in Woolworth's sold for 6d or less until the 1950s, while in the 1930s and 1940s its restaurants (opened in Britain ahead of America) offered main courses for 6d and a full meal for two shillings (10p).

In 1916 Woolworth's opened its 66th British store in Blackpool, close to the Tower. It was rebuilt in 1926 and again in 1936, when it absorbed the Royal Hotel on the key corner site next door to create the world's biggest Woolworth's. It boasted three large sales floors, two thousand-seat cafeterias finished in pastel green and primrose Vitrolite and a second-floor restaurant. On the fourth floor were separate staff dining rooms, and hidden on the roof was the store's own bakery. The exterior featured cream faience bricks from Darwen, Lancashire, formed into fluted piers. The ventilation shaft that dominates the composition became a stepped clock tower and an advertisement for the cafeterias. Long counters were piled with goods – chocolates next to china and displays of lampshades. Only old photographs show how richly decorated was the building, from the complex curving of the shopfronts, which featured a 'W' motif, to little cigarette kiosks by the main doors.

Woolworth's sold the store in 1983 and the stripped-out interior became a Wetherspoons pub, named after Stanley Holloway's comic monologue which references the Woolworth's store.

RANDALLS DEPARTMENT STORE

VINE STREET, UXBRIDGE
1937–38; WILLIAM L. EVES
LISTED GRADE II

The furniture store was a 1930s' phenomenon, built to serve the thousands of new homes being flung up across London's Metroland. The development of hire purchase, whereby people could buy furniture and larger appliances over weeks or months, brought larger and more luxurious items within the means of those residents in steady employment. Most surviving 1930s buildings in the High Street were built for entertainment; this is a rare indicator of changing lifestyles in the home as well. Randalls opened their first shop in 1891 and expanded in 1937–38 to meet the growing market. Furniture stores tended to occupy the cheaper sites on the edge of town centres, where they advertised their presence with large shop windows and neon displays, as here. Randalls was long a rare, almost perfect survivor, designed by a little-known architect who nevertheless had sufficient flair to make the architectural press.

William Eves's style is derived from that of Willem Dudok, its constructivist planes tempered by tasteful lettering and – originally – a large projecting clock. For his facade he chose faience, supplied by Doultons, long manufacturers of London's drainpipes but by the 1930s specialising in Carrara Ware – a hard, smooth surface available in a variety of creams, browns and black. The combination is used very effectively here, contrasted with red lettering and glass lenses that allow light to penetrate the broad, stepped canopy. Sir John Randall finally closed the family store in January 2015, and a mixed retail and housing scheme of conversion was approved in 2017.

CO-OPERATIVE EMPORIUM/ DANUM HOUSE

St Sepulchre Gate, Doncaster
1938–40; T.H. Johnson & Son
Listed grade II

Doncaster has the most strikingly moderne Co-operative department store. It was designed not by an in-house Co-operative architect but by a young local man, Henry Arthur Johnson. He studied at the Bartlett School of Architecture in London before working for his father and then with his friend William Crabtree – also from Doncaster and architect of London's truly modern Peter Jones store. Johnson's store is best seen head on, where it appears entirely symmetrical around its staircase tower, and he acknowledged the influence of Mendelsohn's blocky Columbushaus (rather than the go-faster asymmetrical lines of his earlier department stores) and Peter Jones. The facades feature blue and black Vitrolite with glass and faience from Shaws of Darwen, all on a steel frame.

The Doncaster Mutual Co-operative and Industrial Society began in 1867 and opened its first shop in 1869. Its fortunes suffered in the 1920s under the impact of the miners' strike, but revived thanks to hire purchase and a recruitment drive for members – in which the new emporium played a part. However, only the ground floor opened in December 1940, after German steel was substituted by material from Dorman Long of Middlesbrough; timber veneers remained unavailable. There was a basement air-raid shelter, and Johnson assured the Co-operative Society that the structural design was equal to buildings that had withstood air attacks in Barcelona. Later the upper floors sold ladies' fashions and furniture, with a restaurant and dance hall on the third floor, where the Beatles played in 1962. These floors were converted into flats in 2017–18.

KENDAL MILNE & CO./ HOUSE OF FRASER

98–116 Deansgate, Manchester
1939–40; Louis David Blanc and John S. Beaumont
Listed grade II

Kendal Milne's facade is monumental and stark. Louis Blanc was a specialist store designer and realised that windows on the upper floors only detracted from the sales displays by casting them into shadow. So he put all five upper storeys into a single steel-framed composition that balances vertical bands of dark glazing with full-height ribs and mullions of Portland stone (a light colour for Manchester) that ripple light and shade across the main facade – architecture at its most elemental. Chamfered corners repeat these motifs with little more than canopies and columns to denote the entrances.

Kendal Milne originated in a small draper's store founded in 1796, which was taken over by Thomas Kendal, James Milne and Adam Faulkner in 1836 and expanded rapidly on both sides of Deansgate. On the east side of Deansgate there survives an earlier Kendal's store of 1872–73 by E.J. Thompson, which was refurbished before the decision was made to totally rebuild the holdings across the road. Blanc (1877–1944) was Harrods's in-house architect, responsible for their D.H. Evans store in London's Oxford Street (which has the ingredients of Kendal's but is less refined) and Swan and Edgar's at Piccadilly Circus, as well as Stuttaford's in Cape Town. Beaumont provided local supervision and took most of the credit.

Kendal Milne was taken over by Harrods in 1919 and thence by House of Fraser in 1959, though it retained its traditional name until 2005. It was saved from closure in late 2018.

E. PELLICCI CAFÉ

332 Bethnal Green Road, London
1946; Achille Capocci
Listed grade II

Bolotonno Fabrizi acquired a confectioners' shop here in 1908, and passed it to the Pellicci family in 1915. Mrs Elide Pellicci turned it into a café in 1939, but the new facade of lemon yellow Vitrolite and a claustrophobically small yet jazzy interior – its walls featuring cocktail shaker-shapes in panels of contrasting marquetry – are said by her family to date only from 1946. They were installed by another member of the local Italian community (perhaps even a relation), Achille Capocci.

The years immediately after the Second World War were the heyday of the Italian café, particularly in London, where it offered a way of stretching limited rations (controls continued until 1954). The need for renovation on hygiene grounds cut through restrictions on new building, although the chromium signage is later. The tiny café, now run by Elide's son Nevio, is encrusted with many generations of family photos and international awards.

While Alfredo's (see page 138) has changed hands, the Pellicci's family business lives on. Their café is an oddity, lying on the cusp between Art Deco and the post-war world of Formica, which first appeared in Britain when it was used on the RMS *Queen Mary* in 1934, and the Gaggia espresso machine introduced to London in 1952.

ALFREDO'S CAFÉ/
MEAT PEOPLE

4–6 ESSEX ROAD, ISLINGTON, LONDON
1933, 1949; DESIGNER NOT KNOWN
LISTED GRADE II

Alfredo's was founded by Vincent de Ritus and taken over in 1920 by his son, actually Alfonso – but he thought Alfredo sounded better. He was born in London to Italian parents, at a time when many Italian families were migrating to London to open cafés, supported by the wholesalers who settled centrally around St Peter's Italian Church in Holborn. Alfonso linked two shops on the ground floor of an early 19th-century terrace, itself remodelled in 1933.

Cafés enjoyed a revival after the Second World War, when they helped stretch out rations, and Vitrolite and chromium were among the few materials readily available for refurbishments. The menu is immortalised in the panels beneath the chromium-framed windows, ranging from 'breakfasts' and 'snacks' to 'teas', 'ices' and 'sandwiches'; Alfonso made his own ice-cream in premises across the road. Vitrolite panels edged in chrome, interspersed with mirrors, also survive inside while the ceiling has Vitrolite panels framed in wood.

Pigmented structural glass was developed c.1900 by the Marietta Manufacturing Company of Indianapolis and in 1916 by the Vitrolite Company, which gave its name to the product manufactured in Britain under licence by Pilkington's between 1932 and 1968.

Alfredo's featured in the film *Quadrophenia* and regularly appears on television. It closed in 2000 but reopened as the more upmarket S&M Café in 2003 and as Meat People since 2012. A bar has been added but above dado height the fittings remain largely original.

HOTELS AND PUBLIC HOUSES

PARK LANE HOTEL/ SHERATON GRAND HOTEL PARK LANE

PICCADILLY, LONDON
1925–31; KENNETH ANNS AND HENRY TANNER JNR
LISTED GRADE II

The Park Lane Hotel contains the best Art Deco ballroom in London, behind a disarmingly quiet facade. Henry Tanner made his reputation with government buildings and the plainer parts of Regent Street, a safe rather than spectacular architect. The main hotel has its Oak Room and Palm Court, and incorporates *boiseries* in Louis XV style made for Pierpont Morgan's house in Princes Gate, Kensington, in 1904 as well as an original cocktail bar. Underlying it all is a steel frame erected in 1913–14 but abandoned for a decade when the original developer Sir Richard Sutton was killed in the war. When construction recommenced for a Yorkshire entrepreneur, it became the first hotel in London to have an en-suite bathroom in every bedroom.

The ballroom is part of the original building, but it is entered from the addition made to the east in 1930–31 on the site of the Savile Club. Submerged in a basement, it was described by the art historian Dan Klein as 'Hollywood spectacular' for its giant chandeliers, uplighters and peach-tinted mirrors – a night architecture designed to show the debutante at her most elegant. Finest of all is the ballroom foyer or 'Silver Gallery', so-called for its walls of silver leaf lacquered with gold contrasted with Swedish green marble and stained sycamore. Fountains of light froth from silver piers and on the staircases a Miss Gilbert painted murals depicting décolleté nymphs and classical figures in silvery pastel tones.

The Twentieth Century Society began here (as the Thirties Society) in 1979.

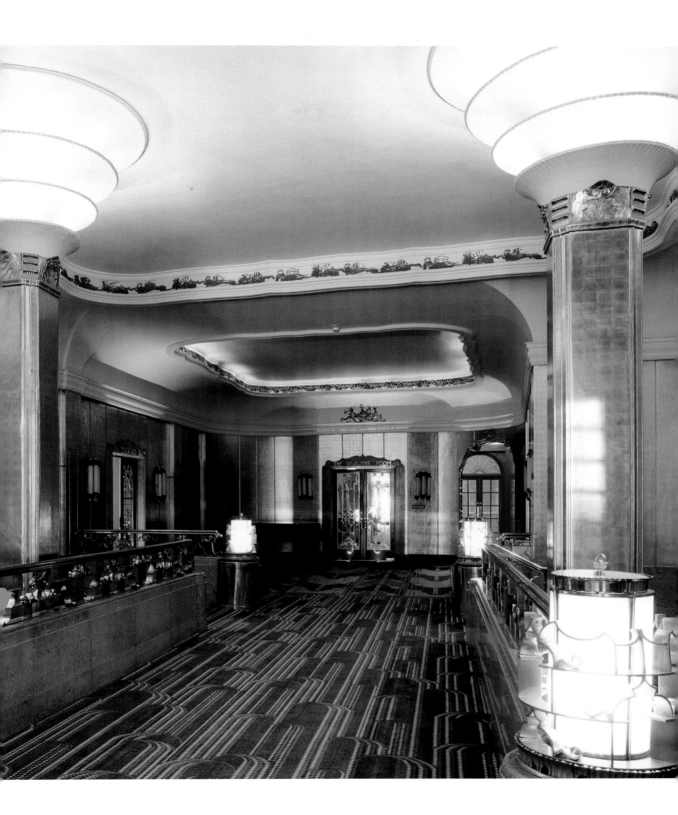

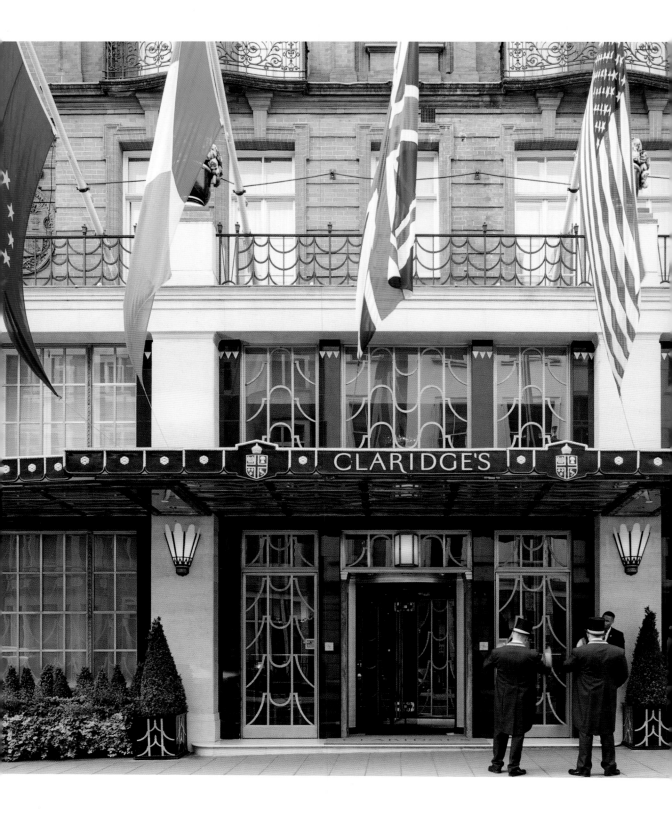

CLARIDGE'S

**45–57 (ODD) BROOK STREET, WESTMINSTER, LONDON
1894–98; C.W. STEPHENS;
1926, BASIL IONIDES; 1929–31, OSWALD P. MILNE
LISTED GRADE II**

Ionides and Milne were the two greatest designers of luxury West End interiors and both worked at Claridge's. The luxury hotel still symbolises the elegance of 1930s Mayfair, but their work is now subsumed beneath the greater opulence and soft furnishings of modern decorators' deco.

James Edward Mivart developed a fashionable hotel here in 1812, which he sold to his neighbours William and Marianne Claridge in 1854. Richard D'Oyly Carte and Cesar Ritz bought it in 1892 to rescue it from bankruptcy and in 1894–98 rebuilt it to the designs of C.W. Stephens, later to design Harrods, with interiors by Ernest George and Yeates. Their staircase survives.

Ionides introduced the Art Deco style when he remodelled the corridor serving the side entrance in Davies Street and the adjoining restaurant, replacing George and Yeates's panelling with engraved glass panels and light fittings in the shape of elephants surmounted by pagodas.

In 1929 Milne replaced an awkward *porte cochère* with a new main entrance, its stone framework topped by painted urns and infilled with chevron glass in black surrounds. He transformed the foyer and remodelled the restaurant again, putting in piers and lighting but retaining Ionides's glass screens, today to be found in the Reading Room. In 1930–1 he added an extension to the east, with its own entrance leading to three ballrooms at the rear, and new suites on top.

The most convincing of the new interiors is perhaps David Collins's Art Deco bar of 1998.

BURGH ISLAND HOTEL

BURGH ISLAND, BIGBURY-ON-SEA, DEVON
1929, MATTHEW DAWSON; 1931–32, WILLIAM ROSEVEARE
LISTED GRADE II

Burgh Island lies 250m (270 yards) from Bigbury-on-Sea, accessible from the mainland by a causeway at low tide and now also by sea tractor. The music-hall artist George H. Chirgwin had built a wooden house for weekend parties in the 1890s, which in 1927 was bought by Archibald Nettlefold, an impresario who had forsaken engineering for a career in filmmaking and the theatre. He mixed with the rich and famous, yet his architect best friend was a lecturer at the Bartlett and Cambridge schools and a designer of minor Hampstead houses.

Dawson produced the first British attempt at the 'ocean liner' style of architecture so appropriate for seaside hotels. The sturdy four-storey concrete frame suggests this could have been a rational modern design, yet there is a random quality to the steel windows and long balconies and a jauntiness to its central copper cupola. The frame is visible through the building, supporting vertical radiators and lighting sconces but softened by built-in fittings, murals (repainted) and colourful fabrics. Fragments from the captain's cabin of HMS *Ganges*, built in 1821 and the last sailing ship to serve as a flagship of the Royal Navy, were incorporated into a protruding addition after being broken up at Plymouth in 1930. This may have introduced Nettlefold to a young Plymouth architect, Roseveare, who added a more rational wing – replete with peach glass mirrors, concealed lighting troughs and a staircase to the restaurant of black Vitrolite – and a palm court, its cupola featuring peacock decoration.

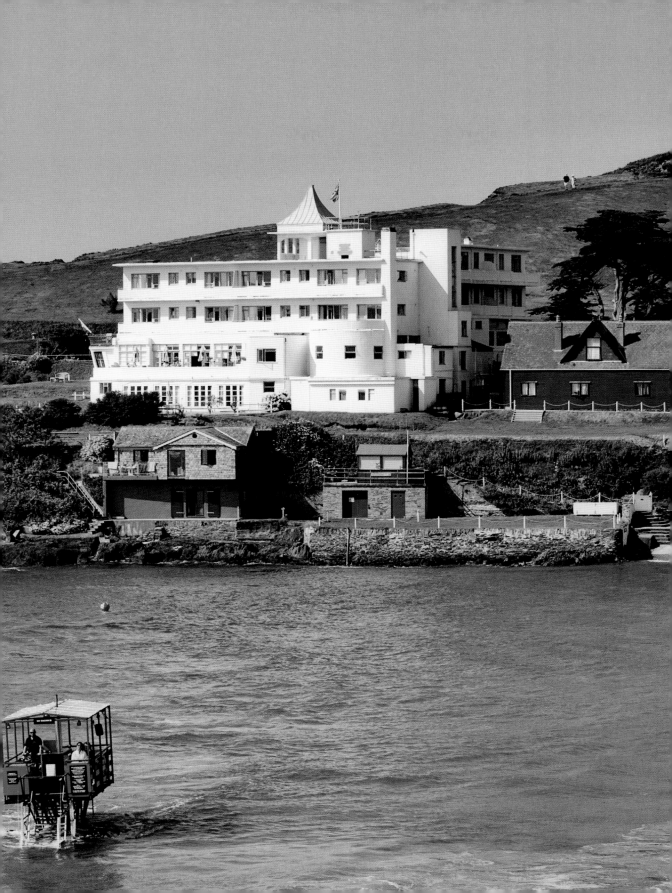

THE KING AND QUEEN

14–16 MARLBOROUGH PLACE, BRIGHTON
1931–32; CLAYTON & BLACK
LISTED GRADE II

Converted in 1779 from a rambling farmhouse and named in commemoration of George III and Queen Charlotte, the pub was given a Georgian guise to blend into the new Brighton growing up around it.

Not so in 1931. When the pub was rebuilt it was as a vision of Merrie England more akin to the movies than real history, a reminder that the nooks and byways of historicist revivals extended across Art Deco down the cul-de-sac of Mock Tudor. The date on the rainwater head (1931) belies any medieval reality. The King and Queen does its half-timbering and painted pargetting with infinitely greater relish than in the Middle Ages, commemorating Henry VIII and Anne Boleyn as most befitting the era of Errol Flynn, if inside the giant fireplaces, panelling and balustrading are 17th-century in style. The interior designer Ashby Tabb of Heaton Tabb & Co. added stained glass – including a Spenserian knight, and a barrel-vaulted wooden ceiling to the first-floor 'children's room', now a general function space. The *Brighton Herald* declared it 'something more than a handsome, spacious building ... it is a gorgeous flight of architectural imagination'.

Such was the pub's success that Clayton & Black added a simpler, two-storey wing to the north in 1935–36. The 1930s pub had three interiors, with heavy trestle tables and settles, but in 1967 they were thrown into a single baronial hall, when the staircase was remodelled and the balcony glazed. The effect, albeit different, remains impressive under a later layer of sports regalia.

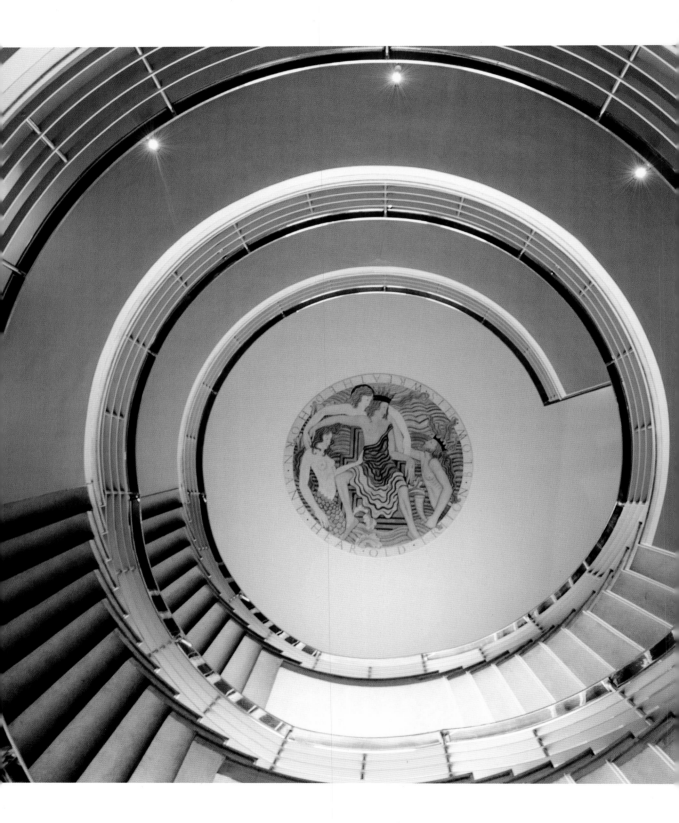

MIDLAND HOTEL

MARINE ROAD CENTRAL, MORECAMBE, LANCASHIRE
1932–33; OLIVER HILL
LISTED GRADE II*

The Midland was built by the London, Midland and Scottish Railway's hotel chain, replacing an 1848 hotel and intended to revive its interests in Morecambe by attracting a young clientele. William Towle had commissioned several modern hotels for the Midland Railway before 1914; now his son Arthur proposed Oliver Hill, an enthusiast for swimming and nude sunbathing who had embraced a lively modernism after visiting the Stockholm Exhibition of 1930.

Hill was no structural expert, and his modernism exudes a flashy showmanship befitting the seaside. The hotel curves towards the sea, with a separately curved end tea pavilion. Emulating Sweden, it is filled with art. Eric Gill modelled two seahorses resembling Morecambe shrimps over the central convex entrance, and inside added a mammoth stone relief of *Odysseus Welcomed from the Sea by Nausicaa*. He also designed a ceiling plaster relief over the circular staircase behind the entrance and a decorative wall map of Lancashire, painted by his son-in-law, Denis Tegetmeier. A mural by Eric Ravilious in the tea pavilion rapidly deteriorated because of damp. Hill meanwhile took responsibility for every detail of the furniture and fittings.

The hotel declined after the war, its fate mirroring that of the resort. *Odysseus* went missing after being lent to the Gill Exhibition at the Barbican in 1998, to be recovered only as the building closed and fell into dereliction. The building was restored in 2005–08 by Urban Splash, but with a set-back, glazed storey added to the roof and sun lounge to the sea frontage.

SAUNTON SANDS HOTEL

SAUNTON SANDS, NORTH DEVON
1933–36; ALWYN UNDERWOOD

Saunton Sands Hotel has only the simplest moderne features in its centrepiece and balconies; any internal features are long gone. But its location bestriding the cliff top, like a beached liner above the rolling breakers and acres of sand dunes, is a superb reminder that England's love of the seaside extended across the social classes. The motor car opened up new parts of the coast to more affluent vacationers, although Saunton was then also served by a railway station at adjoining Braunton. The empty expanse of Saunton Sands starred in the opening sequence in Powell and Pressburger's *A Matter of Life and Death* (1946) and many subsequent dramas.

The development of Saunton as a resort began with Augustus Langham Christie, owner of Tapeley Park near Bideford and Glyndebourne in Sussex. Following the arrival of the railway at Braunton he built the clifftop road, a small hotel and a few villas for summer letting, designed using Sussex tile-hanging. A golf course followed in 1897. His son John, bringer of opera to Glyndebourne, first expanded the golf course and then extended the hotel to the designs of another Sussex architect, intending it as the focus of a new holiday village. The public rooms always have had a seaside simplicity. In the Second World War the hotel was camouflaged in green paint and lent to the Duke of York's Military School, evacuated from Dover. Percy Brend, a local butcher turned hotelier, bought Saunton Sands Hotel in 1977 to become the flagship of a small chain.

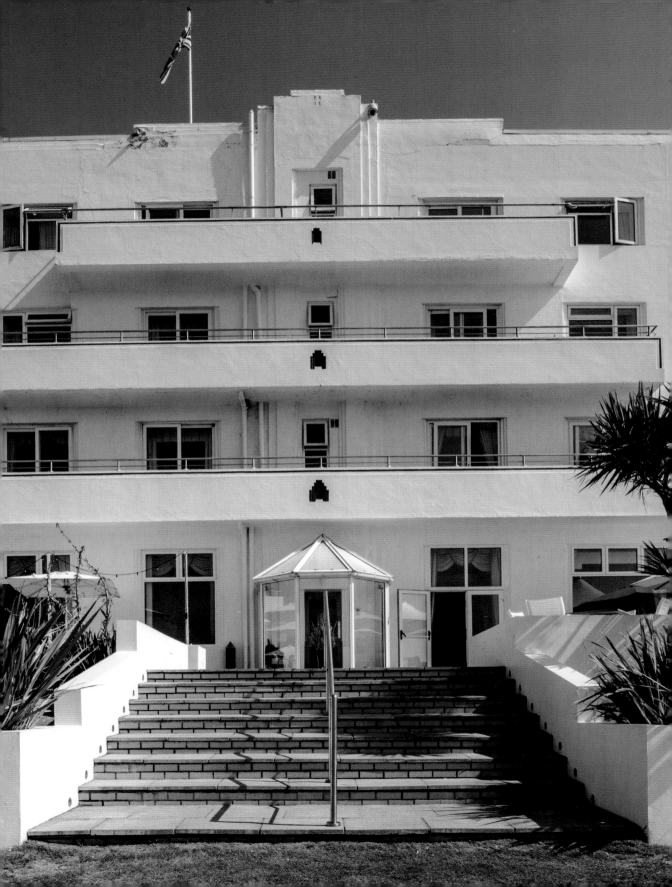

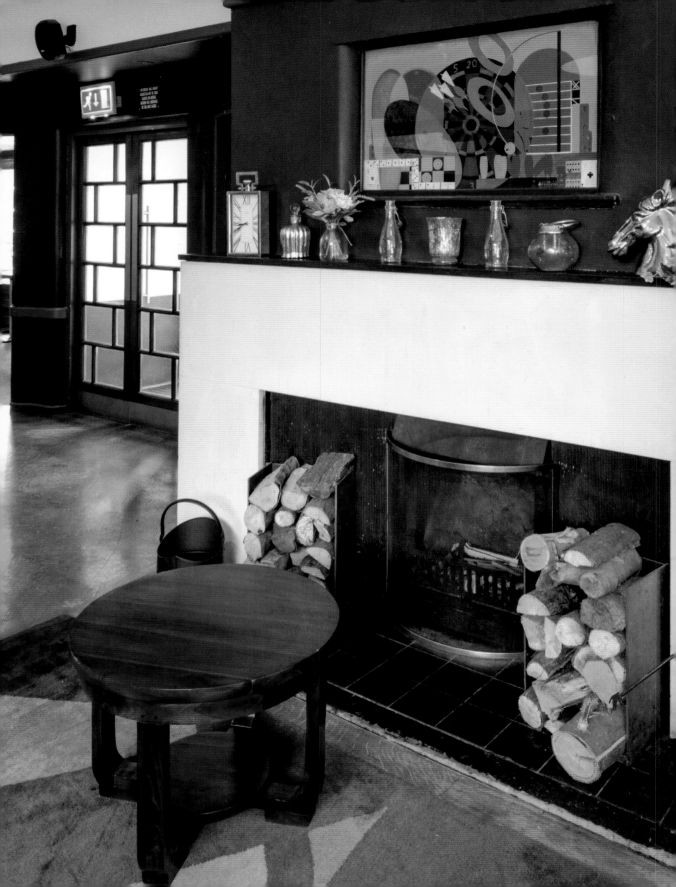

NAG'S HEAD

Dunmow Road, Bishop's Stortford
1934; Ernest Brander Musman
Listed grade II

E.B. Musman (1888–1972) is the doyen of interwar pub design, adept in designing in both traditional and moderne styles. Sadly, his two moderne masterpieces, the Nag's Head and the Comet at Hatfield (1934–36), are not as they were. The sleek lines of the Nag's Head survive, with its original windows and curved prows to the former public bar (on the left) and the longer lounge (to the right) each with their own entrances. Inside, as is common, the lounge, private bar and public bars have been thrown together, while the former off-sales behind the central entrance is now a snug and occasional servery. However, details like the fine fireplaces – one with a frieze by Cosmo Clark depicting pub games – survive amid new furniture and vivid carpets introduced in a well-meaning refurbishment in 2010. In a relief by Eric Kennington (1888–1960) over the central entrance, which celebrates the town's Anglo-Saxon origins, King John clutches a trowel and mallet bearing Kennington's own initials.

Musman followed his success at Bishop's Stortford with the still more modern Comet, Hatfield, named after De Havilland's Comet, winner of the 1934 England–Australia air race. The aeroplane featured in Kennington's most distinctive sculpture, set on a high plinth carved with more reliefs, which is in storage. The pub also has two curved wings like an aeroplane. Hotel facilities were added to the rear in the 1980s and in 2019 the building is being adapted into a hub serving new student accommodation. Quite how much of the interior survives is uncertain.

REGENT PALACE HOTEL/ BRASSERIE ZÉDEL

SHERWOOD STREET, WESTMINSTER, LONDON
1912–15, W.J. ANCELL, F.J. WILLS AND HENRY TANNER JR;
1934–36, F.J. WILLS AND OLIVER BERNARD;
1994, DAVID CONNOR
LISTED GRADE II

Oliver Bernard (1881–1939) worked as a theatre designer before producing ceramics for Joseph Lyons. His skill as a muralist led him to be appointed technical director of the British Pavilion at the 1925 Paris Exhibition, putting him at the heart of Art Deco. Lyons employed him to remodel the entrance to his Strand Palace Hotel in 1929, fragments of which are now at the Victoria and Albert Museum. His less well-known work at the Regent Palace survives, described by *Building* in May 1935 as 'just a trifle dissipated and naughty, but not sufficiently so to be vulgar'.

J. Lyons, remembered for his 'corner house' tea shops, built two hotels in London. At the Regent Palace, Bernard remodelled the ground-floor coffee room and added a suite of basement bars and restaurants, now part of Brasserie Zédel's bar and restaurant. He transformed the basement billiard room into the circular Chez Cup Bar (the pun dates from 1935), re-created by Connor in 1994 save for the original floor of radial wood blocks. The smoking room, now Bar Américain, is a beautifully preserved original. Its thick columns, topped with capitals formed of three layers of ribbed glass, frame a central coved ceiling inset with a continuous light fitting; even the ventilation extracts are treated as part of the architecture within the cornice. Banded birch decoration continues into the high foyer area, which also features travertine marble and the box lighting that was such a feature of Bernard's work, as well as renewed murals and the *de rigeur* chandelier.

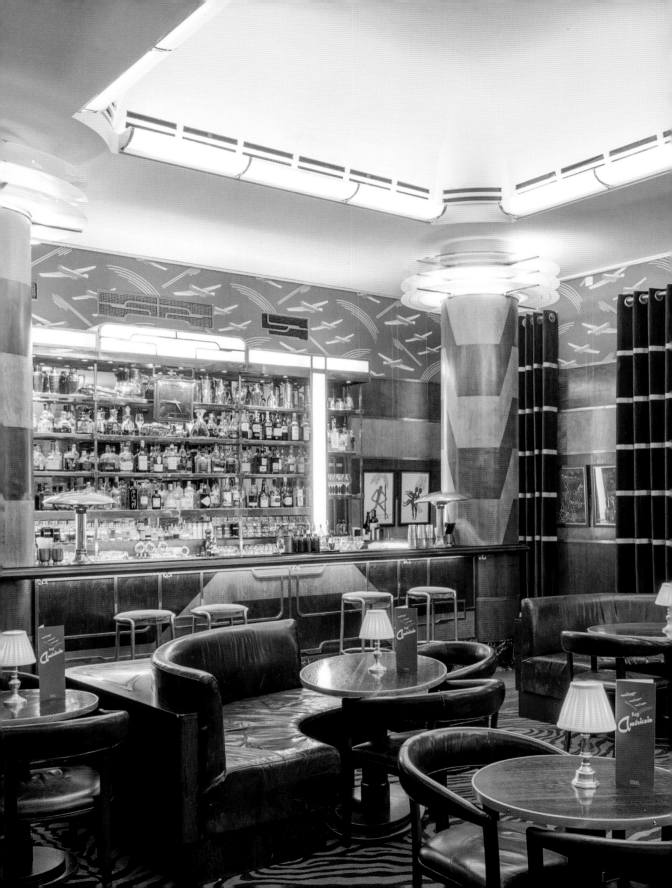

THREE MAGPIES

SHIRLEY ROAD, HALL GREEN, BIRMINGHAM
1935; EDWIN F. REYNOLDS OF WOOD, KENDRICK & REYNOLDS
LISTED GRADE II

Birmingham's licensing magistrates were powerful, and dedicated to ridding their city of the worst vices associated with drinking. In 1904 they pioneered the concept of 'surrender', whereby licences were transferred from crowded central areas to new pubs in the growing suburbs. The brewers, led by Mitchells and Butlers, got one very large pub on a prominent main road in return for giving up licences on several back-street dives. Birmingham remains the place to see these 'reformed' public houses, their long open bars designed for easy supervision and offering alternatives to discourage standing and drinking that included fine restaurants, function rooms and bowling greens.

The most famous of these pubs is the mock-Tudor Black Horse at Northfield. More unusual is the Three Magpies, because it is moderne and survives complete with its bowling green and pavilion. It was all realised in the style of Willem Dudok – the pub could be mistaken for a Middlesex school or library – with a main square end, decorative brick parapets and a tall fin making it visible well down the Shirley Road. There is a smoking room, assembly hall and an off-sales counter, each denoted by its own double doors, with curved windows to the main lounge. A roof garden (long disused) has its own external stair.

Reynolds was a serious architect of churches and public buildings, but had fun here. He also designed a sister pub nearby, The Baldwin in Baldwins Lane, in 1937, with a more prominent tower and curved end.

BLUE PETER

SHARDLOW ROAD, ALVESTON, DERBY
1935; BROWNING & HAYES

The Blue Peter was one of three near-identical pubs built in 1935–36 on a 'blue' theme for Offiler's Brewery of Derby, run by two cousins – F.H. Offiler being the one who was keen to build pubs with hotel and catering facilities. The first to be built and today the only one still a public house, the Blue Peter has undergone many vicissitudes: GRP windows have replaced the original curved metal lights, the tiled coursing has been rendered and there is an extension at the back, but the striking centrepiece is still an important local landmark. The equally prominent Blue Pool in Stenson Road and the Blue Boy at Chaddesden, both built in 1936, are now supermarkets, though their facades are well-preserved. Offiler's Brewery, founded in 1876, has itself gone, taken over by Bass in 1965.

Nottingham also had breweries that produced light ales of modest strength distinctive to the area and built tied houses using local architects. By the interwar years Nottingham city centre was the domain of two companies, the Home Brewery and Shipstones, with a third, Hardys and Hansons, building in the surrounding county. W.B. Starr & Hall first designed pubs using bright Arts and Crafts tiles before evolving a moderne style, well seen at the Crown, Wollaton Road (1934) for Home Ales. Still more varied is the work of Albert Eberlin of Baily & Eberlin and from 1934 of Eberlin & Darbyshire, such as his mock-Tudor Cock & Hoop in the Lace Market of 1933.

THE MAYBURY/ GROSVENOR CASINO

MAYBURY ROAD, EDINBURGH
1935–36; PATERSON & BROOM
LISTED GRADE B

The Maybury was built yards from the Corstorphine tramway terminus on the edge of the city at the Edinburgh Turnpike. It could thus attract both local customers and those travelling from afar to a classy mix of drinking, driving and dancing in a little bit of Hollywood. The Maybury was advertised as 'a new form of inn', for as well as lounge and public bars it boasted a galleried 'lounge hall' at the entrance with a grand staircase, and a large 'dining and tea room' to the west – also with a balcony all round. There were tea dances three days a week, while the roofs were intended for deck games as on board ship.

The details of the elevation set this roadhouse apart, with its bull-nosed entrance of reinforced concrete balanced by rectangular blocks of brick to either side, its metalwork and chevron glazing. The attention to detail continued inside, seen on the imperial staircase with its quarter rays of metalwork relieving a solid, stepped balustrade, as well as the surviving panelling, steel balcony fronts and coved ceiling lighting. Patterson and Broom also designed housing for sale, thus breeching the code that separated architects and surveyors from speculative developers, and there is no doubt that they had a mastery of the commercial modern idiom.

The building struggled in the 1980s, when it operated as a disco, and in 1987 was remodelled as a conference and banqueting centre, and in 1997 as a casino, for which its Riviera imagery seems perfect.

HOME ALES BREWERY/ SIR J. ROBINSON HOUSE

MANSFIELD ROAD, DAYBROOK, NOTTINGHAMSHIRE
1936; T. CECIL HOWITT
LISTED GRADE II

Howitt entered private practice after completing Nottingham's Council House, designing town halls and Odeon cinemas nationwide, and buildings for local companies. For Home Ales he designed 35 pubs around Nottingham between 1937 and 1982, and prominent brewery offices just over the city boundary.

Home Brewery followed an office block by Howitt for Raleigh Cycles in Radford. Its long facade is dominated by a blocky tower with set-backs, raised over a lorry entrance with iron double gates featuring the company name. The advertising on its flanks read 'Home of the best Ales', until the county council replaced 'Ales' with its own logo when it bought the premises in 1997. The wings are defined by giant pilasters and relief panels of cherubs by Charles Doman. A local artist, Doman also worked at Raleigh, where his precocious putti risked injury welding bicycle frames; here they are energetically brewing beer. Opposite, the listed Coronation Buildings, 1936–37 by local architects Calvert, Jessop & Gleave, is an unusually well-preserved shopping parade, with black metal windows and Vitrolite cladding.

Home Ales was founded in 1875 by local farmer John Robinson, and remained in his family until 1986. When brewing ceased in 1996 most of the buildings behind the offices were demolished, but many of Howitt's pubs survive, notably The Vale, the brewery tap opened nearby on Thackeray's Lane in 1937. A marriage of domestic and Art Deco forms with a high, pantiled roof, it retains its original plan, fenestration and high-quality panelling better than most interwar pubs.

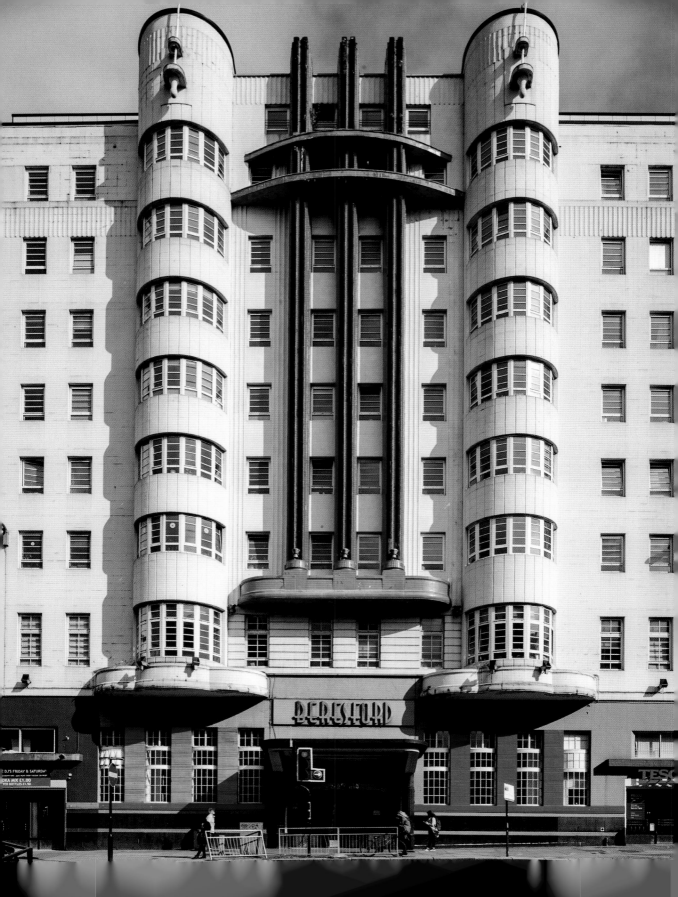

THE BERESFORD HOTEL

SAUCHIEHALL STREET, GLASGOW
1937–38; WEDDELL AND INGLIS
LISTED GRADE B

The Beresford Hotel was a speculative venture, built for visitors attending the Glasgow Empire Exhibition. At ten storeys, it was Glasgow's tallest interwar building, encouraging comparisons with contemporary hotels in New York and Miami Beach. William Beresford Inglis, the architect, was also the owner and managing director, having already built himself several cinemas, so justifiably gave his name to the building. He wanted to 'introduce the colours and lines of the cinema to attract attention', so clad it in mustard yellow, black and red faience, since much over-painted but now with a dramatic three-pronged centrepiece in the boldest of reds.

The Empire Exhibition was a showcase of Scottish culture and manufacturing held in Bellahouston Park in 1938. Its setting was short-lived but remarkably modern, thanks to contributions by every major Scottish architect, and was dominated by a version of Gropius's design for Chicago's Tribune Tower by Thomas Tait, the overall master planner. The tower was sold for scrap in 1939 and all that survives is the Palace of Art, a more robust construction because of the need for security.

The Beresford Hotel proved popular with American servicemen in the war, but declined thereafter and in 1952 a ruined whisky broker, Jimmy Barclay, sold it to ICI for offices. It was converted in 1964 into a student hall of residence, Baird Hall, until 3D Architects remodelled it as 112 flats in 2003–06, accessed from the internal lightwell and with a restored stair hall in return for an additional storey.

ROYAL YORK HOTEL

**67 GEORGE STREET, RYDE, ISLE OF WIGHT
1937–38; J.B. HARRISON AND H.F. GILKES
LISTED GRADE II**

If there is a reason for yet another book on Art Deco this is it – to highlight the perils facing buildings such as the Royal York Hotel, which have lain abandoned for over a decade. The hotel is a local landmark and a characterful hotel design that retained many original features until its closure in 2006.

The first Royal York Hotel opened in 1847, just as Queen Victoria was establishing the Isle of Wight as a holiday resort by building Osborne House. That it was rebuilt in the year holidays with pay became statutory was coincidental; this was a grand hotel with a ballroom, palm court and a spiral staircase rising through four storeys that was finished with a chrome-faced balustrade. Yet by the time I stayed there in 2003 its clientele comprised elderly coach parties, reduced to nightly bingo and at the mercy of a staff that dished out breakfast to guests at long tables like the workhouse spooned gruel to Oliver Twist.

The Royal York festered in its dereliction. The staircase balustrading was stolen, scaffolding shored up the entrance porch and modernisation work was left half completed. As a last resort, planning permission for adaptation into a boutique hotel and four flats was granted in 2015 and work was under way in 2018. The peeling facade is slowly being restored in eau-de-nil and white and windows are being restored or renewed – the stairwell is largely completed externally but the flanks with their curved glass ends present a greater challenge, completed in 2019.

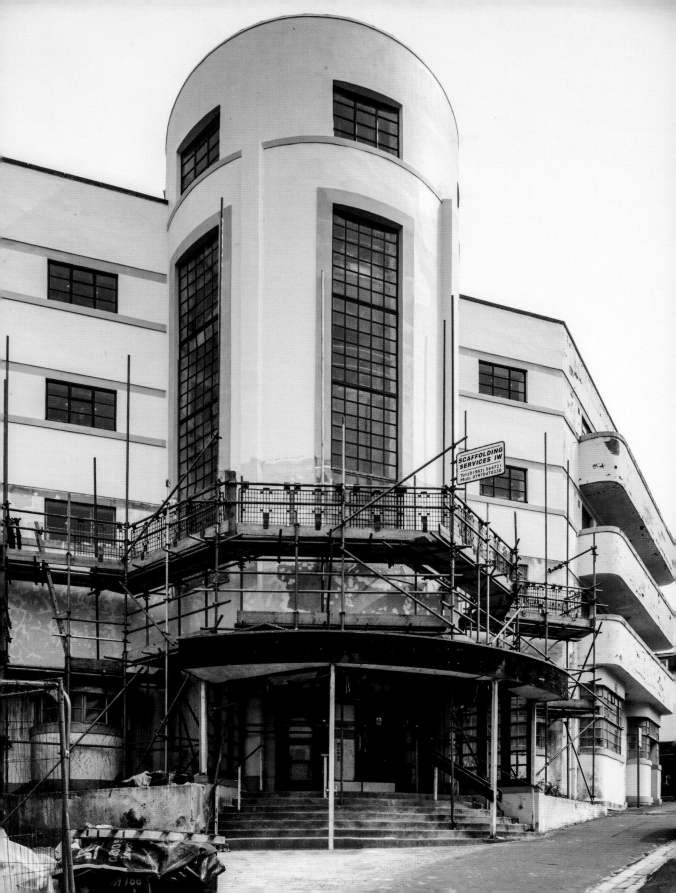

WHITE TOWER CASINO

PLEASURE BEACH, SOUTH SHORE PROMENADE, BLACKPOOL
1937–40; JOSEPH EMBERTON
LISTED GRADE II

Emberton's yacht club at Burnham-on-Crouch was Britain's only contribution to the New York exhibition on the International Style in 1932. However, Emberton's commercial work retained Deco elements, seen here in the pencil-thin twisted ornamental stair, inspired by Theodore Cook's *The Curves of Life* (1914), a study of spirals. The balance of tower and futuristic circular building is masterful. Large panes of glass and pre-cast concrete panels were tests of modern engineering on foundations of shifting sand.

William Bean was inspired by the Coney Island funfair when in 1903 he founded Blackpool Pleasure Beach. On his sudden death in 1929, his daughter Lilian (1903–2004) took over the complex and she and her husband Leonard Thompson made their own pilgrimage to America. Discovering modernist architecture inspired them to remodel many of the rides and to rebuild the 1913 Casino (always an ensemble of bars and restaurants rather than a gambling den). They initially employed a Philadelphian architect, Edward Schoeppe, but in 1933 brought in Emberton to create a unified image. He also contributed entrances to many rides, including the Grand National and Wild Mouse.

The Thompsons quickly adapted the Casino roof into a sun deck, and regularly remodelled the restaurants. Yet on a private mezzanine a manager's flat survives unaltered. Its hallway has veneer doors and matching linings, while the living room is lined in maple, with matching bookshelves, built-in seating and a drinks cabinet. Vitrolite fixtures feature in the bathroom.

TEST MATCH HOTEL

GORDON SQUARE, WEST BRIDGFORD, NOTTINGHAM
1938; A.G. WHEELER OF WHEELER & CO.
LISTED GRADE II*

Externally, the Test Match presents a stately Georgian facade. Yet inside is one of the finest moderne pubs, the quality of its fittings and dining facilities promised by brewers Hardys & Hansons of Kimberley and their favoured local architect finally seducing magistrates who for 40 years had steadfastly refused to license a pub in sedate West Bridgford. Nottingham's smartest suburb, West Bridgford was long a Methodist fiefdom. The name Test Match was preferred to 'The Rushcliffe' only as construction began.

Now three large lounges, the Test Match originally contained a lounge, smoke room and assembly hall – the public rooms of a hotel – though it had only a handful of bedrooms. The tone is set by the handsome double-height entrance hall, with its figured panelling, sweeping staircase and laylight. Murals of local cricket heroes George Parr and William Clarke were added c.1949–50 by T.L.B. Huskinson, and that of the Ashes urn is later still. To the right is the former 'Gentlemen only' smoke room, cosily panelled, its curved timber-lined bar banded with brass trimmings. Behind, the assembly room is now used for dining rather than dancing, where ice-cream-cone brackets support the ceiling beams; the low intervening snug with wall-lights is, surprisingly, a slightly later addition, replacing a service area.

A public bar is discretely tucked to the rear. Denoted by cheaper panelling and black metal banding instead of brass, today it is the least altered space, noteworthy for its terrazzo floor. Even the lavatories retain their tilework and vintage fittings.

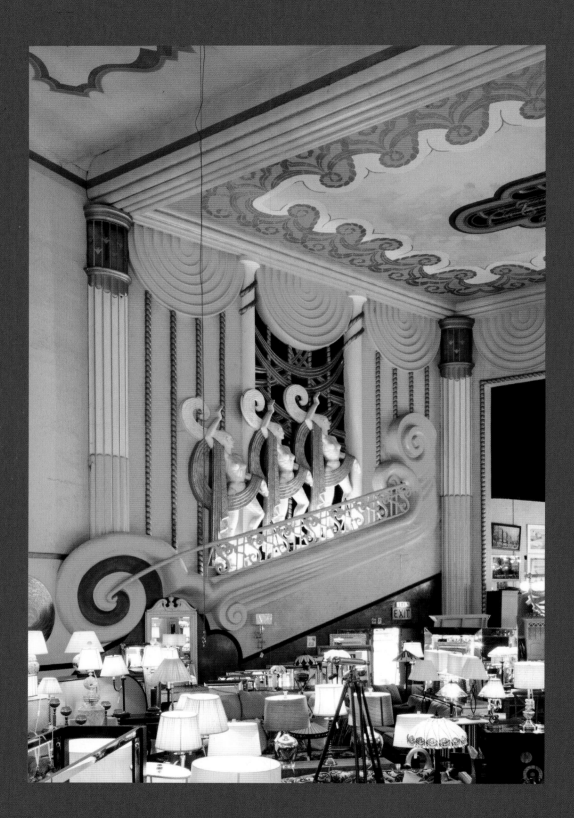

Cinemas, Theatres and Concert Halls

ASTORIA CINEMA/ ACADEMY

**STOCKWELL ROAD, BRIXTON, LONDON
1928–29; EDWARD A. STONE WITH T.R. SOMERFORD,
EWEN BARR AND MARC HENRI
LISTED GRADE II***

'An acre of seats in a garden of dreams', claimed advertising ahead of the Astoria's opening in August 1929. The opening programme featured Al Jolson in *The Singing Fool* (the first 'talkie' widely shown in Britain) supported by a full variety show featuring the Astoria Orchestra and its Compton organ.

The Astoria was Britain's first cinema to fully emulate the 'atmospheric style' made fashionable in America by the architect John Eberson. Most of the design work was by Tommy Somerford, remembered for temperance billiard halls across London. Henri designed the auditorium, its three-dimensional architectural details enhanced by theatre sets, sculpture and landscape effects, lighting and cloud machines. The audience enjoyed the illusion of being in an Italian garden, its fake trees rising above Roman sculpture while a Brenograph projected artificial sunshine, clouds and moonlight on to a giant dome.

Brixton's Astoria was the first of four cinemas of that name built by Stone, who was chairman of the operating company as well as its principal architect. Brixton was followed by Astorias in Old Kent Road (demolished), Streatham (much altered as the Odeon Cinema) and Finsbury Park, now a church but for most of the 1970s and 1980s a major music venue, the Rainbow – where twinkling electric stars above a scene from the Arabian Nights added to the escapism. Such lavish cinemas were hard to run. In 1931 Astoria secured funding from the American company Paramount Pictures, but in 1939 was taken over by Odeon – who promptly scrapped the stage shows.

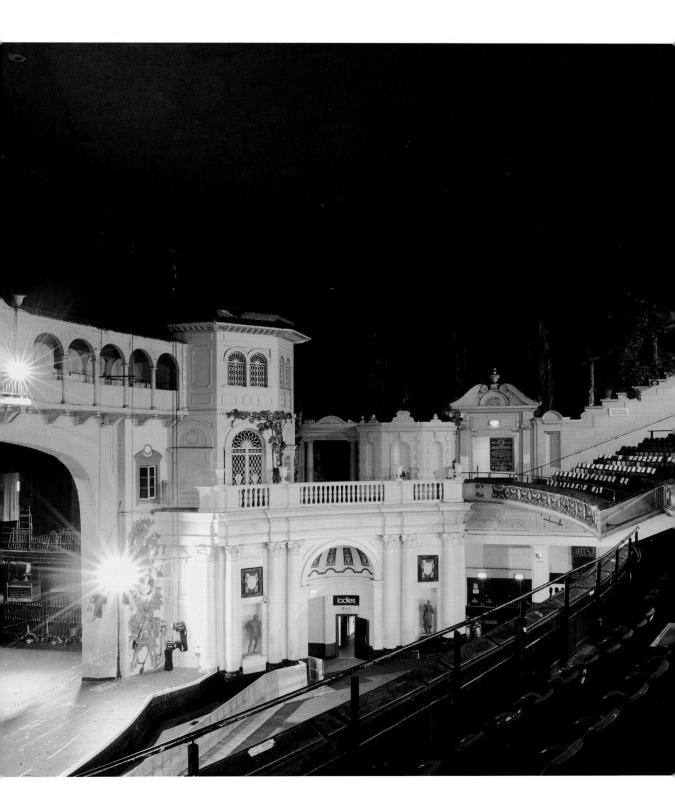

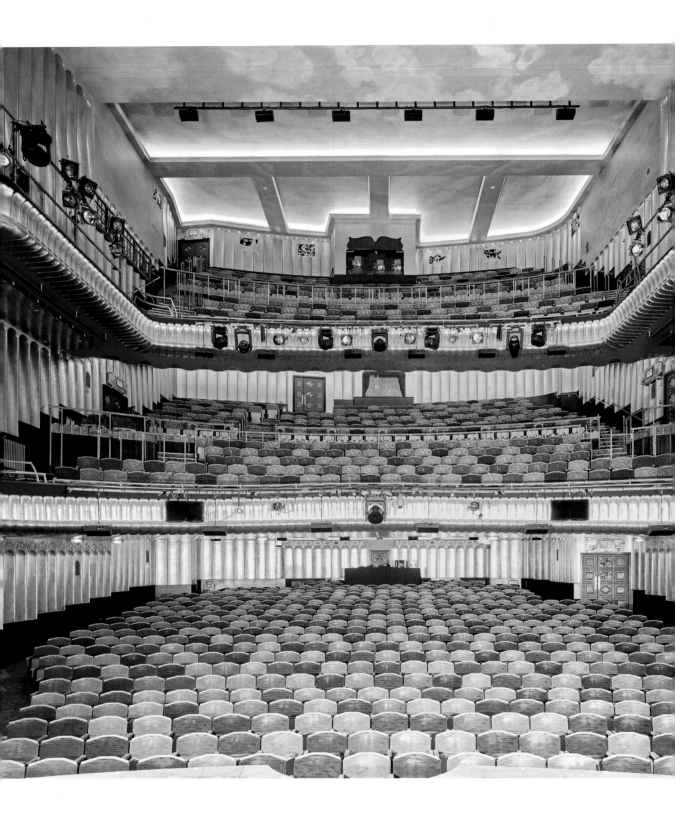

SAVOY THEATRE

SAVOY COURT, WESTMINSTER, LONDON
1881, C.J. PHIPPS; 1929, FRANK A. TUGWELL AND BASIL IONIDES
LISTED GRADE II*

'The new Savoy Theatre is the first really outstanding example of modern decoration applied to a public place on a commercial basis.' So wrote Christopher Hussey in *Country Life* in November 1929 on the remodelling by Rupert D'Oyly Carte's of his father Richard's ground-breaking theatre. The original Savoy Theatre was built to showcase Gilbert and Sullivan's comic operas, and was the first building in London lit by electricity. The theatre is deceptively large, for it is tucked into the steep slope towards the river; originally entered from Carting Lane, a new entrance was formed in Savoy Court when the Savoy Hotel of the D'Oyly Cartes was remodelled in 1903 and again by Easton & Robertson with a stainless-steel canopy following Tugwell's work on the theatre. Thus you enter the theatre from above, where the upper circle is at street level.

Tugwell simplified the interior by reducing the circles from three to two, and replaced 18 boxes with just one. But it was Ionides who turned it into a jewel box. Square panels around the proscenium and fluted side walls are coated in aluminium leaf, the panels with relief figures based on a Ming-dynasty screen, the fluting concealing lighting under the ceiling. The rows of seats were richly covered in shades of gold and red, repeated in the curtains.

Fire destroyed the auditorium in 1990, but insurance ensured it was meticulously restored by Red Mason of William Whitfield and Partners, with improved stage facilities and a health club and swimming pool added on the roof.

CARLTON CINEMA / GRACEPOINT

161–69 ESSEX ROAD, ISLINGTON, LONDON
1929–30; GEORGE COLES
LISTED GRADE II*

Nowhere in London demonstrates the influence of Tutankhamun's tomb so determinedly. Egyptian motifs range from the covered cavaletto frieze, the battered walls of the flanking pavilions, the papyrus capitals to the columns and the brilliant colour in the Hathernware tiles with which the facade is clad.

George Coles was London's leading cinema architect by the late 1920s, brought in by Albert Clavering and John Rose of C. & R. Cinemas after an earlier scheme by A.G. Alexander had been approved in April 1929. Coles had already designed the Carlton Upton Park in 1928 for the same company with a simpler Egyptian facade, destroyed by a V2 rocket in 1945. The clients were proud of their Egyptian image, using a perspective of the Essex Road cinema on their notepaper with the slogan 'Be Wise – Carltonise!'

The interior was more typical of Coles's super cinemas of the late 1920s, a 'marble hall' leading to a Roxy-inspired classical auditorium featuring colonnades and niches under a domed ceiling. Advertising emphasised the peach-tinted mirrors and subdued amber lighting. The Carlton was opened in September 1930, with Harold Lloyd in his first talkie, five variety turns and a recital on the Compton organ. The fully equipped stage was licensed for music, dancing and plays until it suffered war damage in 1941. The first-floor tea room was converted into a hairdressing salon in 1957.

Films ended in 1972 and the subsequent bingo in 2007, when the building was acquired by the evangelical group Resurrections Manifestations as 'Gracepoint'.

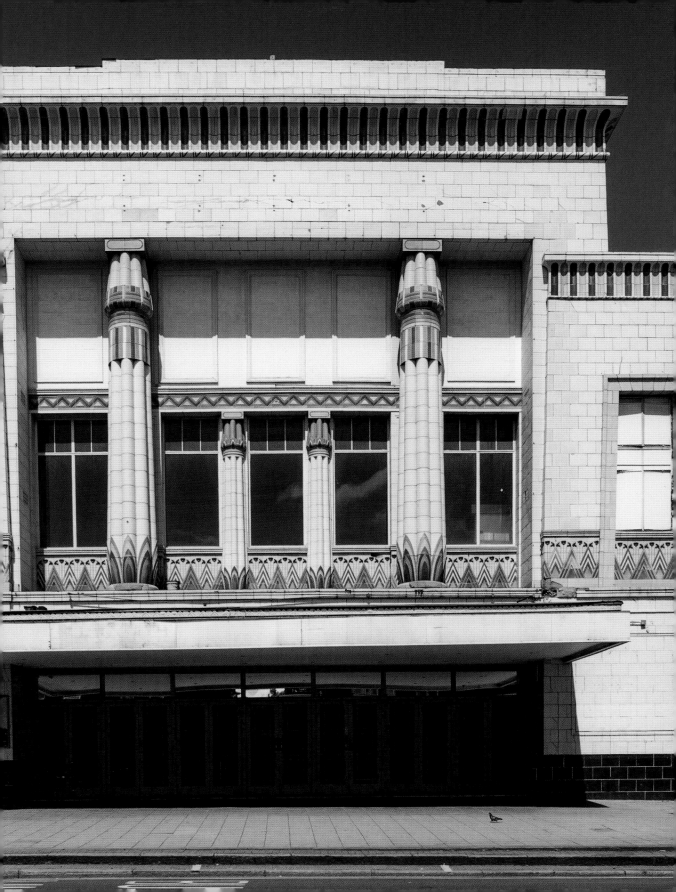

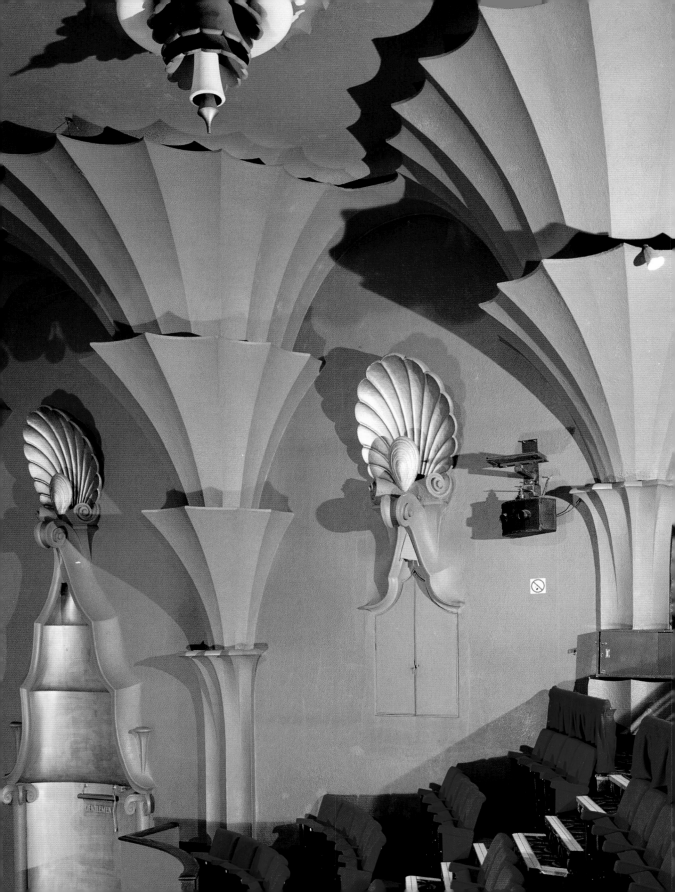

NEW VICTORIA CINEMA/ APOLLO VICTORIA THEATRE

17 WILTON ROAD, WESTMINSTER, LONDON
1929–30; ERNEST WAMSLEY LEWIS WITH WILLIAM E. TRENT
LISTED GRADE II*

Wedged into a tiny site between Wilton and Vauxhall Bridge roads, the New Victoria has a sophistication lacking in other cinemas, a one-off feat by a young architect who turned to conservation work. Philip Morton Shand made it the 'stop press' frontispiece of his *Modern Theatres and Cinemas* (1930), declaring it 'a symbol of hope' for British architecture. Trent managed the budget and planning permissions as in-house architect for Provincial Cinematograph Theatres; the design was Lewis's.

Wamsley Lewis had trained at the Architectural Association and in 1927 won a scholarship to study theatre architecture in Berlin and New York. He striped the near-identical elevations like contemporary radio sets, outlined by neon at night and with reliefs by Newberry A. Trent depicting cinema audiences. The source for the interior, Lewis admitted, was Hans Poelzig's Grosses Schauspielhaus of 1919, a Berlin theatre hung with stalactites, but adapted here with shell motifs and fountain uplighters in deep-sea greens to create a 'mermaid's palace' – so-called on a whim to appeal to the client's love of boats. Newberry Trent added a mermaid relief in the foyer, but more moderne were rubber floors and exuberantly fluted mouldings that are reminiscent of Frank Lloyd Wright's Unitarian Chapel. Yet Lewis's greatest coup is unseen, for only by planning the basement stalls and stage to extend under the roadway, with the entrances and offices tucked beneath the rear circle, could the cinema be large enough.

The cinema has been used for live shows and as a theatre since 1975.

SHAKESPEARE MEMORIAL THEATRE

WATERSIDE, STRATFORD-UPON-AVON
1929–32; ELISABETH SCOTT
OF SCOTT, CHESTERTON AND SHEPHERD
LISTED GRADE II*

A fire at the Shakespeare Memorial Theatre in 1926 stifled a debate about its inadequacy for the growing numbers of American tourists visiting Stratford. A two-stage competition was the first to be won by a woman: aged 29 and representing a powerful generation of female graduates from the Architectural Association, Scott's great uncles included the leading church architects Sir George Gilbert Scott and George Frederick Bodley. She formed a partnership with her boss, Maurice Chesterton, and John Shepherd to realise a scheme thought daringly modern by the British establishment, admired for its scale and simplicity of handling. Walter Gropius, visiting in 1934, recognised it was more Deco than modern but refrained from comment.

The theatre was raised on a terrace, where Scott added a riverside restaurant in 1938, and a loggia shielded the old theatre's shell (now the Swan). Her brick facade reflected contemporary Dutch design and was enriched with cut-brick sculpture by Eric Kennington. The fan-shaped auditorium, fashionable in the 1930s, was found to have awkward sightlines and acoustics; remodelled and shorn of its rich veneers in the 1950s, it was rebuilt in 2005–11 by Bennetts Associates. The foyer thought so ample in 1932 now seems tiny, as does the circular staircase drum to the side (a reflection of David Garrick's original 1769 rotunda here) with a fountain by Gertrude Hermes. Nevertheless, the green marble veneers and chromium metal doors and kiosks create bold abstract patterns, producing one of the first and best syntheses between civic and modern design.

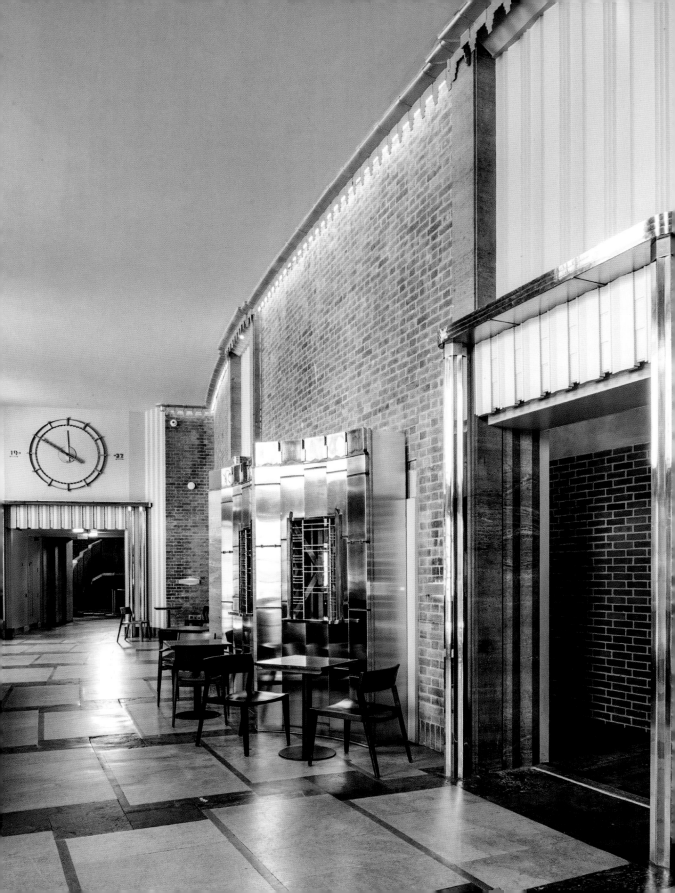

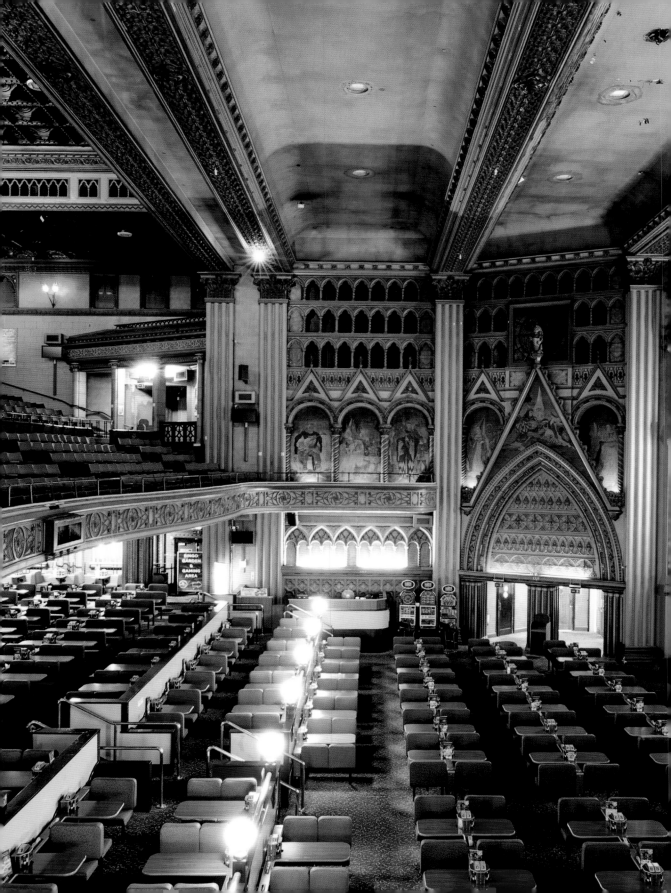

GRANADA CINEMA/
BUZZ BINGO

50–60 MITCHAM ROAD, TOOTING, LONDON
1930–31; CECIL MASEY
WITH THEODORE KOMISARJEVSKY (INTERIORS)
LISTED GRADE I

The *Bioscope* magazine in 1931 promised that 'a decorative scheme which is absolutely new to the cinema theatre world' would soon be unveiled at the Granada Tooting. This is no fake atmospheric, but a fully architectural Moorish palace that is Britain's finest cinema and the only one listed grade I.

Alexander Bernstein was an immigrant entrepreneur who built up a chain of variety theatres and cinemas, taken further by his son Sidney after he visited New York's movie palaces and brought in Masey and Komisarjevsky from the live theatre world. He chose the name 'Granada' as having 'a flavour of romance' impossible in modernism. The exterior is grandly classical. But to step inside is to leave Tooting for another world: a triple height space with above you the former 'all electric' café and ahead a double staircase. The circle seats are reached through a 150ft (46m) long arcade where mirrors reflect you into infinity. Inside the auditorium, Gothic arches either side of the proscenium are filled with coloured glass and folklore figures by Lucien le Blanc and Alec Johnstone. The Wurlitzer organ was brought from Sacramento, California; the 35ft (11m) stage was used most extensively in the 1960s when visiting bands included the Beatles.

Amid fears for its future, with Bernstein commissioning plans for an office block, the Granada was listed in 1972. It closed suddenly in 1973, standing empty until the company gave up on demolition and installed bingo. The Wurlitzer was restored in 2007 only to be damaged again by flooding.

PLAZA CINEMA

MERSEY SQUARE, STOCKPORT
1931–32; WILLIAM THORNLEY
LISTED GRADE II*

William Thornley submitted plans for a 1,600-seat cinema in 1929, including a café and billiard hall, to be called the Regal. But then the site passed to the exhibitors Read, Snape and Ward, who commissioned a more grandiose scheme closer in style to their flagship super-cinema, the Regal Altrincham (by Drury & Gomersall, demolished). Thornley accordingly updated his plans, introducing shell patterns and fountain motifs inspired by the 1925 Paris Exhibition as well as a bas relief of dancing nymphs.

Some 10,000 tons of rock were hued out of the cliff face to create an external stairway and the 1,845-seat cinema, the latter squeezed in only by setting the stage area underground. It opened on 7 October 1932. The decorative scheme by G.F. Holding used gold, silver and rose tints (popular colours for cinemas since they were bright but did not show the dirt), flooded by the latest Holophane multi-coloured lighting effects, while the seats were upholstered in dark blue and gold moquette. Programmes combined films and live performances, with Cecil Chadwick providing interludes and accompaniment on the Compton organ, the first to be built with sunburst decorative glass panels that can be illuminated in various colours.

The Plaza closed in December 1966 to become a bingo hall, with Samantha's Disco in the café. It passed to the Stockport Plaza Trust in March 2000 and reopened that October, with major restoration works following in 2009 and subsequently – notably with the restoration of murals in the tea room and balcony.

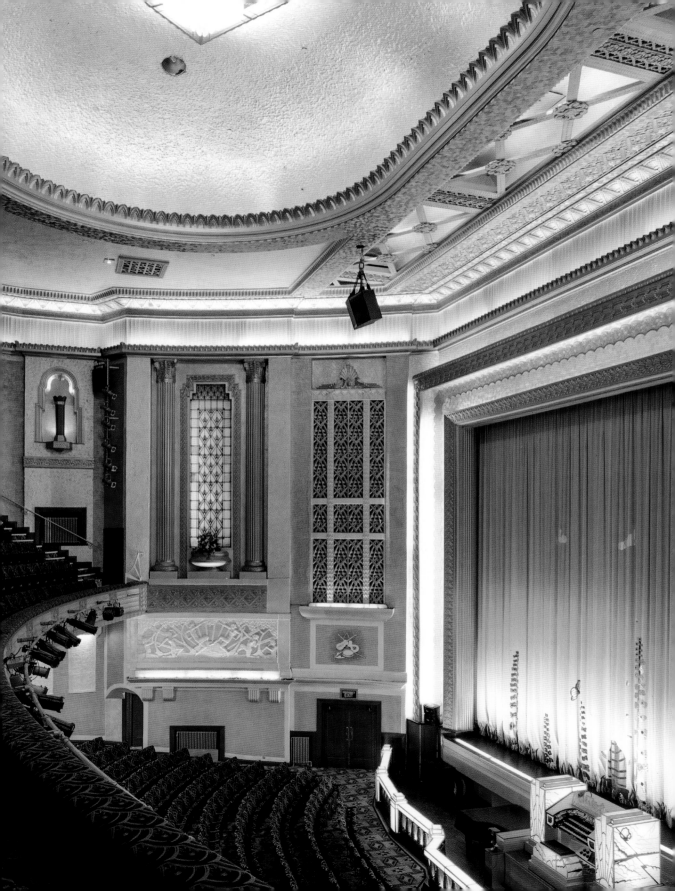

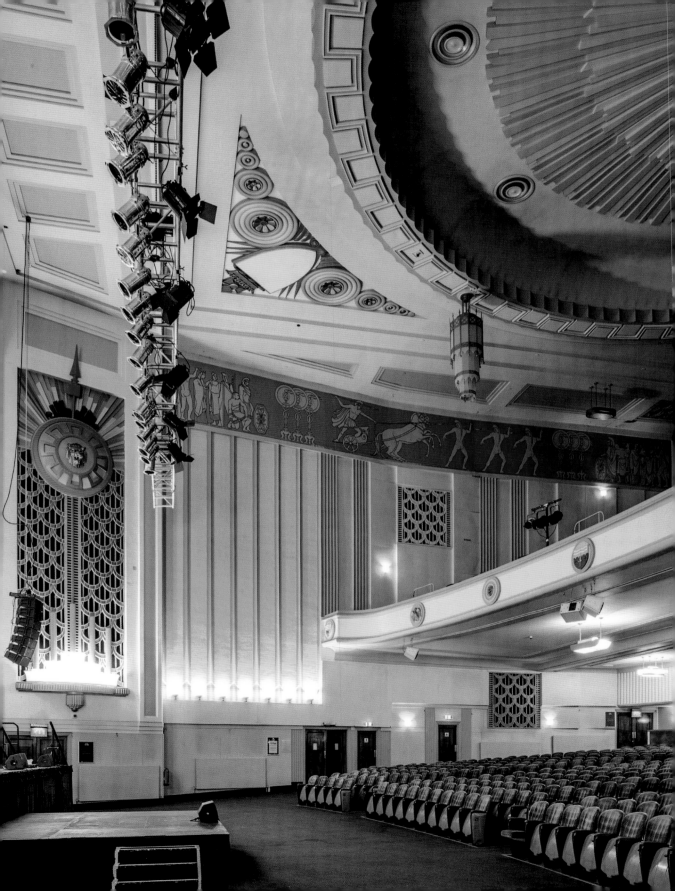

FORUM CINEMA

SOUTHGATE STREET AND ST JAMES'S PARADE, BATH
1933–34; WILLIAM H. WATKINS AND E. MORGAN WILLMOTT,
ASSISTED BY A. STUART GRAY
LISTED GRADE II*

A prominent street corner in downtown Bath demanded an austere classical facade of local stone, relieved only by a giant order. That it is not even obviously a cinema adds an extra thrill on finding the succulent auditorium hidden inside. The city crest surmounts the proscenium, but otherwise the decoration reinterprets the era when Bath was Aquae Sulis and Romans relaxed in its hot springs. However, the fluted surrounds, the shields topping the ventilation grilles in the ante-proscenium and the deep frieze of chariot racers symbolise the occupying army's more military side. The fluting and plaster grillework continue in the foyers, giving the Forum a rare if cold-hearted consistency that extends to a café and upstairs ballroom. Yet there is also richness, found in its colour and especially the light fittings: pendant candelabra flank a giant sunburst set in a shallow dome, its three layers descending to a delicate plaster parasol. Watkins was the South-West's leading cinema architect, working mainly for Gaumont British, which had a 49 per cent share in the Avon Cinema Co., builders of the Forum, and this is his best surviving work.

The cinema closed in 1969, to become a bingo hall and dance school. The Bath Christian Trust purchased it in 1988 and with the architects Stubbs Rich made an immaculate restoration, initially for their own services. The building was restored again in 2013 when as Bath Forum it began to be used more extensively as one of the largest music venues in the South West.

BRIGHTON DOME AND CORN EXCHANGE

CHURCH STREET, BRIGHTON
1803–08, WILLIAM PORDEN; 1934–35, ROBERT ATKINSON
LISTED GRADE I

It was perhaps his successful nearby Regent Cinema that got Atkinson the job of transforming Brighton's concert hall. The result is at once oriental in the spirit of the adjoining Pavilion – itself arguably a prototype of Art Deco – yet refined with chromium plating, faience, linoleum, neon tubing and all the materials and effects unavailable before the 20th century.

The site was that of the stables and riding school erected by George, Prince of Wales in the early 1800s, the horse boxes set around a circular dome inspired by the great Jama Masjid (Friday Mosque) in Delhi. Brighton Corporation bought the stables in 1850, and in 1864–67 Philip Lockwood converted them into a concert hall. The riding school became the town's corn market and later a military hospital and roller-skating rink.

Atkinson ripped out the old structure, replacing its dome with iron stanchions concealed behind giant plaster petals in cream and orange. He installed the balcony, supported on columns incorporating uplighters and doubling the capacity, as well as an elaborate concert organ. Walnut panelling lined the rear walls, now covered by acoustic panels during concerts following a restoration programme in 2002. Atkinson then adapted the Corn Exchange for functions, removing later subdivisions and inserting new windows resembling William Porden's originals. An additional entrance in Church Street featured a figure of the grain goddess Ceres by James Woodford, one of his first works. The Corn Exchange was restored in 2017–19.

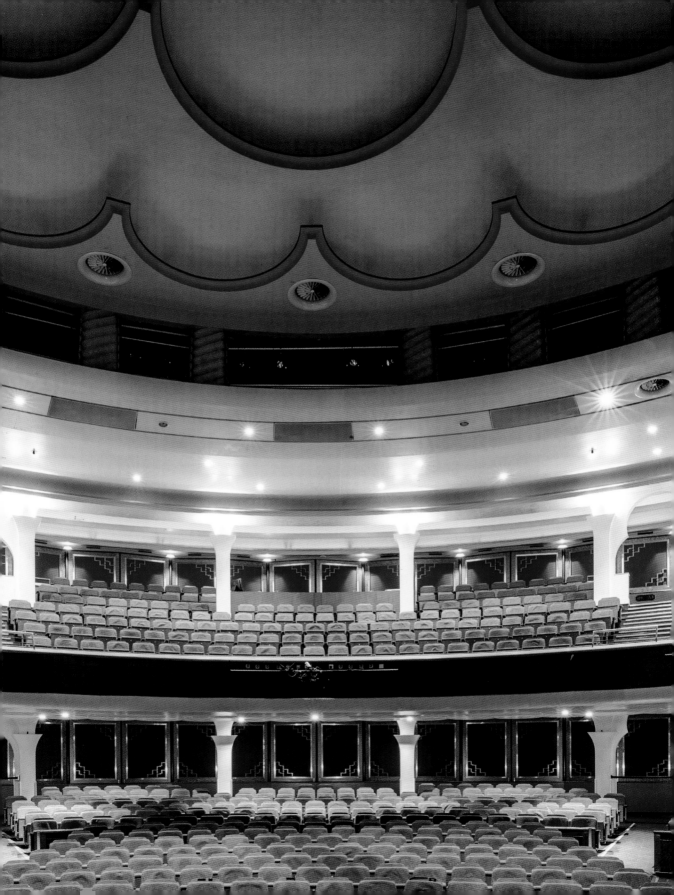

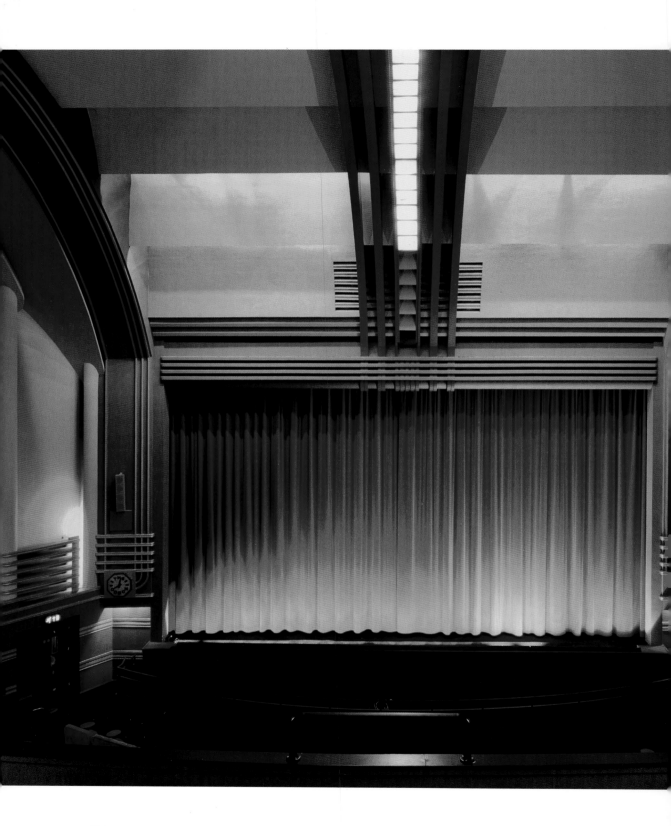

ODEON/ EVERYMAN CINEMA

FORTIS GREEN ROAD, MUSWELL HILL, LONDON
1935–36; GEORGE COLES
LISTED GRADE II*

George Coles designed most of the Odeons for Oscar Deutsch in the London area. Compared to other Odeons, Muswell Hill has a simple exterior but an unusually elaborate interior, after opposition from Hornsey Council and a nearby church forced the cinema entrance to be built in the side street. There is the cream faience typical of Odeon cinemas but no tower.

The historian Richard Gray suggests that the double-height foyer, with its curved ends enlivened by giant paired columns and horizontal bands, is reminiscent of the film set of H.G. Wells's *Things to Come* of 1936. The circular inner foyers discreetly turn the customer through 90 degrees into the auditorium, with between them vestibules – the upper one originally a tea room and both now bars. The interior retains its key features in the 250-seat Screen 1. Its shape is that of a vintage film camera, illuminated by coved lighting concealed in the ceiling and side walls, a subtle interplay of slender columns, narrow horizontal railings and dominating curves. Lights run down the ceiling like a strip of film descending towards the screen. 'Odeon' clocks to either side of the proscenium have been replaced by clocks saying 'The Everyman' in place of numbers.

With the New Victoria, the Muswell Hill Odeon interior best demonstrates the influence of German expressionism in British cinema design. It was restored and reopened as an Everyman cinema in 2015 and remodelled with two small additional screens in 2016.

GROSVENOR CINEMA/ ZOROASTRIAN CENTRE

ALEXANDRA AVENUE, RAYNERS LANE, GREATER LONDON
1936; F.E. BROMIGE
LISTED GRADE II*

Frank Ernest Bromige was a 'rogue' cinema architect, designing a handful of
idiosyncratic venues from an office in Kingley Street, Westminster. The interior of
the Rio, Dalston, which he remodelled in 1937, is an indication of his lively style,
but best of all are the curves and fins that graced his exteriors, at the Dominion,
Acton (1937); the Dominion, Harrow (built in 1936 but now concealed behind
metal cladding); and above all the Grosvenor, Rayners Lane. Bromige liked to
place bulging staircase towers either side of a central feature, here a projecting fin
from which were hung bulbous letters spelling the name Grosvenor, behind which
a double-height convex window is almost an understatement. Bromige forsook
cinemas' habitual faience in favour of white cement render that could be moulded
into any form he chose. Behind the entrance doors was a sunken café surrounded
by columns, with coved lighting on two levels. Best of all is the auditorium ceiling,
which features long ripples of ice-cream render that splayed out from above
the broad proscenium. It was a great place to see a film, as easily adapted to the
conditions of the 1980s as it had been a centre of sophistication in the 1930s.

The cinema closed in 1986 and suffered a series of conversions as one bar-cum-
disco chain followed another. The building was saved when in 2000 it was sold to
the Zoroastrian Trust Funds of Europe, who restored the building sensitively as a
community centre and place of worship, completed in 2005.

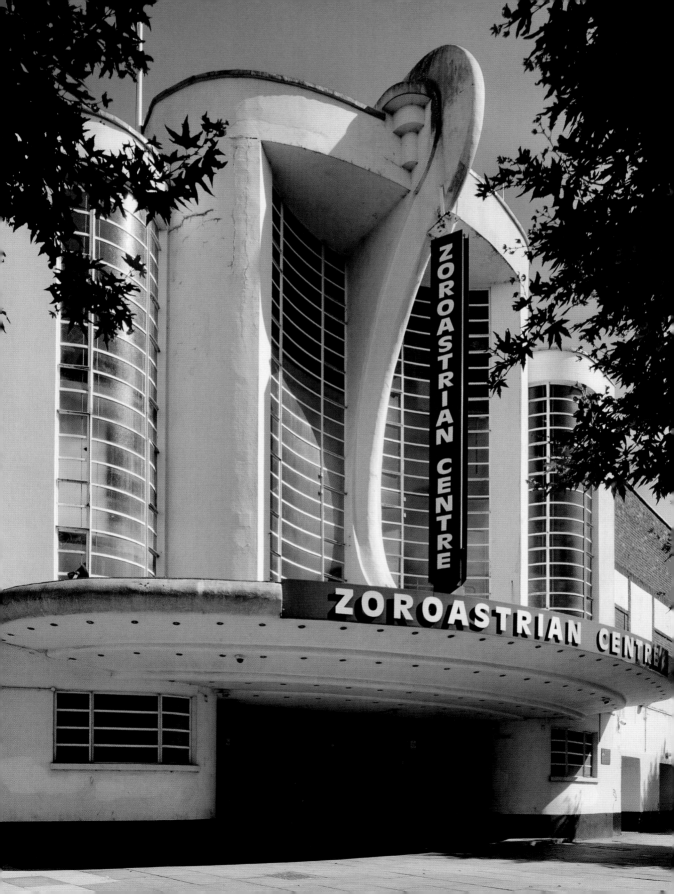

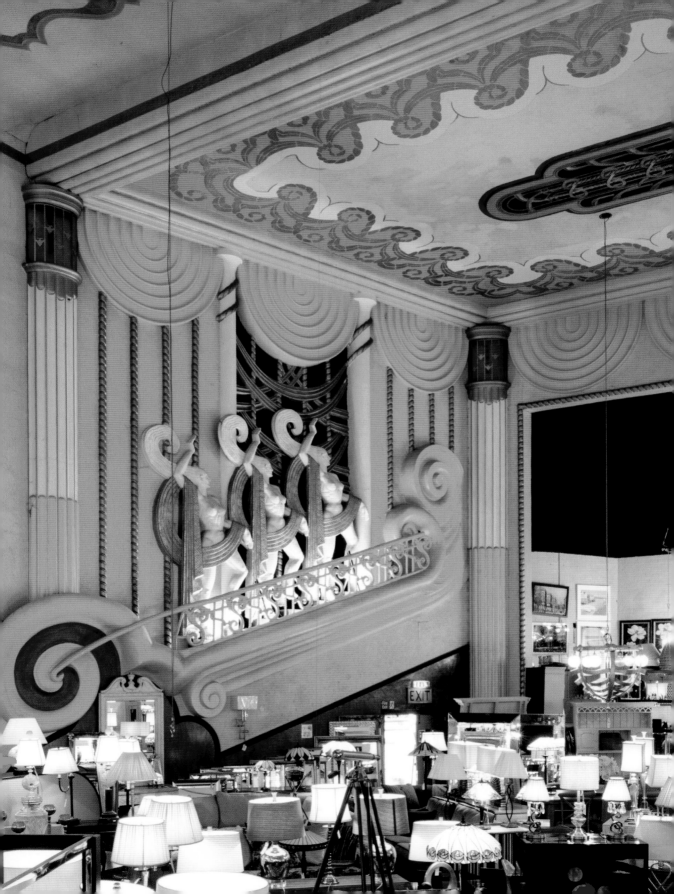

NORTHWICK CINEMA/ GRAYS OF WORCESTER

**OMBERSLEY ROAD, NORTHWICK, WORCESTER
1936–38; C. EDMUND WILFORD WITH JOHN ALEXANDER
LISTED GRADE II**

With its stylish, American-style vertical sign, the Northwick would stand out in a city centre, let alone on the edge of town. The client was a local entrepreneur who ran the Northwick in tandem with the city centre Scala. Also remarkable is its survival, despite closing as a cinema in 1966. The original doors and 'push' signs are complete, as well as the decoration on the ceilings and side walls of the un-subdivided auditorium.

Wilford was a competent architect, but he did not design the lavish interior. Little is known about the interior designers of most cinemas, but the Northwick is an exception since it is the work of John Alexander, a designer and fibrous plaster manufacturer based in Newcastle upon Tyne. We know something of his work because an elegant set of watercolours are held by the Victoria and Albert Museum, yet this is the only building where his work survives complete, with three dancing girls riding a giant wave or chariot either side of the stage, their hair spiralling over the surf, 'S'-shaped motifs in the balustrade suggesting seahorses. More lavish decoration surrounds the proscenium and fills the ceiling, contrasting with conventional columns.

The building lingered in bingo use until 1982. After years of dereliction and twice being threatened with demolition, it was converted in 1991 into a music venue, with occasional cinema shows, and restored again in 2003 – adopting something approaching its original peachy pink and gold colour scheme – to become a distinctive furniture showroom.

APOLLO CINEMA/ O2 APOLLO

STOCKPORT ROAD, ARDWICK, MANCHESTER
1937–38; PETER CUMMINGS AND ALEX M. IRVINE
LISTED GRADE II

The Apollo opened in August 1938 with a programme of music, dancing and films, a late example of a ciné-variety hall seating 1,750 people. It was the flagship of an independent company, Anglo-Scottish Theatres Ltd, led by a London manager, Arthur Segal, and a builder, R.C. Roy, one of Manchester's first black businessmen. Roy employed his own architect Alex Irvine, while Cummings was a regular collaborator who designed cinemas around the north-west.

The finest part of a cinema was traditionally the auditorium, often the work of a specialised decorating firm. Mollo & Egan's work remained little known until the 1990s, when they were revealed as one of the industry's most prolific and distinctive design teams. Michael Egan made a feature of horizontal bands of intricate plasterwork, which in his most elaborate work he combined with swashbuckling diagonals. Here Cummings designed a trough for a colour-changing Hollophane lighting system devised by R. Gillespie Williams and described by Eugene Mollo as 'night architecture'. The effect is of a giant kiss blown around the stage/screen, later slightly cropped – perhaps to accommodate the widescreen films of the 1950s.

The theatre also had a café (now a bar but retaining its fluted classical columns) and, in a separate wing facing Hyde Road, a ballroom and milk bar. The two wings originally flanked an earlier Picture House cinema, which was bombed in 1941 – though the Apollo was undamaged. It began to stage concerts regularly in 1977, unusually retaining an option of standing or seating in the stalls.

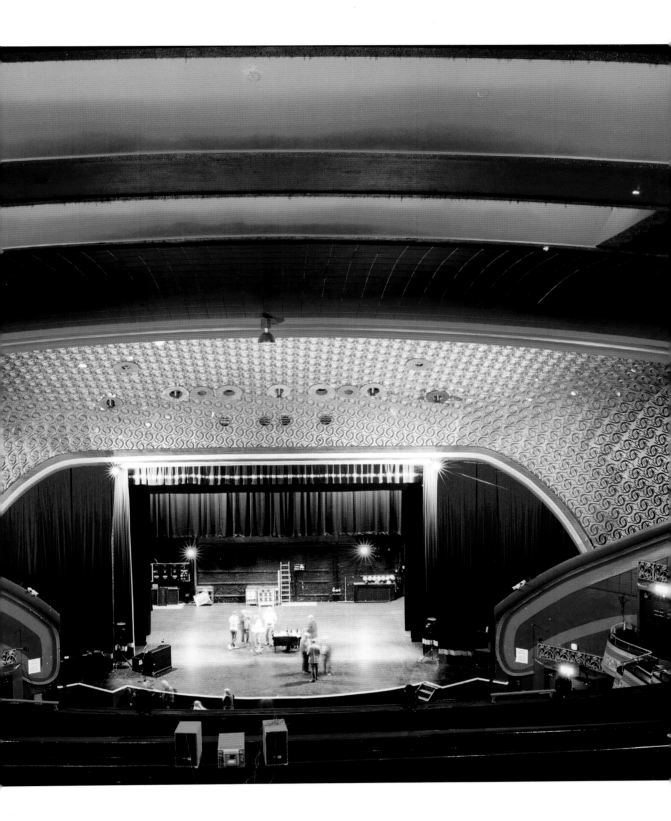

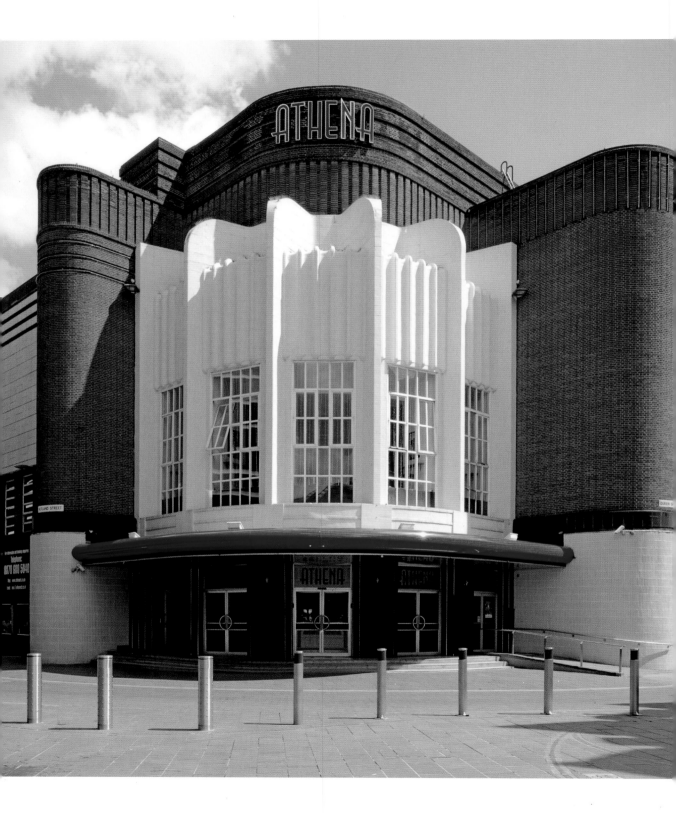

ODEON CINEMA/ATHENA

RUTLAND STREET, LEICESTER
1937–38; HARRY WEEDON AND ROBERT BULLIVANT
LISTED GRADE II

Weedon was a Birmingham architect who specialised in factory buildings in his home town, after working for Robert Atkinson. He was thus superbly placed to work for another Birmingham man, Oscar Deutsch, the entrepreneur behind Odeon cinemas – 'Oscar Deutsch Entertains Our Nation' ran one contemporary slogan. Weedon produced the interior of the Odeon at Warley in the West Midlands, and his office designed a cinema at Kingstanding, Birmingham, for W.H. Onions, which Deutsch took over during its construction. This was the key to the look of subsequent Odeons, the most distinctive of British cinema chains. The actual design work was by a young assistant, Cecil Clavering, who introduced faience-clad fins based on Julian Leathart's Dreamland cinema at Margate, published in the architectural press while still under construction in 1934 and itself based on German cinemas, notably the Titania-Palast, Berlin, of 1928 by Schöffller, Schloenbach and Jacobi.

Clavering designed further cinemas at Scarborough, Sutton Coldfield and Colwyn Bay (demolished) and gave Odeon its generic style of a cream faience facade with a prominent advertising tower. In 1936 he left for a job in the Office of Works, to be replaced by Robert Bullivant, who continued the style, completing the Odeon Scarborough and producing designs in brick for Chester and York that were considered more harmonious for such historic cities. His scheme for Leicester had to fit a tight site and, unusually, is symmetrical, with staircase towers in the place of decorative fins, which instead form a motif across the corner site.

PHILHARMONIC HALL

HOPE STREET, LIVERPOOL
1937–39; HERBERT J. ROWSE
LISTED GRADE II*

Rowse's masterpiece in the Dudok style is modern yet grand in its scale and – unusually for the idiom – symmetrical. It replaced a neo-classical concert hall built in 1846–49, which was destroyed by fire in July 1933. Insurance money promised that a replacement could be built quickly, until the city council demanded the building also serve as a theatre and cinema, and a compromise was only secured in 1937. Rowse brought in as his assistant Alwyn Edward Rice, a younger pupil of Charles Reilly from the Liverpool School of Architecture who had designed a theatre as his student project. The final design follows the massing and general layout of this scheme.

The Victorian hall was a large volume with excellent acoustics. The replacement followed the fan shape popularised by the Salle Pleyel in Paris, which Rowse divided into staggered sections by a series of lighting coves, the figure on each leaf providing the hall's only decoration save for perforated screens around the stage. Rushworth and Dreaper built the organ, its console rising from the stage, as does a cinema screen set within its own proscenium. Hector Whistler supplied etched glass for the facade and door panels, and a copper memorial commemorates musicians lost on the *Titanic*. Peter Carmichael refurbished the hall in 1995, renewing the side walls in concrete and installing hard surfaces to lengthen the reverberation time in consultation with the acoustician Larry Kirkegaard. The auditorium was restored again and an extension rebuilt in 2012–15 by Caruso St John.

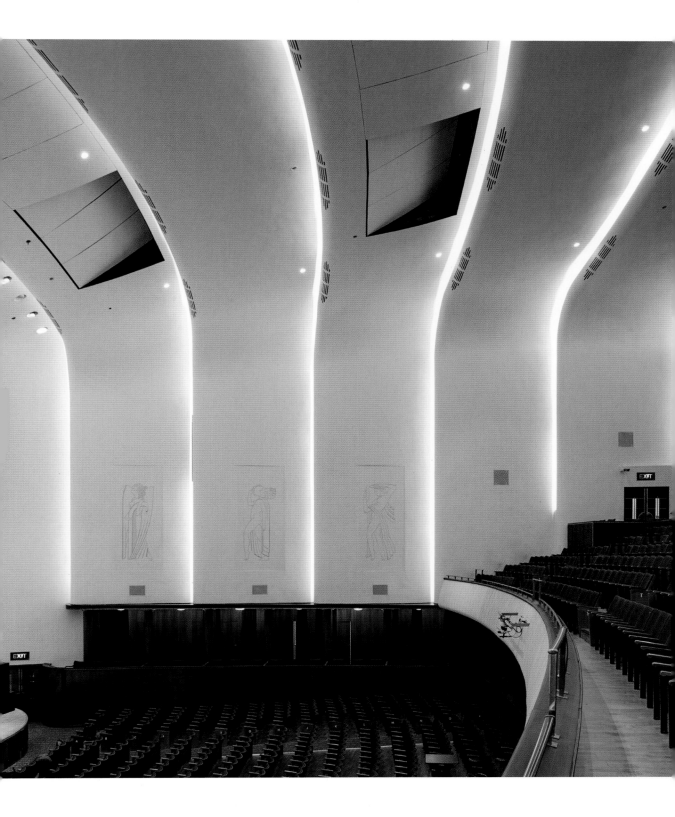

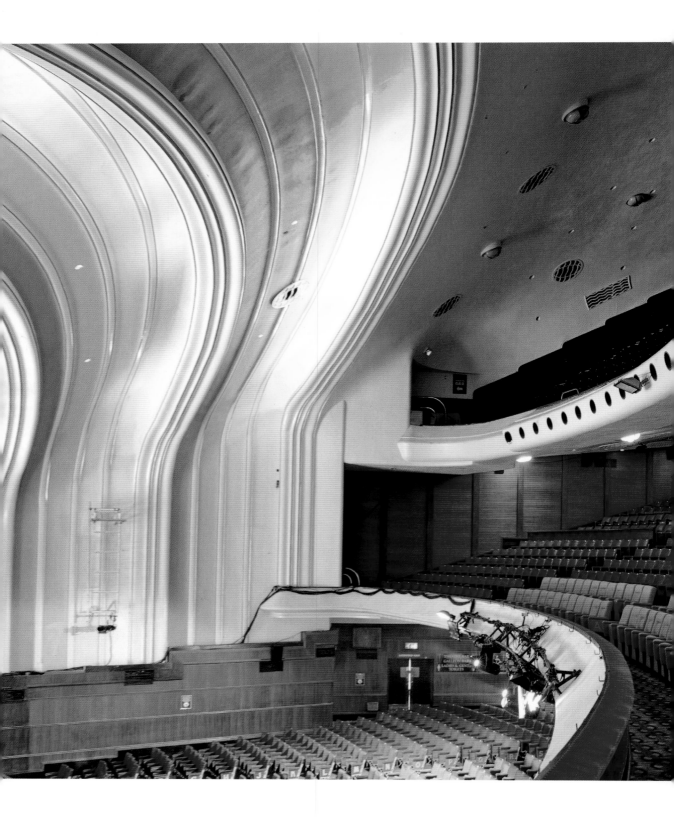

WINTER GARDENS

ADELAIDE STREET, BLACKPOOL
1938–39; CHARLES MacKEITH
LISTED GRADE II*

Blackpool's vast Winter Gardens is a bewildering array of halls, bars and restaurants dating back to 1875, its cornucopia of styles reflecting changing tastes through the golden age of theatre and entertainment design. One sequence of spaces from 1930–31 includes the Spanish, Baronial, Windsor and Ye Galleon halls created by in-house architect John C. Derham and the freelance theatre designer Andrew Mazzei, intended for fine dining, dancing and afternoon tea. Derham's signature faience facade originally fronted the Olympia amusement park added in 1929, but was extended when the Opera House was rebuilt. This is the third opera house on the site, and replaces buildings by Frank Matcham from 1888–89 and Mangnall & Littlewood (designers of the Empress Ballroom behind) from 1911.

By contrast MacKeith's Opera House appears almost austere, its overwhelming feature its sheer size with nearly 3,000 seats and the largest stage in Europe. Its decoration is a series of sinuous arches that conceal lighting and serve to draw the eye to the stage, giving an impression of intimacy and countered by contrasting curves to the front of the dress circle and gallery. It was originally decorated in bands of peach and russet, and timber veneers to the side walls continue in the panelled vestibule that retains its original built-in seating. A royal box was added when the Queen attended a variety performance in 1950.

Charles MacKeith succeeded John Derham as resident architect to the Blackpool Tower and Winter Gardens Company and designed many smaller buildings in Blackpool.

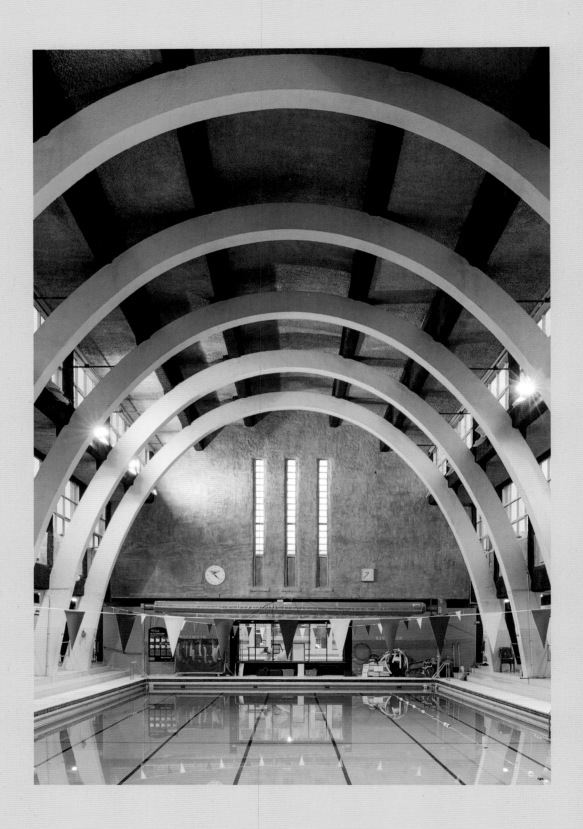

SPORTS
BUILDINGS

TINSIDE LIDO

HOE ROAD, PLYMOUTH
1932–35; J.S. WIBBERLEY, CITY ENGINEER
LISTED GRADE II

Tinside is more conventional in shape than the Jubilee Pool at Penzance– a horseshoe wedged between the rocks off Plymouth Hoe – but it has more elaborate buildings. The seawater pool was the culmination of a protracted programme of providing bathing facilities, since deep water close to the city centre meant there was no safe place to swim. This began in 1913, when the local paper commented that 'whatever romanticists may think of the taming of Tinside, the Town Council has the blessing of all those who go down to the sea in bathing costumes'. But little was done until a colonnaded shelter was erected in 1928. More elaborate buildings followed in 1932, including the higher terraces and a bridge, and part of the rocky foreshore was levelled and concreted to make a beach. The entrance building to the lido on its seaward front dates from 1933, featuring a relief figure of a swimmer.

In 1935 the pool was finally completed. It is semi-circular – 180ft (55m) in diameter. It is formed of mass concrete, strengthened by counterfort walls, and reinforced concrete inner walls, ducts and floors. Fresh seawater was pumped into the pool through three 'cascades' or aerators, giving a complete change of water every four hours at all stages of the tide. At night, the water was floodlit from below, as were the cascades, which went through three colour changes. The pool closed in 1993 because of erosion, but was restored following its listing in 1998, reopening in 2003.

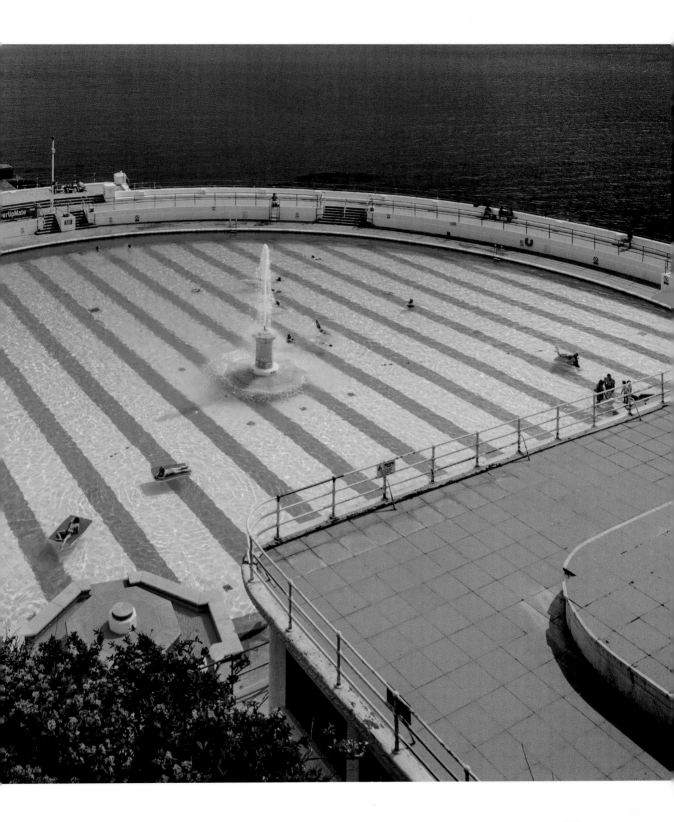

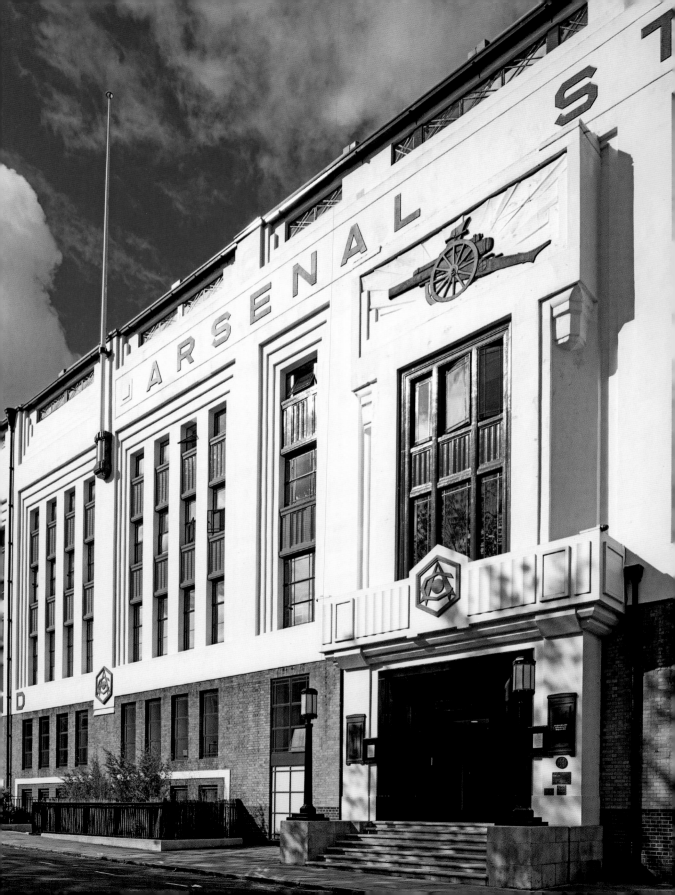

ARSENAL FOOTBALL GROUND/HIGHBURY STADIUM SQUARE

AVENELL ROAD, ISLINGTON, LONDON
1932–36; CLAUDE WATERLOW FERRIER AND WILLIAM BINNIE
EAST STAND LISTED GRADE II

Arsenal Football Club left its native Woolwich in 1913 for a recreation ground at Highbury. When, in 1925, it bought the land outright, manager Herbert Chapman began to realise his ambitions off the pitch as well as on it. First came a larger bank on the north side, followed in 1932 by the West Stand by Ferrier, the first anywhere to make an architectural display. There was seating for 4,100 and standing for 17,000, sheltered by Art Deco sunbursts of glazing at either end. The team responded by winning the league for three seasons in a row in 1932–35. Chapman even persuaded London Transport to change the local Tube station's name from 'Gillespie Road' to 'Arsenal'.

A corresponding East Stand followed in 1936. It was similar in style save that it housed the offices, players' and executive facilities, with an imposingly moulded and decorated facade fronting Avenell Road. Ferrier had died by this time and the design was by his partner, William Binnie.

After Arsenal moved to the new, larger Emirates Stadium nearby in 2006, Highbury was redeveloped with housing around the old pitch. The facades of the East and West stands were retained, including the lettering 'ARSENAL STADIUM' in red, gun-carriage motifs and the club's initials embracing footballs, together with the sunburst glazing to the sides. Inside the East Stand, Chapman's bust (by Jacob Epstein) was taken to the Emirates but the emblem of a gun carriage remains in the terrazzo floor of the 'marble hall' inside the entrance.

JUBILEE POOL

The Promenade, Penzance, Cornwall
1934–35; Captain Frank Latham, borough engineer
Listed grade II

The Jubilee Pool was built near the harbour at the Battery Rocks, a popular bathing spot until damaged by erosion and surrounded by slum housing. The council cleared the old cottages in 1933 to create a park (now mainly car parking), and below it a lido seemed a logical solution to the loss of the beach and a symbol of municipal pride. The pool was 330ft (100m) long by 240ft (73m) wide at its greatest extent, and its depth made it the largest in the country by volume of water, but it is by no means rectangular. Its curves were determined by the rocks on which it is built – Latham used the existing seabed for economy and designed the shape to deflect the pounding storm waves, inadvertently also making a lido of exceptional beauty. The triangular form also disorientates the swimmer used to the straight lines of a conventional pool. The high, streamlined sea walls provide strength as well as shelter, and are terraced to give views of the swimmers and across the town.

The pool was rescued in 1992 by John Clarke, a retired architect who formed the Jubilee Pool Association. It was listed and restored, reopening in 1994, and refurbished in 2014–16. Part of the pool is now heated geothermally.

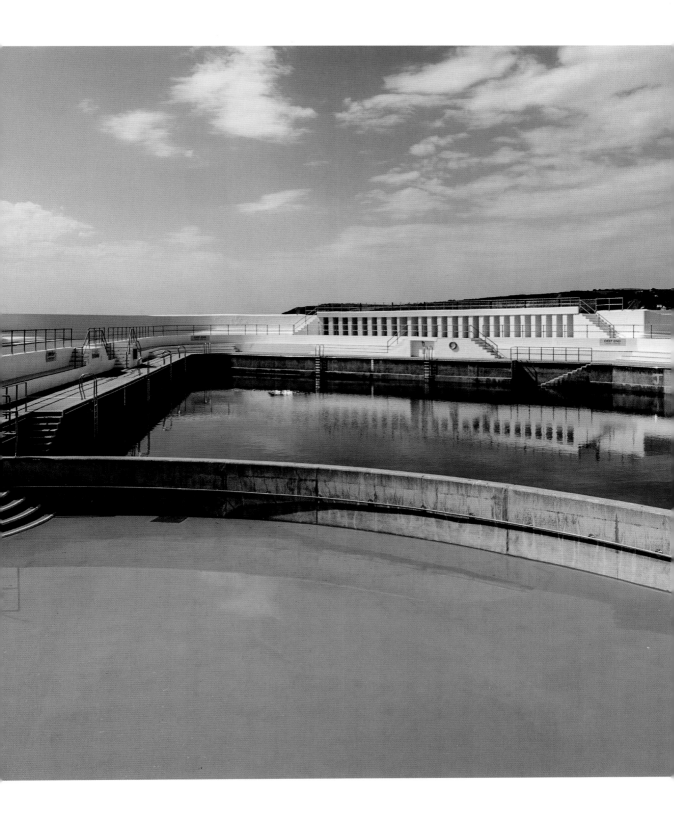

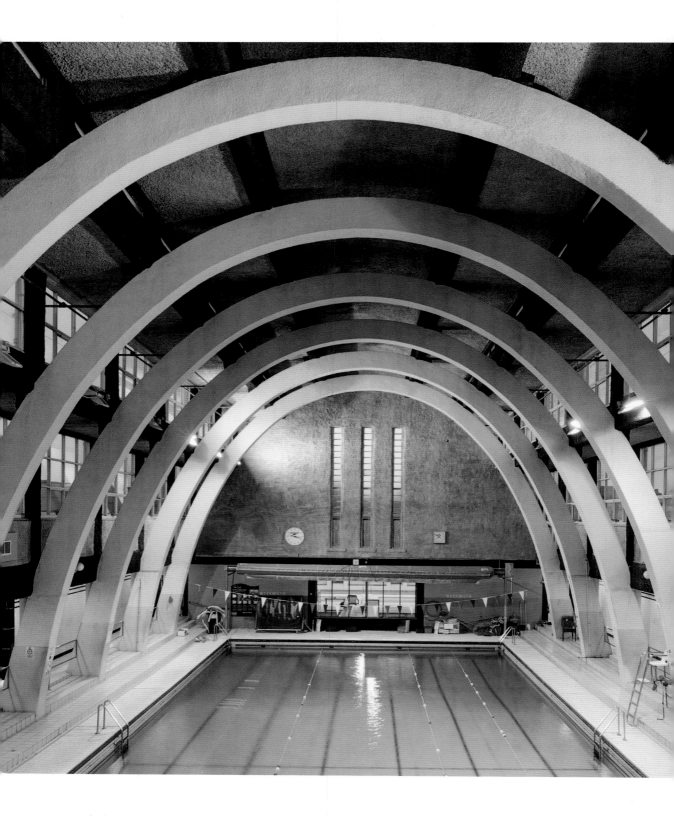

MOUNTS BATHS

Upper Mounts, Northampton
1935–36; J.C. Prestwich & Sons
Listed grade II

Is there a more dramatic, better preserved swimming pool of the 1930s in Britain? The eight reinforced concrete arches, a method of construction introduced in Britain at the Royal Horticultural Hall, proved an economical way of bringing natural light right across the pool, for they permitted continuous clerestory glazing in three diminishing steps. It is entered from the single-storey entrance block faced in Bath stone through doors finished in black Vitrolite. The changing rooms on either side are denoted in the entrance hall by Art Deco raised panels depicting a male and female swimmer respectively, and originally there were also bath tubs (slipper baths) – a reminder that swimming pools had grown out of legislation permitting local authorities to provide for private ablutions. The east side retains the original Turkish baths; the former laundry is now a dance studio. The architects had planned an open-air pool to the rear to replace pools in the local parks, but this was cut to save money.

W.J. Bassett-Lowke, who had commissioned Charles Rennie Mackintosh to alter his house in Derngate, was the chairman of the Baths Committee charged to replace a prison on Upper Mounts. A competition was won in 1932 by J.C. Prestwich & Sons of Leigh, Lancashire, in practice the son Ernest, a specialist in civic buildings. The realised design is a revision of 1934, made to reduce costs after he built the adjoining fire station; the police station balancing the composition was completed only in 1941.

WALTHAMSTOW STADIUM

CHINGFORD ROAD, GREATER LONDON
1935, 1951; ARCHITECT UNKNOWN
LISTED GRADE II

The Goodwood of greyhound racing began as a series of corrugated iron sheds erected by local bookmaker Bill Chandler in 1931 on the site of Walthamstow Grange Football Club and the local tip. Aviator Amy Johnson performed a grander opening ceremony in 1933 when licensed racing began. Speedway was added to the attractions the next year. Chandler's interests were legitimised with the legalisation of on-course betting in 1934, and he began an extensive building programme. Up went a steel-framed stand, followed by totalisator or 'tote' boards, giant hand-cranked calculators that gave the accumulative odds on a night's races. That to the west was unusually elaborate, a stepped concrete structure topped by a clock on either side. The outward face, advertising the stadium across the nearby North Circular Road, was decorated in neon, renewed in 1951 for the Festival of Britain, originally with illuminated pillars either side of the word 'stadium'.

 Greyhound racing evolved out of hare and rabbit coursing, when Owen Patrick Smith of Hot Springs, Dakota, developed an electric hare and circular track. In 1926 the first British track opened at Belle Vue, Manchester, quickly followed by the conversion of White City and Wembley and a new stadium at Harringay. Walthamstow's good looks and family atmosphere appealed to celebrities and city slickers, and the Charlie Chan nightclub was an additional attraction. Yet the stadium lost money and closed in 2008, to be replaced by housing. The listed board and entrance survived and the neon was restored in 2016.

218

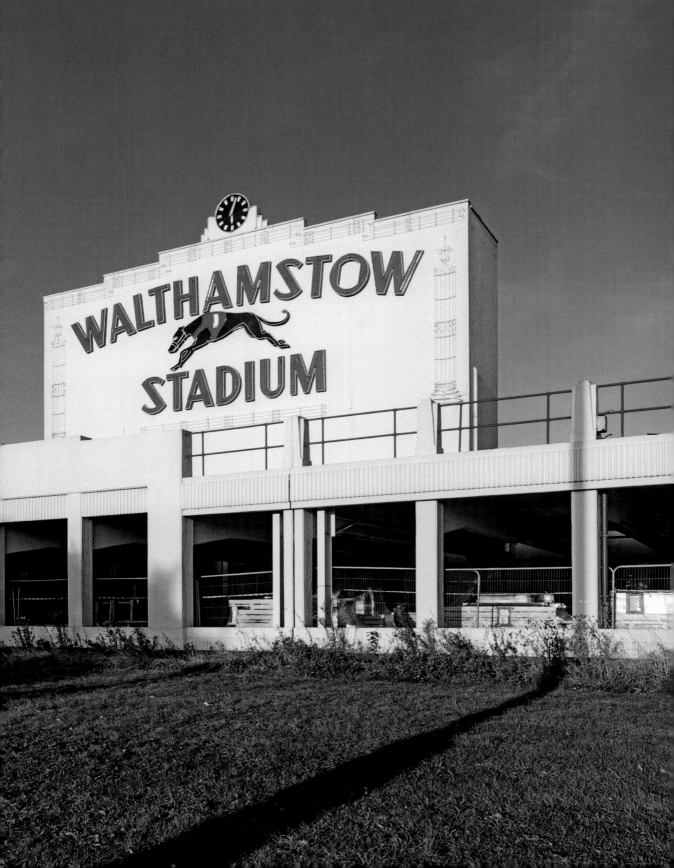

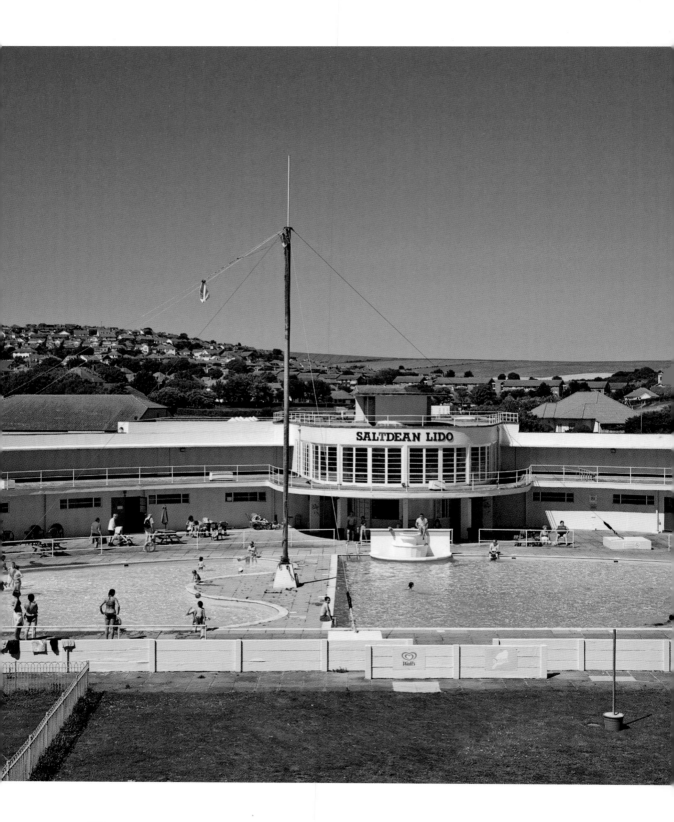

SALTDEAN LIDO

**SALTDEAN PARK ROAD, SALTDEAN, BRIGHTON
1937–38; RICHARD W.H. JONES
LISTED GRADE II***

Saltdean was conceived as a seaside resort by Charles Neville, the developer of downmarket Peacehaven next door. There was a gap in the cliffs to the shore but no beach, so a lido became the settlement's focus, designed by Jones along with a hotel. He may have looked at Erich Mendelsohn's truly modern Bexhill Pavilion along the coast, for there are similarly clean lines and contrasting curves. The main crescent-shaped pool is embraced by two sun-gathering arms, with a first-floor lounge and café thrust forward over the centre, convex and glazed, whereas the wings housing the changing rooms are concave bands of cream walling and ocean-liner decking.

Opened in May 1938, with sixpence charged for admission, the lido attracted both holidaymakers and local residents. Its purified water was aerated by a central fountain – an ice-cream cone in concrete. Visitors could enjoy a three-tiered diving board, a purpose-built beach with 'real seashore sand' and sunbathing lawns. Speakers played music across the grounds and the café was used for dances.

The lido closed once the Battle of Britain began in 1940. Its neon sign disappeared, and the fire brigade used the pool as a water tank. It was reopened only in 1964 by Brighton Council, which added a library. Businessmen took over in 1997, but when they proposed to convert the lido into housing in 2010 a protest movement of local residents took over and restored the pool, reopened in 2017. They are now conserving what is surely Britain's finest lido building.

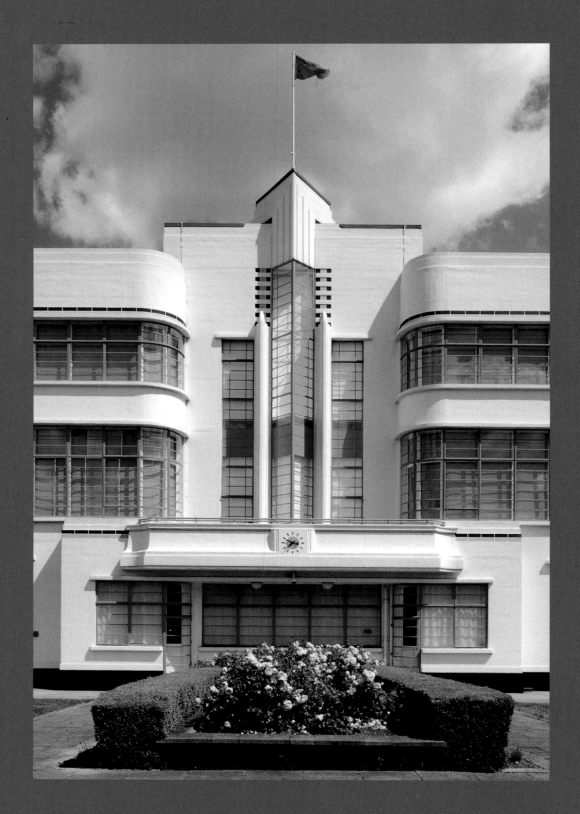

INDUSTRIAL
PREMISES

CARRERAS CIGARETTE FACTORY/ GREATER LONDON HOUSE

180 HAMPSTEAD ROAD, CAMDEN, LONDON
1926–28; M.E. COLLINS, O.H. COLLINS AND A.G. PORRI

Sales of ready-rolled cigarettes took off during the First World War and soared through the 1920s. A leading brand was Craven A, in 1921 the first machine-made cigarettes with cork tips. Bernhard Baron, founder of Rothman's, also owned the Carreras Tobacco Company and built a new factory on Mornington Crescent Gardens amid controversy that led in 1931 to the London Squares Act to preserve open spaces.

Marcus Collins (1861–1944) was fascinated by Egyptian motifs, which he superimposed on Porri's initial design. The Atlas White cement facing was manufactured to look like sand and featured a giant order with papyriform capitals inspired by the tombs at Amarna, coloured using Venetian glass as aggregate. The impressive Considère concrete structure was not pre-stressed (as some modern writers claim), though the columns were admired for the quality of their pre-casting and brilliant colours. Other motifs recalled the Sun god Ra. Two black cats guarded the entrance, copies of the god Bubastis at the British Museum but over 8ft (2.4m) high. More cats' heads lined the main frieze. This was not only fashion: the motif alluded to an earlier taste for Egyptian cigarettes (made from Turkish tobacco) and to the first Rothmans/Carreras brand, Black Cat, introduced in 1904.

When Carreras/Rothmans moved out in 1958, it despatched the cats, one to its new factory in Basildon and the other to its works in Jamaica. The columns were boxed in, ornament removed and the building adapted as offices, to be restored only in 1997–99 by Munkenbeck & Marshall.

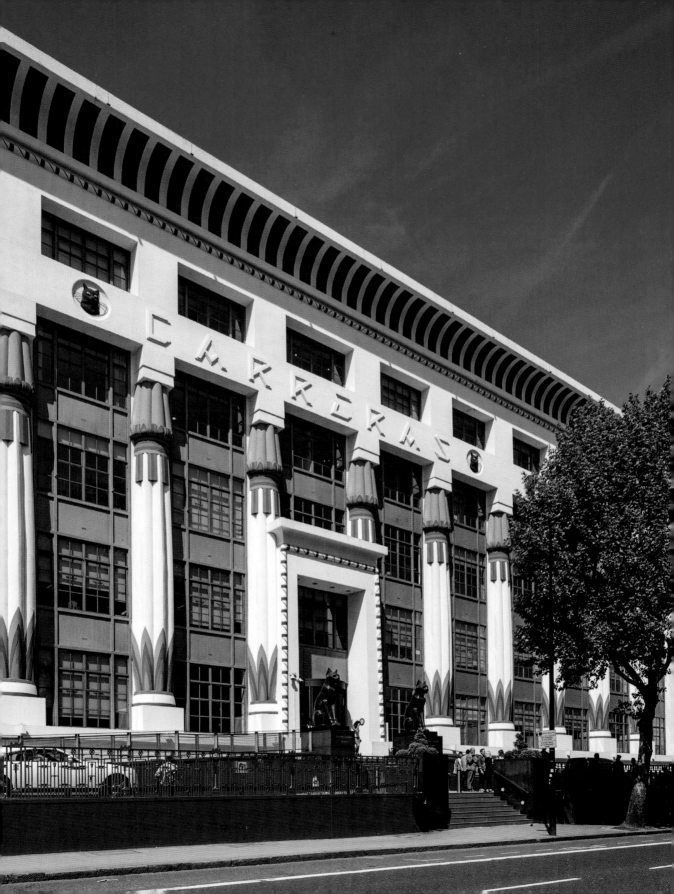

INDIA OF INCHINNAN

**GREENOCK ROAD, INCHINNAN, RENFREWSHIRE
1929–30; WALLIS, GILBERT & PARTNERS
LISTED GRADE A**

When John Cooper and Andrew Melville secured a concession from India Tyres
of Akron, Ohio, to manufacture tyres in Britain, they sought a version of Wallis's
Firestone Factory for their offices. In 1927 they had bought a First World War
airship factory, which they adapted for their production line, and built workers'
housing in nearby Allands Avenue and India Drive. The plant quickly proved
successful and after the Wall Street Crash it became wholly British owned.

Wallis's team designed a two-storey office facade rendered in Atlas White
cement, its metal windows divided by giant piers finished with tiles in red, green
and black forming bases and capitals. A stepped parapet boldly proclaims 'India
of Inchinnan' in curly cypher. Fluted tiles in red and green surround the central
entrance, which is denoted by the sign 'Offices', but was only used by directors and
visitors. Mosaics in the terrazzo floor of the entrance hall still reference India Tyres.
Low curved walls with geometric cast-iron rails, pylon-shaped piers and original
lamp standards surround the frontage. The design was intended to be raised a
storey but instead in 1955, east and west of the two powerful staircase pavilions, the
facade was extended by five set-back bays in a similar style.

India Tyres vacated the site in 1981 and the vandalised factory was demolished
the next year, leaving only the office block. It was eventually renovated for the
software company Graham Technology in 2003 by Gordon Gibb, who added an
extension inspired by airship design.

OXO TOWER

OXO Tower Wharf (formerly New River Plate Wharf),
Upper Ground, Southwark, London
1929–31; Albert W. Moore

The Oxo Tower is a glorious snub, a finger cocked at authority. It was built just as the London County Council was cracking down on illuminated signs and considering legislation for the South Bank, fearing that the neon and moving signs that had arrived in Piccadilly Circus in 1923 would be repeated across London. So Moore, Oxo's company architect, created a tower with round and cross-shaped windows in glass blocks, an invention of the 1880s beginning to find popularity and here specially manufactured by Crittall. The pointed top and copper finial add a Deco touch.

In 1927 the Liebig Extract of Meat Company, manufacturer of Oxo beef stock cubes, had formed a property company to redevelop the General Post Office's central power station (1905–08 by John Taylor) as offices and warehousing for its meat imports. In fact, Moore adapted rather than rebuilt the old brick and concrete structure, save for the addition of his tower. After turning down an electric sign, the council had to give way to the 'elemental geometric forms' of two noughts and a cross. Contemporary accounts admired it as 'London's Lighthouse' and Clive Aslet in *Country Life* described the tower as 'a cheeky parody of Big Ben'.

The LCC's successors, the Greater London Council, campaigned vigorously to save the tower when it was threatened with demolition in 1983, and the London Borough of Southwark made it a miniature conservation area. The architects Lifschutz Davidson Sandilands eventually refurbished the building as shops, workshops, housing and a restaurant in 1996.

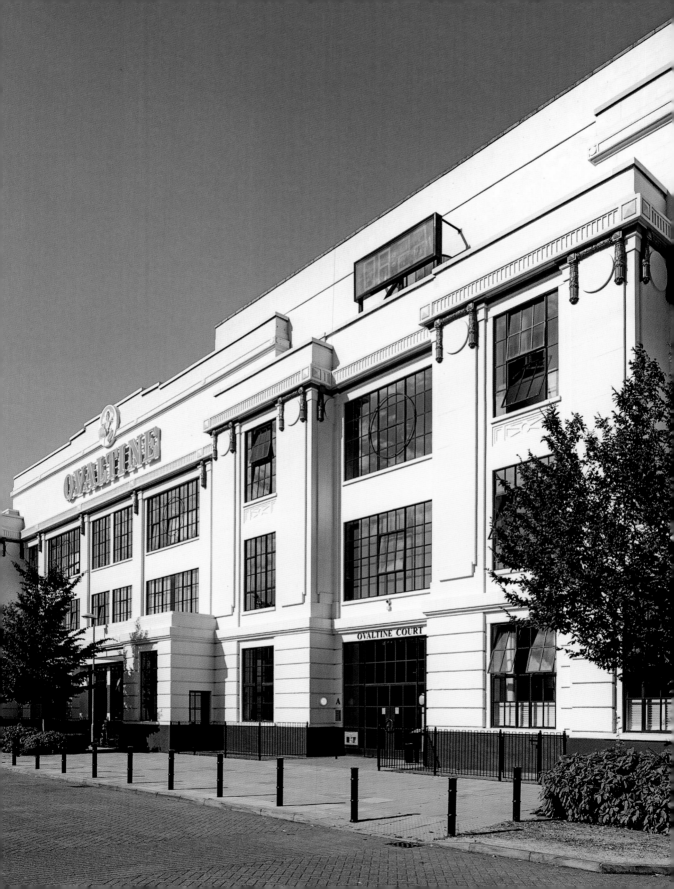

Ovaltine Factory/ Ovaltine Court

Station Road, Kings Langley, Hertfordshire
1929–31; John Albert Bowden

This great facade is a familiar landmark to train passengers from Euston, a faience frontage dominated by a giant order. The idiom is a stripped-down Hoover Factory with classical tassels to its simple capitals, and Bowden and Thomas Wallis were briefly in partnership before the latter formed Wallis, Gilbert & Partners.

Milk-based drinks aiding health and sleep featured large in the 19th-century commercialisation of foodstuffs and were popular before domestic refrigerators became widespread. In 1865 George Wander, a Swiss chemist, established the nutritional value of barley malt, which he combined with milk, eggs and cocoa and marketed as Ovomaltine. His son simplified the name when he brought the drink to Britain in 1910, choosing Kings Langley for his factory in 1911 because it was close to farms, cheap labour and coal supplies via the Grand Union Canal. Ovaltine prospered thanks to aggressive marketing, led in the 1920s by the advertising pioneer Horace Bury and extended in the 1930s to include a children's club and radio programme, *The Ovaltineys*. This led Bowden to expand the factory with its showcase facade and in 1930–32 to build two farms on the other side of the railway for the supply of eggs and milk in mock-Tudor style to distinctive plans, the circular dairy farm (now housing) modelled on that built by Louis XVI for his wife, Marie Antoinette.

The factory closed in 2002 and Ovaltine production returned to Switzerland. Bowden's facade was retained in a mainly residential development by Paul Johnson.

BATTERSEA POWER STATION

KIRTLING STREET, BATTERSEA
1929–35, 1937–41, 1953–55
J. THEO HALLIDAY AND SIR GILES GILBERT SCOTT
LISTED GRADE II*

Battersea Power Station was built in two halves, so that its upside-down table appearance dates only from 1955. Britain's biggest power station on completion, it heralded the creation of the National Grid.

Permission was granted on condition that one half be constructed first and its smoke and sulphur emissions tested before building the other half. The engineer Standen Leonard Pearce conceived the symmetrical design of two stations either side of central boiler houses. Sir Giles Scott was hired to dress up the exterior to assuage local opposition, and he gave the towers a stepped profile, a mounting verticality emphasised by tall decorative flutings of recessed brickwork. He chose fluted pre-cast concrete blocks for the chimneys, and re-created this fluting when in-situ concrete was preferred for its greater stability.

The scale of the turbine hall pushed Halliday to produce a decorative scheme of commensurate power to Scott's. Giant piers are treated as fluted pilasters faced in faience tiles. He lined the adjoining control room in marble, with a steel and glass ceiling the length of the room, and long banks of switches and dials, each annotated with the locale they served.

Part of Station B followed during and after the war to a more austere design. Station A closed in 1975 and Station B in 1983, and they were partly demolished in 1989, when a redevelopment scheme failed. The site eventually passed in 2012 to Malaysia's S.P. Setia and Sime Darby, who are remodelling the building with shops, offices and flats.

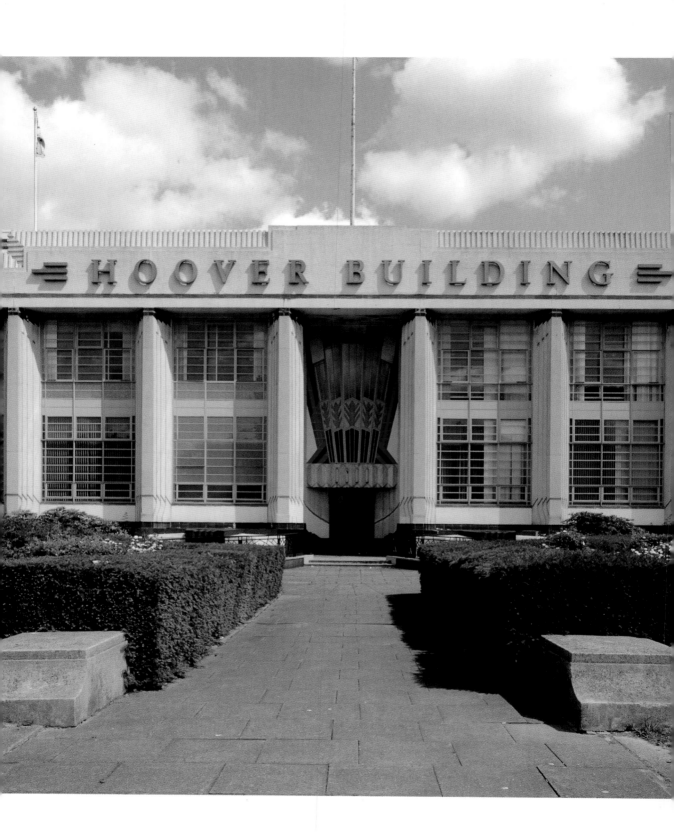

HOOVER BUILDING

WESTERN AVENUE, PERIVALE, GREATER LONDON
1931–33, 1935, 1937–38; WALLIS, GILBERT & PARTNERS
LISTED GRADE II*

The demolition of the Firestone Factory left Hoover as the supreme example of an Art Deco industrial building in Britain. The Western Avenue was conceived as a new arterial road towards Oxford in about 1910 but reached Perivale only in 1927. The new road and proximity to the railway made for a prime factory site, with plentiful housing for the skilled workforce available nearby.

The vacuum cleaner was invented in 1908 by an asthmatic Ohio caretaker called Murray Spangler, who obtained financial backing from his cousin W.H. Hoover. Between 1919 and 1931 they exported machines to Britain through Canada. Thomas Wallis's partner, Frederick Button, oversaw the design and supervised the work, beginning with the office front that survives today. The engaged fluted columns, with faience bands but no moulded capitals, metal windows and a giant sunburst over the entrance advertised modernity to passing motorists. The frontage was carefully landscaped, but the interior was simple save for an entrance hall with fluted pilasters and a staircase with chevron sunrise ironwork, and resplendent green urinals in the gentlemen's lavatory.

Additions followed from 1932 with a factory for Hoover's new range of smaller domestic appliances. A canteen block was added by Wallis's assistant, J. Macgregor, in 1937–38, lighter, more fluid and including a dance floor.

The complex was acquired in 1989 by retailers Tesco, who demolished the rear factory for a supermarket but left the frontage range as offices. These were converted into 66 flats in 2017–18.

COTY FACTORY/ SOFTSEL COMPUTERS

941 GREAT WEST ROAD, GREATER LONDON
1932; WALLIS, GILBERT & PARTNERS
LISTED GRADE II

The Great West Road through Brentford gained renown as the Golden Mile for its prestigious factories and advertising signs. Fragments survive in a variety of commercial and residential uses.

Opposite the site of Wallis's lamented Firestone Factory (whose concrete fence posts survive) are the frontage blocks from two smaller developments by the practice. One is Westlink House, built in 1928–30 on the Firestone model for Pyrene, manufacturers of fire appliances. The central entrance has a faience surround with fat piers, set under a staircase tower serving first-floor offices and a boardroom, with long wings (now altered) to either side.

The adjoining Coty Factory marked a change of style for Wallis. Coty was a French perfume company that chose to manufacture in Britain when, in 1930, it expanded into toiletries and cosmetics. Its building is altogether simpler, perhaps reflecting the lack of a headquarters office function: two wings with bands of windows either side of a slightly stepped centrepiece. The distinctive features are three horizontal bands either side of the entrance (repeated in chrome on the doors), convex capitals to invisible piers defined only as flutes dying into the concave walls. They acknowledge the fat, stylised classicism of the elegant pavilions built for department stores at the 1925 Paris Exhibition, a nod to the French clients. Otherwise the building marks a move towards the simpler moderne idiom of the 1930s. Coty moved out in 1979 and the building became a clinic and offices, but the entrance hall and spiral stairs remain.

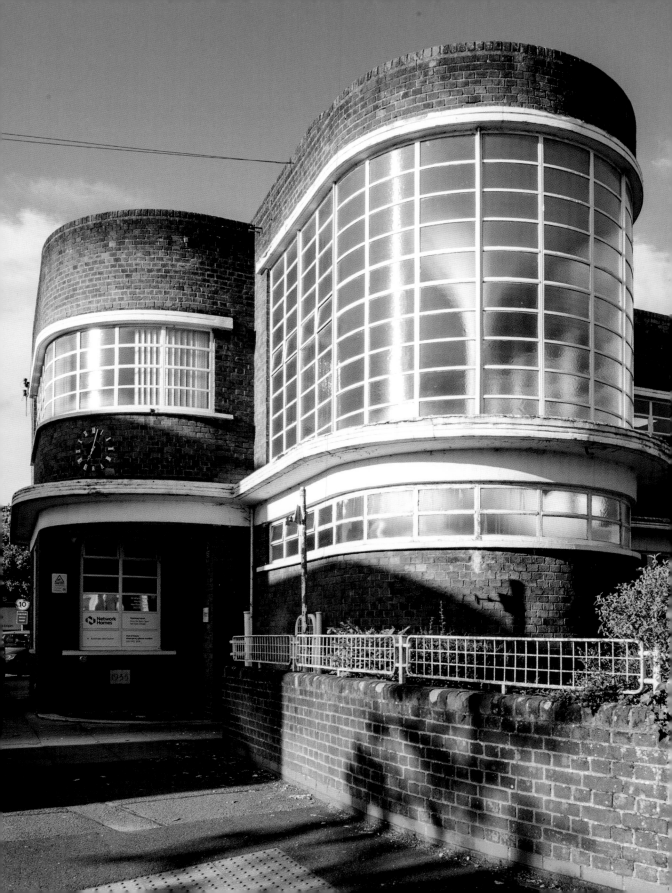

ADDIS FACTORY/ RIVERSMEAD

WARE ROAD, HERTFORD
1935; DOUGLAS HAMILTON
LISTED GRADE II

Hertfordshire as well as Middlesex was a centre for new light engineering industries in the 1930s, ranging from aerospace to household goods, but – still more than in West London – their sleek, moderne factories are becoming rare. Addis's low brick lines contrast with narrow bands of horizontal framed windows that reveal set-back blue columns and culminate in a projecting staircase tower that presents a great glazed curving front. A clock with individually mounted numbers adds an advanced Scandinavian touch.

William Addis is credited with inventing the toothbrush in 1780, using bone, wood and pig's bristles. His descendants supplied toothbrushes to the troops during the First World War, introducing the habit of teeth cleaning to many men. In 1919 the firm moved from London to Hertford, where a new factory began production in 1920, and in the late 1930s adopted celluloid plastics and nylon to create the modern Wisdom toothbrush. The building's clean lines symbolise hygiene as well as modernity – its shape a toothbrush on its side. The office interiors have been remodelled, but the entrance lobby, stair (supported by a concrete column) and first-floor boardroom retain original detailing.

Addis opened a second factory in Swansea in 1965, which took over production following a management buy-out in 1996. Although the rear factory buildings have been demolished, there survives a facing building from the 1950s (now also offices) that repeats elements of the streamlined style alongside a square block punched with porthole windows more clearly of the age of austerity.

PITHEAD BATHS

**CHATTERLEY WHITFIELD COLLIERY, STOKE-ON-TRENT
1936–37; G.H. OLIVER OF THE MINERS' WELFARE COMMITTEE
LISTED GRADE II***

The pithead baths built across Britain's mining areas in the late 1930s were distinctive, Dudok-inspired designs. Their curved lines and simple brickwork proclaimed cleanliness and health, enhanced by natural light – important for men who spent long shifts underground. Many, like Chatterley Whitfield, adopted an 'L'-shaped plan divided into three areas: 'clean' lockers for home clothes, green tiled communal showers that supplied every man with 6 gallons of water, and ventilated, heated lockers where wet pit clothes could dry overnight. Chatterley Whitfield was the second largest example, designed for 3,000 men, and included a canteen.

Chatterley Whitfield was Britain's most productive colliery in 1937, the first ever to extract a million tonnes of coal in a year. Yet despite a decade of growth and national legislation it took until January 1938 before facilities opened for miners to wash and change.

An Act of Parliament in 1920 had established the Miner's Welfare Fund from a levy on coal and created a committee to build social facilities and pithead baths. Appointed in 1926, its chief architect, John Forshaw, established regional teams, who designed over 300 baths complexes. He repeated this system of group working when, in 1941, he was appointed architect to the London County Council.

Chatterley Whitfield Colliery closed in 1976 when it proved easier to extract its coal from an adjoining pit. It became a museum, thus surviving the wholesale demolition of collieries in the 1980s but not the financial difficulties that saw its closure in 1993. Its future is precarious.

241

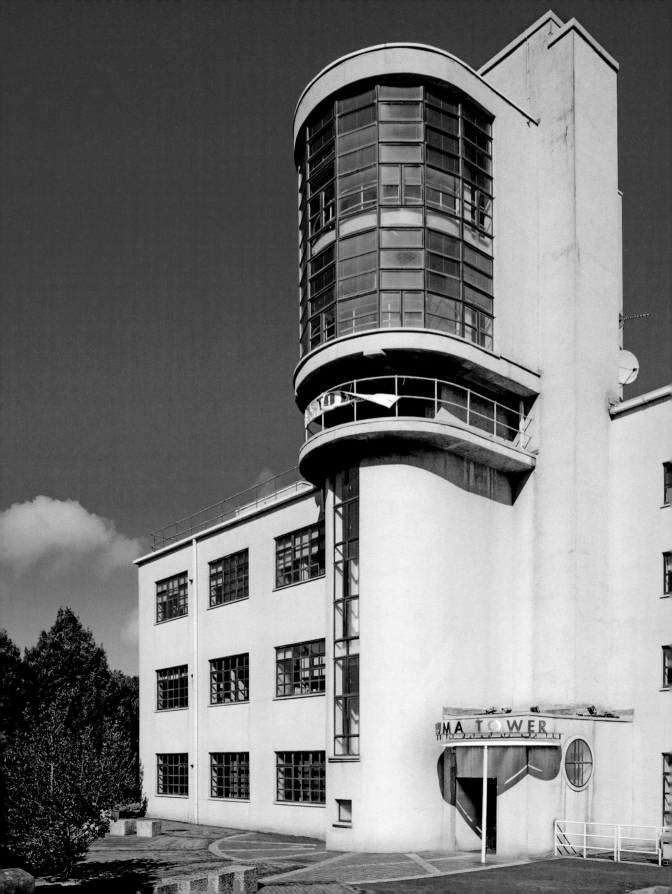

LUMA LAMP FACTORY/
LUMA TOWER

RENFREW ROAD, SHIELDHALL, GLASGOW
1936–38; CORNELIUS ARMOUR, SCWS
LISTED GRADE B

Luma was the Glasgow headquarters of the first international co-operative factory for electric lamp manufacture, opened to coincide with the Empire Exhibition of 1938. It was a joint experiment by the Scottish Co-operative Wholesale Society (SCWS) with the Swedish Co-operative Society to combat the international Phoebus cartel that was producing only short-lived and expensive bulbs.

Built largely of brick concealed behind render, the factory's moment of drama is the projecting conning tower on top of the glazed staircase, used for testing the lamps' longevity and a showcase for the co-operative's research. Armour was architect to the SCWS, and designed shops, factories and dairies across Scotland, but this work is very similar to the Lumafabrikens building in Stockholm, now also offices and housing.

Luma is all that survives of Shieldhall, one of Glasgow's largest industrial sites and built to answer a demand for SCWS products. By 1918 there were 17 different departments, producing a wide range of manufactured goods and providing employment for some 4,000 people. The SCWS sought to provide model conditions for their workers and the factory was to be accompanied by a garden village, until the opening of an electric tramway rendered this unnecessary.

After use as a caravan showroom and years of dereliction, Cornelius McClymont Architects converted the building into 43 flats for Linthouse Housing Association, in 1995–96. The fenestration has been reconfigured, somewhat reduced and regularised, save for the tower, which still dominates. New apartments to the rear funded the restoration.

LITTLEWOODS

EDGE LANE, LIVERPOOL
1938; GERALD DE COURCY FRASER

Littlewoods was a vast empire, including department stores and catalogue shopping, all founded on football pools, which first offered the chance of winning large prizes for a small stake. This mighty headquarters was their home, used for printing coupons each week and to check those submitted for the winner. It has a simple grandeur thanks to its central clock tower, flanked by wings each 26 bays long, defined by a giant order of pilasters, a fluted frieze and small lights (long gone) between every sixth window. The end pavilions are slightly battered, but also curve inwards, providing the one piece of spatial complexity. There were no elaborate interiors, just huge spaces housing the printers with above them open offices where rows of women checked coupons.

John Moores started the pools in 1923 and became a millionaire by 1931, when he used the printing part of the business to develop a mail-order catalogue. During the war the pools companies combined as Unity Pools, and slips continued to be checked while the presses were requisitioned to print government forms and part of the building given over to produce barrage balloons and parachutes as well as fighter aircraft.

Gerald de Courcy Fraser was Liverpool's leading commercial architect in the interwar years, also designing Lewis's city-centre department store. The Littlewoods Building has been empty since the mid-1990s, but there were permissions to convert the building into film studios when it was gutted by fire just three days after this photograph was taken.

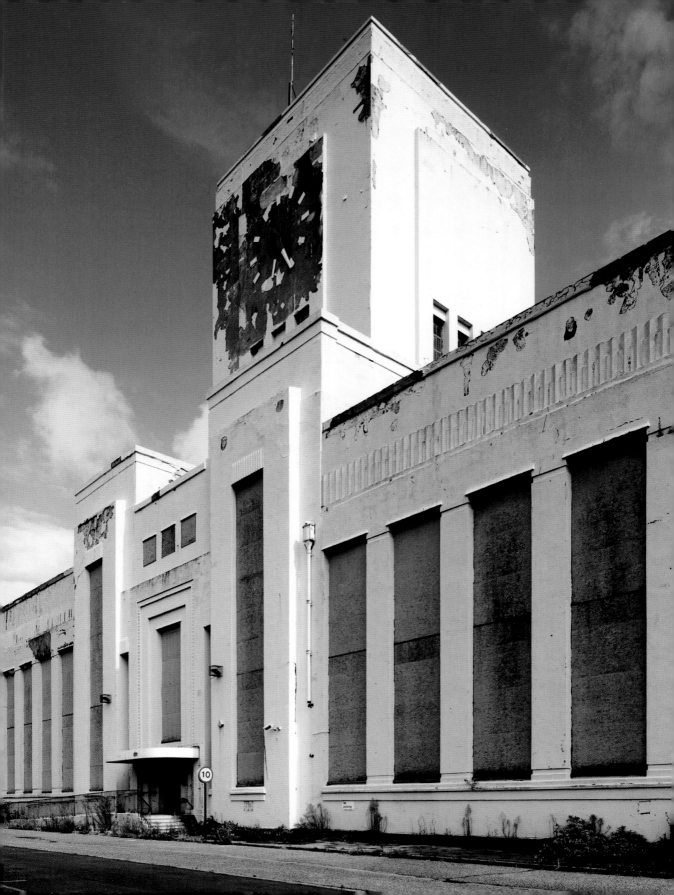

TRANSPORT

George's Dock Ventilation and Central Control Station, Mersey Tunnel

GEORGE'S DOCK WAY, LIVERPOOL
1925–33; HERBERT J. ROWSE
WITH SIR BASIL MOTT AND JOHN A. BRODIE, ENGINEERS
LISTED GRADE II

This is the most sophisticated of four towers built for the Mersey Tunnel, properly Queensway, that, with the tunnel entrances, comprise a great Art Deco complex. There are three brick towers on the Birkenhead shore, and the original toll booths at the entrances were also Art Deco in style, along with the lamp pillars. Tucked behind the Three Graces at Pier Head, St George's tower is finished in Portland stone, with relief sculptures by Edmund Thompson on each side of its tapered tower, bronze figures and empty niches for more. The detailing of the entrances and the ironwork is exquisite, while the set-backs and a giant scalloped cornice are worthy of a far larger and less industrial building. Most of the interior is taken up with the air shaft and the immense machinery that powers it, with offices on its lower flanks. Vintage knobs and switches survive in the control room, but the tunnel is now governed by computers.

The tunnel was a long-heralded response to the problem of traffic congestion crossing the River Mersey by ferry. First proposed in the 1820s, the project was revived in the 1920s in response to growing goods traffic and as a means of reducing unemployment. At just over 2 miles (3.2km), on its official opening in July 1934 it was the longest road tunnel in the world, an honour it held until 1948, and included a tramway below the road that never opened. Kingsway, a second, brutalist, tunnel followed to the north in 1971.

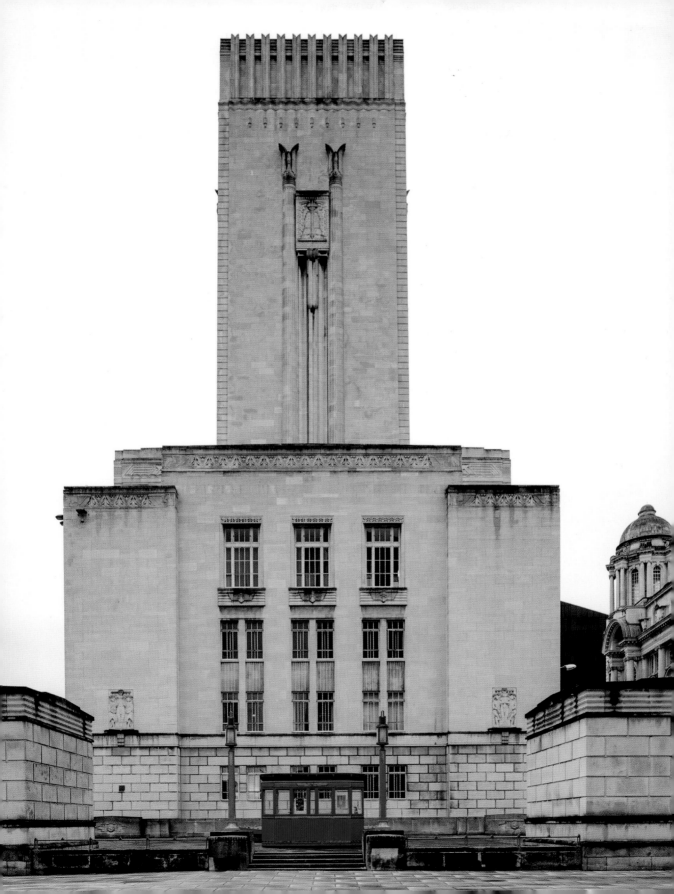

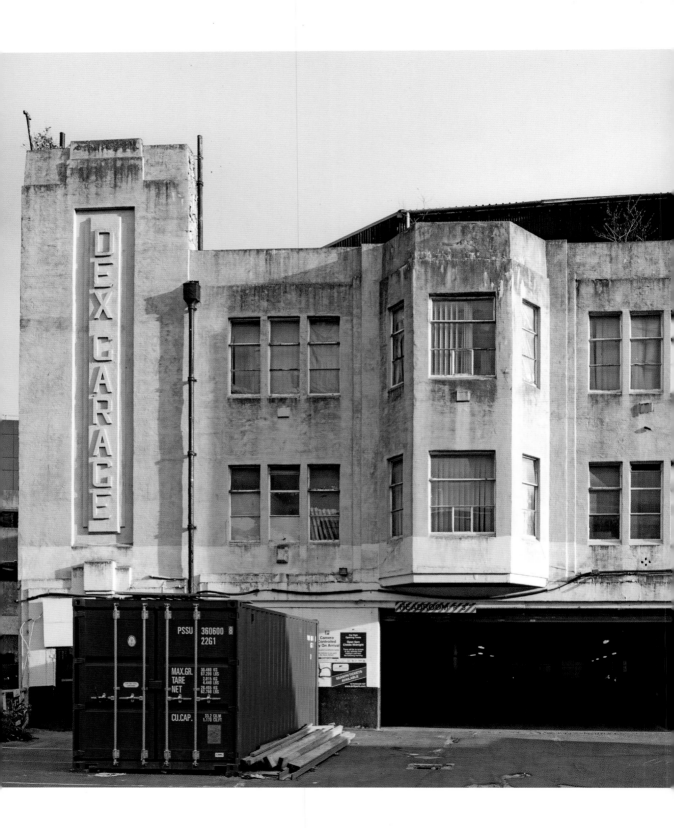

250

DEX GARAGE

New Bridge Street, Newcastle upon Tyne
1930–31; L.J. Couves and Partners

Set close to the A1 north of the Tyne Bridge and Pilgrim Street, developed with offices and entertainment in the 1930s, the Dex was promoted as 'the gateway to Newcastle'. The name was a homage to the Lex car park off Lexington Street, London (1929), and a pun on its parking decks.

The construction is an unusual mix of a steel-framed structure with suspended concrete floors, ramps, roof and staircases. In addition to 360 spaces on three floors, the Dex included rest and washing facilities for chauffeurs while they waited for their employers, which are still recognisable; a car lift and turntables, the latter removed only in 2007. The passenger lift in the right-hand tower retains its original doors with copper glazing, and the ramps have their original steel handrails. The forecourt contained petrol pumps and a showroom until c.1980. In 1934 the council approved plans for a rooftop showroom, car wash and office, although a steel box was added there only in the 1940s.

Though unlisted (English Heritage turned it down in 2009) the Dex is actually more complete than the Daimler Garage in London (see page 255). The appeal is that it is still fully used despite its near total dereliction. The oldest ramped car park outside London, it came back into use in 2017, although it remains under threat of demolition. The adjoining Paramount (later Odeon Cinema) by Verity and Beverley of the same date, and with which it was associated, was demolished in 2016–17 after standing empty for 14 years.

VICTORIA COACH STATION

BUCKINGHAM PALACE ROAD, VICTORIA, LONDON
1931–32; WALLIS, GILBERT & PARTNERS
LISTED GRADE II

Victoria's ascendancy as a hub for coach travel is indebted to the dominance of Brighton as an early destination from 1904 and again from 1919. A local trader, Len Turnham, was drawn into a pool of nine operators, which in 1925 formed a single company, London Coastal Coaches. They leased a temporary site in Lupus Street, Pimlico, until the Buckingham Palace Road site became available just as new regulations made licensing compulsory and eased out smaller operators.

Opening on 10 March 1932, Victoria Coach Station comprised a ground-floor booking hall, shops and buffet, with a lounge bar and 200-seat restaurant at mezzanine and first-floor levels. The rest of the first floor was the company offices, with lettable offices above – including those of architect Thomas Wallis himself. It was Britain's largest coach station, London Coastal's advertising promising 'comfort and pleasure' from its services and its glamorous image enforced by an 'original and bold colour scheme' of green and black faience contrasting with red faience and coloured glass – all features that have now disappeared. What survives is the building's bold massing, strong horizontal wings with curved ends contrasting with a corner tower that steps forward and upward, with fluted mouldings and chevron-moulded mullions. Thomas Wallis is most closely associated with factory buildings, but he also built bus stations across south-east England for the London Passenger Transport Board's country services.

The freeholder, Grosvenor Group, announced in 2013 that it wanted to relocate the coach station and redevelop the site, but the building was then listed.

DAIMLER HIRE GARAGE/ MCCANN ERICKSON

7–11 HERBRAND STREET, LONDON
1931–33; WALLIS, GILBERT & PARTNERS
LISTED GRADE II

A set-back Art Deco building is a surprise amid the hotchpotch of housing and back offices tucked down Herbrand Street, always a service street to the grander thoroughfares of Bloomsbury. It stored the Daimler car fleet, inaugurated in 1919 as a backup service for owners whose own vehicles had broken down, but quickly expanded with 250 vehicles for general hire. A staircase and lift tower soars above the entrance, denoted by the tall, thin window that is the most distinctive piece of Wallis Gilbert styling, with pairs of corner windows to the sides linked by bands in the render that follow the lines of the glazing bars. It is less obvious that the correspondingly broad drum to the right with its spiral band of windows was a continuous car ramp serving four storeys of parking – a triumph of in-situ concrete casting for its date. Each floor had an electrically operated washing plant, and there was a waiting room, attendants' office, lavatories and telephones. The basement stored privately owned vehicles, served by its own ramp tucked to the left of the main entrances.

After many years as the headquarters of a coach firm and the London Taxi Company, whose cabs continued to use the ramp, in 1998 the building was restored and raised a storey by PKS Architects as offices for an advertising agency. Its features are all still there, save that the ramp entrance is now a very large window and revolving door, yet it is less obviously a garage.

OSTERLEY STATION

GREAT WEST ROAD, GREATER LONDON
1931–34; STANLEY HEAPS
LISTED GRADE II

Charles Holden's stations on the Piccadilly Line are rare beacons of modernism in suburban London. Holden met Frank Pick, managing director of London Underground, in 1915 through the Design and Industries Association, of which they were co-founders. He discovered an exceptional client thanks to the latter's belief in good design and attention to every detail. Holden first raised the standard of design for the stations on the Northern Line's southern extension from Clapham South to Morden, and designed the company's headquarters at No.55 Broadway in 1925–29. Pick visited the 1925 Paris Exhibition and was unimpressed; instead, he and Holden toured Sweden, Denmark, Germany and Holland, particularly admiring the simple brick architecture of Germany and Holland.

The first outcome of their recce was a truly modern box of brick and glass, topped by a concrete lid, for Sudbury Town Station in 1930–31. More Piccadilly Line stations followed, far more than Holden could handle, and a handful were designed by London Underground's in-house architects, led by Stanley Heaps. At Osterley, he replaced Holden's outline scheme for another 'box' with a low ticket hall and a spire of glass blocks, a glowing Deco symbol when seen from the Great West Road. Historians have likened this finial to the pylons outside J. Wils's Olympic Stadium or J.F. Staal's De Telegraaf offices, both in Amsterdam, but Charles Hutton, who assisted on the design, claimed that it was inspired by a natural form such as a cactus. The central control centre and ticket office was replaced by a larger office to one side in 1989.

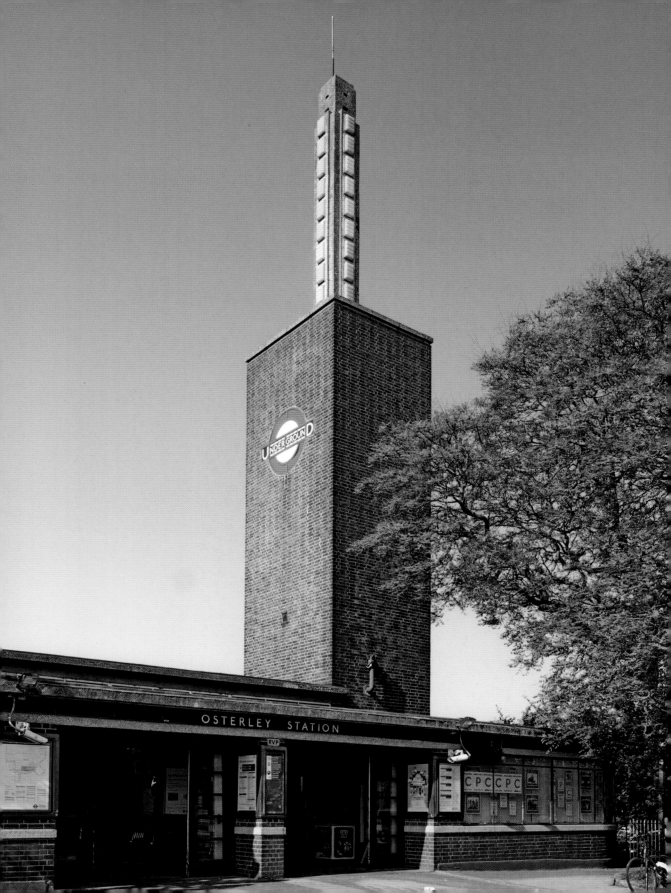

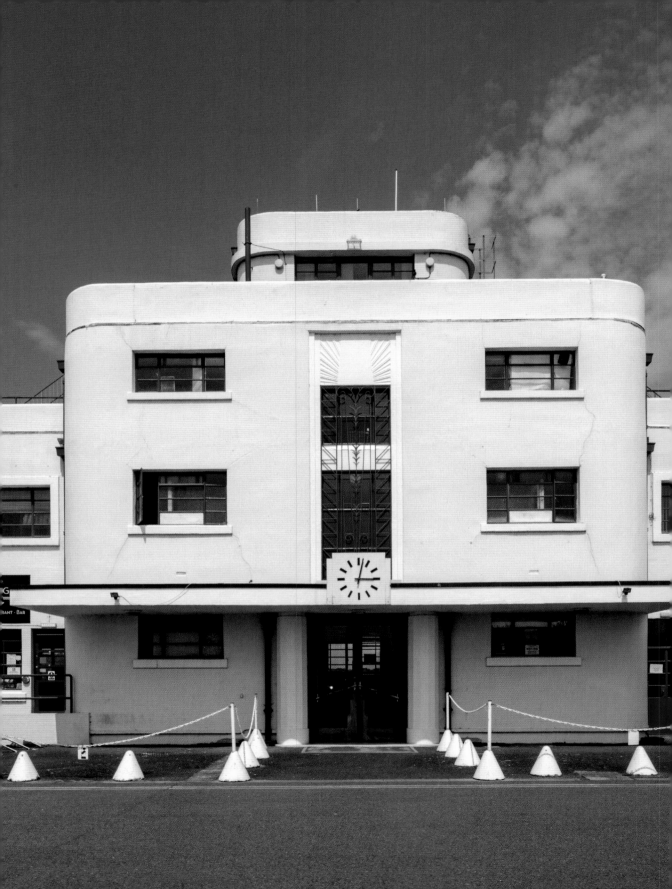

SHOREHAM AIRPORT (BRIGHTON CITY AIRPORT)

**CECIL PASHLEY WAY, SHOREHAM-BY-SEA, WEST SUSSEX
1934–36; R. STAVERS HESSELL TILTMAN
LISTED GRADE II***

This surprisingly small building resembles a monoplane on plan. It contains a double-height foyer with a heavily moulded balcony, a wing of offices and the Hummingbird Restaurant, with original bar fittings. Two tiny aircraft continually circle the shallow central dome. A new control room (1988) sits atop the old, but otherwise the building retains its original character. It has appeared in several episodes of *Poirot* and in the film *The Da Vinci Code*. Alongside, No.2 Hangar (listed grade II) also dates from 1936.

George Wingfield first leased grazing land in 1909 for a flying base at Shoreham, which became popular with old boys from nearby Lancing College. The airport opened formally in 1911, and is the oldest in Britain; it also claims the world's first cargo flight, for a box of light bulbs was flown to Hove that year. It was used for training pilots in the First World War and as a base by John Alcock, one of the first men to fly the Atlantic.

The boroughs of Brighton, Hove and Worthing took over Shoreham as a municipal aerodrome in 1933, and brought in local architect S.H. Tiltman to design a terminal. Tiltman was a prolific designer of public houses, and the terminal has a similar mix of practical commercial nous and joie de vivre. Its success led to further commissions at Belfast and Leeds airports.

After wartime use by air-sea rescue and other services, civilian flying clubs returned to Shoreham in 1946, though commercial flights never recovered their pre-war activity.

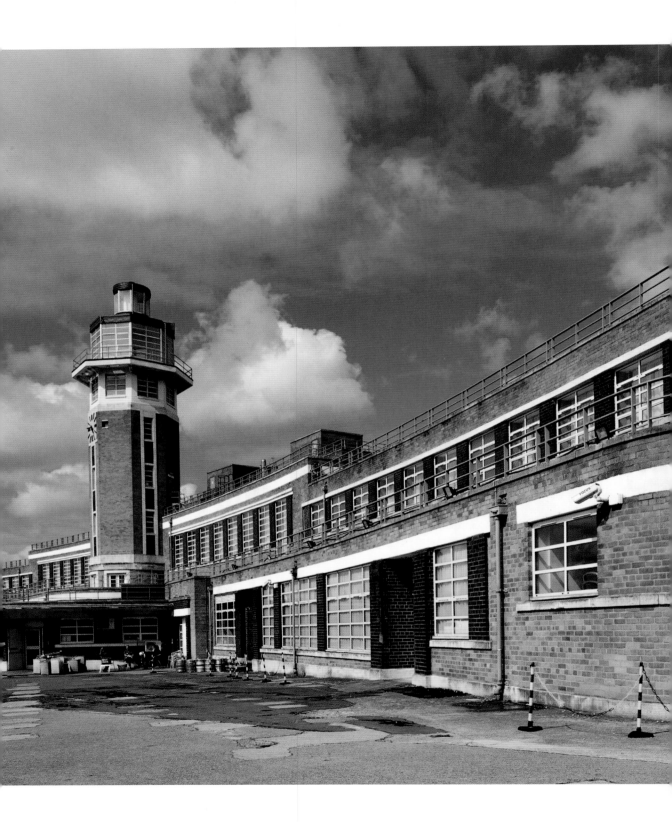

LIVERPOOL (SPEKE) AIRPORT/CROWNE PLAZA LIVERPOOL JOHN LENNON AIRPORT HOTEL

SPEKE ROAD, LIVERPOOL
1935–40; E.H. BLOOMFIELD, LIVERPOOL CITY COUNCIL
LISTED GRADE II*

Liverpool was one of the first municipal airports built in Britain. It began as an elaborate concept that included a seaplane hangar and a hotel. Instead only a conventional hangar was built, along with a control tower – resembling a lone lighthouse – and these not for five years after the first scheduled flights to Manchester and London, and two years after the airport officially opened in July 1933. The eventual terminal building that opened in 1938 exudes civic grandeur as well as the symbols of flight, its long wings resembling those of an aeroplane. The architect was an assistant in the city architect's department more expert in housing. The plan was based on Hamburg's Fuhlsbuttel Airport of 1931 (long demolished), visited on a fact-finding mission by the council in 1934 along with airports at Amsterdam and Berlin.

This was the most expensive terminal built in Britain in the 1930s. Its brown brick is contrasted with turquoise green railings that protected spectator terraces – visitors to its air-side restaurants were at first a major source of income. The drainage hoppers are decorated with relief figures of aircraft. The tower features a clock on its flight side. The hangar was the largest in Britain and decorated with sunburst glass and bas-relief eagles. A second hangar followed in 1939-40, simpler save for a winged crusader figure wearing headphones and little else.

The terminal was repaired and extended in 1999–2001 and, true to the original concept of 1932, it is now a hotel.

STATES OF JERSEY AIRPORT

L'Avenue de la Commune, St Peter, Jersey
1936–37; Norman & Dawbarn
Listed grade 2

Nigel Norman was a flying ace, surviving the First World War only to be killed in the second. Dawbarn was the designer, and when, in 1931, he won a RIBA award to study airports in the United States Norman piloted them some 7,000 miles (11,000km) in a de Havilland Puss Moth. Thereafter, they dominated the building of Britain's early airports, including Manchester, Birmingham, Wolverhampton and Brooklands as well as those on Guernsey and Jersey. Dawbarn made his first designs for Jersey in 1934 after the Chamber of Commerce had proposed building an airport as early as 1930. The plan is aeroplane-like, with low wings providing restaurants for passengers and plane-spotters either side of a central office building and control tower. Equally appropriate are the curved moderne facades, in which some horizontal steel windows survive.

With its bold crest and date stone, the terminal is the first building seen by most visitors to Jersey, and indicates the island's growing prosperity in the 1930s as a centre of commerce and tourism. St Helier, the main town, retains some good shopfronts and has private houses in all styles dotted around the island, as well as many pastiche Art Deco flat developments from the 1980s.

The terminal was sited to allow flights to take off in all directions, for with only a grass runway wind direction was all-important. The building was set for demolition, despite its listed status, but a campaign to save it in 2019 scored an early success.

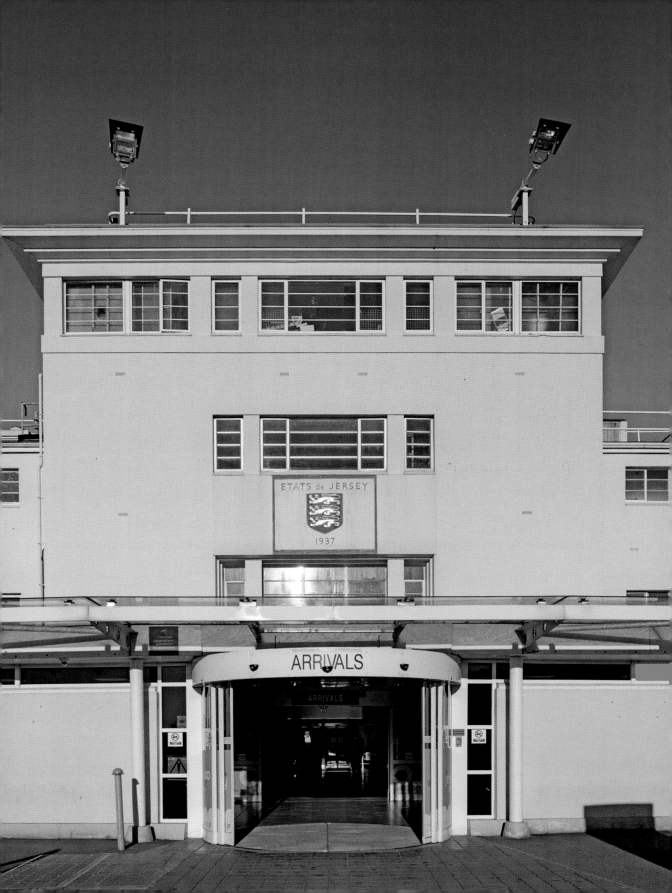

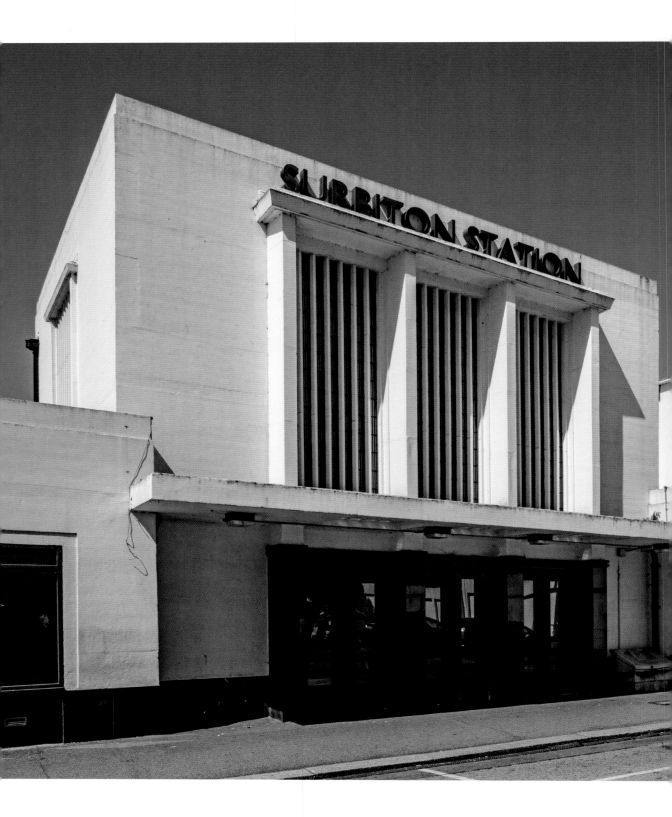

SURBITON STATION

VICTORIA ROAD, SURBITON, GREATER LONDON
1937; SOUTHERN RAILWAY ARCHITECT'S DEPARTMENT
UNDER J. ROBB SCOTT
LISTED GRADE II

One station on Britain's mainline railways (then divided between four private companies) matched the radicalism of those being built by Charles Holden for London Transport. Ironically, it was in leafy, conservative Surbiton, one of the first commuter towns to be built when the railways reached Surrey in 1838.

Surbiton's rebuilding owed most to the growth in commuter traffic as central London filled with offices. It also coincided with Southern Railway's partial electrification of its lines, though there remain some smoke deflectors on the footbridge added to protect the white reinforced concrete. There is a clock tower, its horizontal banding indebted to the 1925 Paris Exhibition, while the two ticket halls are lined in limestone polished to resemble marble and entered through heavy wooden doors finished in bronze. The mullions of the main windows have all the weight of a lost giant order, but the station signage is ultra-modern and a curved shopfront flanks the busier north side. And the scale is grand. The complex footbridge separated passengers from those merely crossing the tracks and from freight (the goods yard is now a car park).

Who designed all this? The chief architect of Southern Railways, James Robb Scott, gets all the credit or none – the latter is probably nearest the truth, if we accept Max Fry's acerbic recollections of working for him in the 1920s. By the late 1930s Scott had an excellent team of assistants working in the moderne style across the southern counties, and this was their finest moment.

EMPIRE AIR TERMINAL/ NATIONAL AUDIT OFFICE

**BUCKINGHAM PALACE ROAD, VICTORIA, LONDON
1938–39; ALBERT LAKEMAN
LISTED GRADE II**

Opposite the Victoria Coach Station is another streamlined building, now offices but built as the Empire Terminal, headquarters and passenger check-in for Imperial Airways. Something of its glory survives in the ten-storey landmark clock tower, despite crude additions from 1955. The sculpture of winged male and female figures over the world that enlivens the central entrance was by Eric Broadbent.

The idea was that passengers could assemble on the ground floor, check in their baggage and travel in style to the isolated Croydon Airport, to flying boats which operated from Southampton Harbour or, later, to Gatwick. The building had its own basement access to platform 19 of Victoria Station behind, where passengers could step on to a special train consisting almost entirely of first-class Pullman carriages. The main survivor today is a boardroom in the tower, panelled with hardwoods from the empire.

Imperial Airways was nationalised as the British Overseas Airways Corporation specialising in long-haul flights in April 1940. The idea of a convenient central London check-in remained an essential part of luxury air travel into the 1950s, when BOAC's rivals, British European Airways, built a new terminal on Cromwell Road, Kensington, to serve Heathrow. The Victoria building remained in use until 1981, but in 1984–86 it was converted into the National Audit Office and was refurbished again in 2009.

FOOTNOTES

[1] Henry-Russell Hitchcock and Philip Johnson, *The International Style*, New York, W.W. Norton, 1932; 1994 edition, p.29.

[2] Berthold Lubetkin, a series of annotated studies produced for students and subsequently for publicity, illustrated in John Allan, *Berthold Lubetkin: Architecture and the tradition of progress*, second edition, London, Black Dog, 2012, p.276.

[3] Osbert Lancaster, *Homes Sweet Homes*, London, John Murray, 1939, pp.64-77.

[4] Alistair Duncan, introduction, in Maurice Dufrène, *Authentic Art Deco Interiors: From the 1925 Paris exhibition*, Woodbridge, Antique Collectors Club, 1989, pp.10–29.

[5] H.C. Bradshaw, 'Architecture', in Department of Overseas Trade, R*eports on the Present Position and Tendencies of the Industrial Arts, as indicated at the International Exhibition of Modern Decorative and Industrial Arts, Paris*, 1925, London, Department of Overseas Trade, 1927, pp.39–50 (p.50).

[6] *Report of a Commission Appointed by the Secretary of Commerce to Visit and Report upon the International Exposition of Modern Decorative and Industrial Art in Paris*, 1925, Washington, 1926, p.16.

[7] Basil Ionides, 'Modern Interior Decoration', *Creative Art*, vol.4, no.5, May 1929, pp.341–45.

[8] Theodore Komisarjevsky, 'The Granada Cinema, Tooting', *Cinema and Theatre Construction*, October 1931; David Atwell, *Cathedrals of the Movies*, London, Architectural Press, 1981, p.130.

[9] *Architect and Building News*, vol.125, 9 January 1931, pp.55–57 (p.57).

[10] Nikolaus Pevsner, *The Buildings of England, Middlesex*, London, Penguin Books, 1951, p.130.

[11] Bridget Cherry, 'The "Pevsner 50": Nikolaus Pevsner and the listing of modern buildings', *Transactions of the Ancient Monuments Society*, vol.46, January 2002, pp.106–109.

INDEX